Questions of Practice

What Makes A Great Exhibition?

Paula Marincola
Editor

PHILADELPHIA EXHIBITIONS INITIATIVE
PHILADELPHIA CENTER FOR ARTS AND HERITAGE

Philadelphia Exhibitions Initiative is a program of the Philadelphia Center for Arts and Heritage, funded by The Pew Charitable Trusts and administered by the University of the Arts.

Philadelphia Exhibitions Initiative
Philadelphia Center for Arts and Heritage
1608 Walnut Street, 18th Floor
Philadelphia, PA 19103
pei@pcah.us
www.philexin.org

Paula Marincola, Director
Ellen Maher, Program Assistant
Tiffany Tavarez, Program Assistant

Second printing, 2008
Printed in China by Oceanic Graphic Printing

ISBN-10: 0-9708346-1-6
ISBN-13: 978-0-9708346-1-4
Library of Congress Control Number 2005-910486

Distributed for Reaktion Books in the USA and Canada by the
University of Chicago Press, 1427 E. 60th Street, Chicago, IL 60637, USA
Distributed in the rest of the world by Reaktion Books Ltd,
33 Great Sutton Street, London EC1V 0DX, UK

Editor: Joseph N. Newland, Q.E.D.
Publications Co-ordinators: Jeremiah Misfeldt, Tiffany Tavarez
Design: Purtill Family Business

Contents

In memory of a curator's curator

Walter Hopps, 1984, photograph courtesy Mary Swift

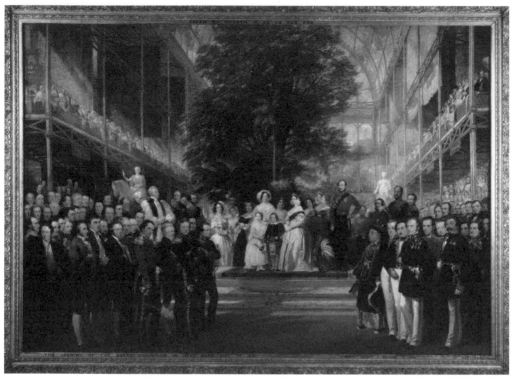

Henry Courtney Selous (England, 1811–1890), *The Opening of the Great Exhibition by Queen Victoria on 1 May 1851*, 1851–52, oil on canvas, 82 ³/₄ x 11³/₄ (210 x 282.5 cm; framed), Victoria & Albert Museum, given by Warren de la Rue.

Introduction: Practice Makes Perfect
Paula Marincola

Exhibitions are strategically located at the nexus where artists, their work, the arts institution, and many different publics intersect. Situated so critically, they function as the prime transmitters through which the continually shifting meaning of art and its relationship to the world is brought into temporary focus and offered to the viewer for contemplation, education, and, not the least, pleasure. Critic and curator Bruce Ferguson has defined exhibitions as "the central speaking subjects in the stories about art which institutions and curators tell to themselves and to us."[1]

1. Bruce Ferguson, "Exhibition Rhetoric," in *Thinking About Exhibitions*, ed. Reesa Greenberg, Bruce W. Ferguson, Sandy Nairne, (London: Routledge, 1996), p. 176.

What, then, makes a great exhibition? The mission of the Philadelphia Exhibitions Initiative (PEI), a granting program that funds visual arts exhibitions and their accompanying publications, is encapsulated in this colloquial, rather naïve-sounding question. It is, nonetheless, the deceptively simple query that has determined and focused PEI's evaluative criteria; the shorthand phrase to which, in our adjudicatory process as well as in other of our professional capacity-building programs, we are repeatedly, if implicitly, referring. Of course, it can be argued that "greatness" resides in the beholder's eye and other organs of reception and is ultimately both an arbitrary and subjective value, impossible to define. Yet PEI challenges our community of arts professionals year after year to devise exhibitions of high artistic merit in order to receive one of our grants. It seems only fair, therefore, to attempt to identify and understand how the elements, practices, and several contingent considerations that factor into creating an exhibition (what we might call the techniques and procedures of curatorial tradecraft) amount to a whole that is significantly more than the sum of its parts.

As PEI approached our fifth anniversary, the notion of producing what I initially considered as a kind of *Festschrift* to mark the occasion became attractive for two major reasons. In our panel deliberations that year, it had become clear that the quality of the applications we were considering had improved demonstrably from earlier efforts in both conceptual and logistical scope. Clearly, the area's arts organizations had taken, quite seriously, PEI's injunction to extend their artistic programming beyond "business as usual," with tangible results. We had, as well, just completed "Curating Now: Imaginative Practice/Public Responsibility," a major symposium on curatorial practice, and the response to that event and to the publication of its proceedings spoke compellingly to the field's

need for continuing discussion and writing around issues of curatorial practice. I asked myself how PEI could not only register a programmatic milestone, but continue to build on the conversation that we initiated with "Curating Now."

The answer seemed self-evident, given our mission and the organizational moment. Why not commission a group of curators to consider this pertinent but rather general question—*What makes a great exhibition?*—in light of their particular professional practice and experience? As exhibitions create a variable framework for looking at and thinking about art, my idea was that these texts might serve an analogous or parallel function for exhibitions themselves—I hoped they would make a display of themselves. Thus, in a quite pragmatic way, "Questions of Practice" was conceived.

What follows here out of that originating impulse is not, perforce, a theory-driven or academic inquiry into the nature of exhibitions. These, while occupying a vital place in what we are pleased to call the discourse surrounding curatorial practice, are not the intended province of this anthology. Nor is *Questions of Practice: What Makes a Great Exhibition?* a mere practicum; the realization of an important show—like that of any other substantial achievement—not being a simple matter of following instructions in a "how-to" manual. Questions of Practice places its emphasis on and asserts the value of how concepts surrounding curating are filtered through the lessons derived from repeated performance, from thinking *and* doing, or, perhaps more accurately, thinking based on doing. It is in practice that *a priori* assumptions and closely argued theories meet with the resistance of the empirical and the contingent. Various factors, many beyond a curator's control—insufficient budgets, recalcitrant lenders, space constraints, competing institutional imperatives and priorities, ancillary resources or lack of them, to name a few—defy the most carefully cherished ideas and ideals. Curatorial intelligence, invention, improvisation, and inspiration are developed and refined by effectively engaging and reconciling these constraints as the inevitable limitations that accompany most exhibition-making. Insofar as *What Makes a Great Exhibition?* clarifies and reflects on the structures, methods, and conditions of exhibition practice, it formulates a rich compendium of highly informed critique. Practice, one could say, makes as great an *im*perfect as possible.

Questions of Practice began to take shape as the investigation of such issues and produced this first report from the front by those stationed there. Believing that the matter of *what* makes great exhibitions would be best addressed by *who* makes them, I focused primarily on contributions from colleagues who work more or less daily in the field, curators in mid-career[2] with substantial track records readily available for inspection and disagreement. I have enormous respect and admiration for each of the contributors. Some have had a prior working relationship with PEI, while professional activities put me in serendipitous proximity to others when I was determining who the

2. One exception is Detlef Mertins. His essay, originally conceived as an historian's analysis of architecture exhibitions, became instead a kind of meta-text that uses Mies' iconic New National Gallery as a prime example of the way visionary museum architecture can dominate the art exhibitions it contains, often forcing new installation solutions from artists and curators in order to accommodate it.

collection's participants might be.[3] Many are identified with particular types or genres of shows—monographic; thematic or speculative; design; film/video; or public art projects, for example—in which they have produced substantial projects, and sometimes benchmarks in the field. They are also, on the whole, curators of contemporary visual art, although the lessons, insights, and examples they bring to their writing should be directly relevant and transferable to historical exhibitions.

Several of the contributors are, or have been, institutionally situated to enjoy the advantage of highly visible, highly influential platforms from which to present their work. For better and worse, institutional context provides a critical framework for exhibitions' creation and reception, and some of the organizations where these curators have worked constitute privileged bases of practice to which the field looks for its standards and cues. Clearly, however, groundbreaking efforts have emerged from curators working independently as well as those affiliated with smaller galleries and museums or alternative spaces, where a quicker response time, more curatorial autonomy, and less financially onerous stakes allow for a concomitantly greater ability to experiment and take risks. This collection, therefore, also acknowledges the too-often overlooked fact that—at least organizationally speaking—bigger is not necessarily better.

My strategy in posing to these authors the initial question—What makes a great exhibition?—was to beg a host of others. Corollary queries arose out of considerations particular to various categories of exhibitions, and to the analysis of components that together configure a show and its impact. I was interested, too, in further investigating ideas germane to the varieties of projects PEI considers in its annual selection process; so that questions at issue in the field were also selected for address here as they intersected this region's roster of shows. These questions were posed as interrogatories necessarily demanding amplification, qualification, even resistance—points of departure from which each writer could then explore her or his given subject. In raising them, I tried as well to identify appropriately expert respondents; the alert and attentive reader will soon recognize my hopefully arranged marriages and can gauge their relative success. The "List of Questions Leading to More Questions and Some Answers" is found here on the back cover and again in the form of a bookmark, so that the conceptual armature structuring the texts can be made visible and help inform a reading of the collection.

In taking up my questions, some authors responded directly, others more obliquely, and some disregarded them entirely—all according to their own interpretation of the parameters laid out for them. This authorial prerogative extended to the format and tenor of their texts, which range from formal essays to lively and frank conversations, and even a passionate, rather quixotic, letter to this editor. Timing, opportunity, and curatorial subjectivities,

3. Naturally, there are many more curators whose work I admire and regard as significant than can be represented in this collection, and I am acutely aware of potential contributors whose voices are missing here. Not from lack of trying, though. I could have gone on almost indefinitely (and very nearly did) inviting colleagues to contribute here as each text suggested others that would add greatly to the mix. I delayed publication more than once waiting for and/ or hoping to entice yet another curator to write for us. (They know who they are). It was only the intervention of my editor that forced me to accept that it might be wise to finish this book before PEI's tenth anniversary rolled around. Three PEI-commissioned essays here have already been published: Ralph Rugoff's by PEI as a prospectus of this book, and those by Carlos Basualdo and Detlef Mertins in the journals *Manifesta* and *Grey Room*, respectively.

then, have shaped this collection as much as any design that I as interlocutor might have initially thought to impose.

Questions of Practice: What Makes a Great Exhibition? takes its place in the burgeoning literature on exhibition-practice, and curating more specifically. We live, as Michael Brenson reminded us not too long ago, in the age of the curator, now fueling a whole industry of academic programs and publications. Books on the subject emerged with regularity as we've been working on this one;[4] others doubtless are set to follow hard on its heels. We can be confident, given the ongoing, not entirely unproblematic professionalization of the field, that more remains to be said and done in this arena.

It certainly took us longer to produce this book than we initially planned—we just awarded our ninth cycle of grants. Questions of Practice, however, began and reaches publication as a different kind of crucial investment that the Philadelphia Exhibitions Initiative, beyond its role as a regional funder, can make in an area of cultural practice to which it is deeply committed. Hoping to match the generosity of our contributors, we offer their insights in a collegial spirit, as stimulus and provocation, and in a continuing effort to generate additional inquiry into and writing about the field. Despite its lengthy gestation, we think it remains very much a worthwhile venture.

The Philadelphia Exhibitions Initiative, moreover, actively seeks to encourage and remain open to curatorial innovation, and to advancing a context to consider the new as it unfolds. We plan to continue as a resource in the field for arts professionals and the interested public alike. The questions that arise out of the daily practice of exhibition-making will obviously evolve as the conditions and definitions of that practice change; our work is enriched by providing a hospitable place in which to formulate and respond to them.

4. See, for example, two publications from the Banff International Curatorial Institute, Catherine Thomas, ed., *The Edge of Everything: Reflections of Curatorial Practice* (Banff, Alberta: Banff Centre Press, 2002), and Melanie Townsend, ed., *Beyond the Box: Diverging Curatorial Practices* (2003); the series *Curating Now*, initiated in 2002 by the California College of Arts M.A. program in Curatorial Practice and having now produced three numbers (http://sites.cca.edu/curatingarchive/publications.html); as well as *The Straight or Crooked Way: Curating Experience* (London : Royal College of Art, 2003); and *Men in Black: Handbook of Curatorial Practice* (Berlin: Künstlerhaus Bethanien; Frankfurt: Revolver, 2004).

Show and Tell
Robert Storr

It is customary in writing about what curators do to use the singular noun *exhibition* to cover what is in fact a plural category. From this, much confusion ensues in the experience and the judgment of the public. Rather than one form, exhibitions take many, some more, some less appropriate to their timing, their situation, their audience, and above all their contents. None of them is ideal and none exhausts the potential meanings of important art. A good exhibition is never the last word on its subject. Instead it should be an intelligently conceived and scrupulously realized interpretation of the works selected, one which acknowledges by its organization and installation that even the material on view—not to mention those things which might have been included but were not—may be seen from a variety of perspectives, and that this will sooner or later happen to the benefit of other possible understandings of the art in question.

In short, good exhibitions have a definite but not definitive point of view that invites serious analysis and critique, not only of the art but of the particular weights and measures used in its evaluation by the exhibition-maker. That term has only recently come into use, and despite its bulkiness, it is preferable in this context to *curator* to the extent that it acknowledges the existence of a specific and highly complex discipline and separates the care or preservation of art—a curator's primary concern—from its variable display. Many of the best exhibition-makers are freelancers or work for institutions that have no permanent collection. It is the privilege of those who are associated with museums rich in holdings to regularly reconfigure their galleries, thereby breaking the monotony of canonical hangings while demonstrating the polyvalence of the works in their charge. While it is generally agreed that such historical collections should retain a degree of continuity in their basic installation of major works and tendencies, periodic reinstallation of larger or smaller sections of that overall layout demonstrate how works familiar, perhaps over-familiar to both the frequent as well as the occasional visitor, can be seen afresh. To be sure, "churning" collections, like churning stocks, opens up the possibility for gimmicks and frauds. But those overly intimidated by this possibility, or simply too conservative to imagine that the official value ascribed to their favorite masterpieces is but a fraction of their true worth when put into circulation with other works, are not the defenders of important art against cheapening misuse, but instead the ones who most grievously underestimate its enduring importance.

The of-late much debated alternatives of thematic versus chronological installations of museum collections—and neither option entirely excludes the other except in the minds of ideological opponents of change—constitute but two of the subgenres of the larger category of the survey show. It, in turn, is but one of the many variants of the group exhibition in which works by different hands are brought together according to a given premise: an overview of a national heritage, an artistic or cultural tradition, a period, a movement, a style, an aesthetic principle in operation, or simply a roundup of current production. The venue, scale, duration, and primary public for such exhibitions all are factors in their development. However, it should go without saying that the work and the exhibition-maker's grasp of that work is, from start to finish, the decisive criterion in the exhibition's presentation. Concessions made to any other consideration that tampers with the fundamental integrity of his or her basic intention will result in flaws that are unlikely to escape the notice of viewers even if they are unaware of why those flaws occurred.

Declaring that such an absolute standard is impractical is too often a plea for ducking the responsibility held by patrons and institutions for fully supporting the people they have given the task of making exhibitions. Skilled practitioners will use constraints creatively, but when it comes to essentials they will, or at least, should be uncompromising on behalf of the art for which *they* have primary responsibility. It is possible to make a good exhibition with an empty loft space and a couple of thousand dollars. Likewise, one can, without waste, fill tens of thousands of square feet and spend millions to that same end. (Botching both due to a basic lack or a messy surplus of ideas is also easy, but the concern here is with avoidable failures). What cannot be done is to cut corners within the framework of a specific proposition without distorting the meaning of the work. In the final analysis, assessing dangers of that kind must be entrusted to those who know the work best.

Similarly all decisions about the architectural layout and sequencing of works should reside with the exhibition-maker, as well as ultimate decisions about lighting, signage, labeling, brochure, and text-panel design and content, typography, wall color or absence of color, and every other detail, large or small, that substantively conditions the encounter between the viewer and the work. On their own, exhibition-makers have diverse degrees of exposure to and command of these areas, and at some point or another all will need to rely on the expertise of specialists for technical advice, as well as for imaginative solutions to specific problems. The crucial issue here is not input, which is essential, but rather fending off the managerial and sometimes market-driven tendency to put together shows by committee. This leads to a bureaucratic division of labor, with sections of the overall enterprise being turned over to professionals in various fields, design (that is, form) to designers, education and communication (that is, content) to educators and press officers, and so on. Special-

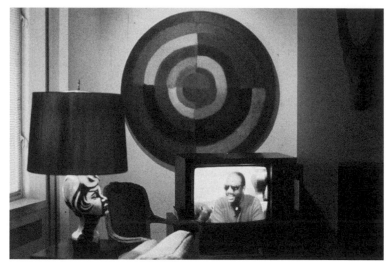

Louise Lawler, *Living Room Corner, Arranged by Mr. and Mrs. Burton Tremaine Sr., N.Y.C. (Stevie Wonder)*, 1985, color photograph and red type on white mat margin, courtesy of the artist and Metro Pictures.

ists of this kind may or may not understand the art that that they are in effect being asked to frame and describe for the audience. Many do, but many others do not, and few people at these or any levels of the art system can be expected to appreciate all of the wide range of work most institutions now cover. In this setting, the central role of exhibition-maker derives from just such an in-depth knowledge of the art, and from the vision of the whole that he or she brings to a given situation. (A corollary of this is that exhibition-makers must abstain from dealing with material into which they do not have a superior insight no matter how tempting the job might otherwise be.) In sum, the exhibition organizer occupies, or should occupy a position analogous to that of a film director who works collaboratively with everyone else involved in the process of making a movie, but who is assured, in spite of all contrary pressures, of final cut.

The same rules apply to other genres of exhibition, most of the rest of which are dedicated to the art of one person. Among them are the commissioned "project" that has become a staple of contemporary museums, Kunsthalles, and alternative spaces. Films, videos, installations, performances, participatory actions or situations, and publications-as-exhibitions are at the moment the most common types in this domain, but ensembles of paintings, drawings, and sculptures also fit this description. In addition there are early- and mid-career surveys of an artist's work, synoptic or comprehensive retrospectives, late-career updates, and posthumous retrospectives, or theme- or time-based reexaminations of an artist's oeuvre.

Each of these subgenres comes with its own opportunities and problems. The commissioned project, for example, requires of the exhibition organizer the utmost in clarity, tact, and firmness. The best such exhibitions result from the artist being able to experiment with previously untried ideas, mediums, and contexts. The worst are situa-

tions where an artist's fantasy comes up hard—but too late—against the reality of limited financial and technical resources, misconceptions about the physical or social "site," or the deferred recognition that the artist's premise simply wasn't substantial enough to produce a work of genuine interest. The exhibition-maker's duty is to calculate the odds of one outcome or the other given his or her research into the artist, his or her work and the givens with which he or she have been asked to contend. Since risk-taking is of the essence, the longing for surefire success is the exhibition-maker's nemesis, and legitimate failures must correspondingly be treated with respect, and valued for what they have brought to light. A case in point would be the huge, toy airplane launching apparatus with which Chris Burden filled the main hall of the Tate Britain in 1999. Very few planes ever made it into flight, but the Rube Goldberg contraption, its painfully obvious travails, and the mechanical frequency of crashes all contributed to a work of greater symbolic significance—a sort of *Titanic* of aviation in the age of NASA—than a clockwork accurate device would have. That said, less experienced artists with less convincing hypotheses have gotten into trouble because exhibition-makers working with them didn't offer timely critical feedback about the basic validity of their initial notion, warn them off patently unfeasible proposals, or simply voice their gut feeling that an artist had somehow gotten off on the wrong foot. Enthusiasm for young or paradigm-breaking artists does not mean passive acquiescence to poorly thought-out schemes. Respect is sometimes best shown by friendly skepticism and disasters are sometimes averted by a plainly stated "no" backed by clearly articulated reasons. In the current climate a significant number of exhibition-makers simultaneously underestimate and overestimate their status in relation to the artist. This confusion is revealing of the present plight of their calling. On the one hand they operate contrary to all that they know or should know as if the artist was always right; and then, having surrendered their authority as specialists, claim in other facets of their activity that, at bottom, they too are artists and deserve exceptional deference. But exhibition-makers are *not* artists, and deference, mixed with envy, is an unhealthy inclination in any dealings based on shared information and passion. When it was said earlier on that exhibition-makers should have what amounts to a filmmaker's final cut, that was not intended to suggest that the result of what they do is comparable in aesthetic terms, only that in both cases a coherent result depends on an equivalence between a holistic conception of what needs to be done and overriding power to assure that what is done matches that conception as much as can be. Perhaps one way of sharpening the distinction between the two separate vocations is this: if a filmmaker blows it, he or she gets a bad review; if an exhibition-maker blows it, it is most likely not he or she but the artist who gets the bad review, and it is more than ever his or her fault if he or she is certain in the first place that he or she chose to represent a strong talent.

In virtually all other instances of the one-person exhibition, the exhibition-maker is working with materials that already exist or will be complete before the show opens. In this respect, errors of judgment fall even more heavily on the shoulders of the exhibition-maker. Insofar as such shows are the means by which the general public becomes acquainted with an artist's work and the basis on which its opinions are formed, vagueness of purpose, lack of criticality, habits in problem solving, an unrealistic sense of what the occasion for the exhibition is, and what its opportunities and constraints are, worsened by any reluctance on the part of the organizer to assert his or her will when necessary, can have severe and lasting consequences for the art. These pitfalls would seem to be self-evident and circumventing them an easy matter, but one needn't look hard to see examples of exhibitions mishandled for one or more or these reasons, and one has only to read the run-of-the-mill exhibition proposal to see early signs of such weaknesses.

Fundamentally, though, since such lapses are rudimentary, the question boils down to two things. The first is never going off half-cocked even as one incorporates into the process of exhibition-making the largest possible margin for tactical maneuver, reconsideration of working assumptions, on-the-spot reactions to art, and on-the-spot invention in the "phrasing" of a show. The second, which follows from the first, is to be as explicit as one can be from the outset about where one is headed and what allowances in time, professional support, and money will be required to get there. This also includes strict understandings about the power of the exhibition-maker and the roles of others involved. Unstated expectations in any quarter, compounded by unspecified lines of authority, are a recipe for misery in doing a show and all but guarantee a bad outcome. Exhibition-makers must know their own mind and then clearly interpret how it works to all concerned, including those who hire them, their colleagues at all structural levels, and, above all, the artist. Like anyone who leads others in a direction of their choosing, they must have, or acquire the capacity to see around corners, to anticipate the effects of what they and others do several moves ahead, and demonstrate the agility to deal quickly with unforeseen challenges in a manner consistent with their agreed-upon aims. They must also have the ability to concede error and to correct their course. These statements would also appear to be axiomatic, but dithering, fitful improvisation, desperate backing-and-filling, spasmodic displays of willfulness and temper, and other signs of unpreparedness and insecurity are rife in the field. They throw everyone off, and, at the risk of excessive emphasis, they are most disconcerting to the artist whose achievement should be squarely in the forefront.

As with the group or thematic show, there are several types and sizes of monographic exhibitions, and, as with the survey, confusion on the part of the organizer about which one is being attempted accounts for many of the problems which arise in the minds of the

public, the artist, and the critical community. Some of these differences are dictated by the scope and scale of the institution, others are caused by them. Thus, it is often difficult for large museums to mount comparatively small exhibitions of an artist's work without that "smallness" seeming to be a judgment on the artist, prompting the spoken or unspoken response: "If they were really behind the artist, it would have been big," or "If the artist was really good, it would have been big." Meanwhile, it is impossible for a small to medium-sized institution to mount a mega-show. Organizers who function in denial of that fact and cram too much material into a given space in an effort to catch up with bigger institutions in sheer "quantity" may betray the artist out of an eagerness to please him or her. One option—and this is of value to small- to medium-sized spaces in major centers as well as small- to medium-sized cities—is for two or more such institutions to divide up the material and collaborate. Given the varied production of some artists this is an attractive solution in other ways, since it allows for parceling out distinct bodies of work among a variety of situations especially conducive to one or another kind of material. This is commonly done now in big surveys, but little-tested though readily conceivable in the case of the one-person show, if the person in question is flexible and sees the benefits of having his or her work crop up in diverse venues, each with its own distinctive characteristics. Increasingly, thinking in terms of such spatial constellations and institutional alliances will be crucial to the organizers of one-person shows since the number of artists who merit such exhibitions greatly outstrips the number of big museums or Kunsthalles capable of hosting a single-site project of this genre, particularly in the United States. And so far as contemporary art is concerned, this distribution/dispersal of work, while not always appropriate, may prove to be not just a necessity, but an occasion for opening up the format, and positively altering the understanding of such "summary" exhibitions by, in effect, accenting the plurality of an artist's interests and practices, rather than their neatly framed unity.

This said, nowadays many debut museum surveys, mid-career shows, and retrospectives are too big and/or too dense with material by any standard, especially those dictated by the actual magnitude of an artist's accomplishment, the manner in which the work "naturally" unfolds, and the capacity of the audience to absorb it. The pressures in this direction are many. First comes the institutional imperative to create a blockbuster and the closely related desire to fill grand architectural gestures that have, alas, become more important to many people involved with museums than the art they might contain. Second, there is the matter of artistic ego in two common but by no means universal forms: on the one hand there is the self-defeating conviction that more is better based on the equally problematic assumption that everything the artist has made is essentially good; on the other hand there is a competitive instinct that pushes even modest artists to want to equal or surpass peers who have recently

had large presentations, especially when they follow closely on the heels of a peer who, for whatever reasons, has been allowed or encouraged to mount an expansive show. The third concerns the ego of the exhibition-maker who loses sight of his or her role and seeks to make a mark by occupying as many square feet and publishing as fat a catalog as his or her sponsors will accede to. As is true for some artists, competitiveness with a curator whose project has recently preceded his or her own often motivates such miscalculations.

Self-discipline, which is not the antithesis of ambitiousness, but rather the expression of a will to make memorable exhibitions over the long haul, is the only answer to the third category of pressure. One has it or acquires it, or one doesn't. Based on such self-discipline, it is the exhibition-maker's challenge to bring similar discipline to institutions and artists. This does not mean dictating to them but assessing the inherent scope of an artist's work and making a strong case for what that work seems to dictate under the prevailing circumstances. The main factors that determine the outcome include the realistic availability of loans, the possible reconfiguration of galleries, and the degree of exposure the artist has already had. Some major artists have been seriously overexposed and are best served by relatively tight shows while those less familiar sometimes benefit from more ample ones that reveal the full texture of their achievement and a host of other considerations specific to the art in question.

Perhaps the simplest way of looking at the exhibition-maker's relationship to both the institution and the artist is to draw an analogy with the literary editor who negotiates with publishers and writers on behalf of the "best" version of work that can be attained. In some cases, the editor is handed an elephantine manuscript that has been written flat out—a Thomas Wolfe or Jack Kerouac novel to continue with the comparison—and discreetly though fundamentally shapes

Louise Lawler, *You Could Hear a Rat Piss on Cotton—Charlie Parker*, 1987, silver-dye bleach print, courtesy of the artist and Metro Pictures.

or reshapes it. In other cases the finished work is so complete and self-contained that only minor decisions on the editor's part are required or appropriate. In either case, and in all those that fall in between, the exhibition-maker is the first, most critical viewer in the way that a good editor is the first, most critical reader. He or she must have the artist's trust and can only earn it through the closest scrutiny of what the artist has done and by developing an instinctive sense for all that was involved in its creation. Based on a genuine commitment to the work and an appreciation of the artist's methods and motives, the exhibition-maker gains the right to speak frankly, and contribute his or her expertise to the endeavor without hesitation.

Selection is the initial, and, in many ways, the touchiest, stage of this negotiation since it inevitably means stating preferences. But not all differences of opinion in this realm hinge on taste alone, and if they do not, all pit the exhibition-maker against the artist over the issue of what the former doesn't like and the latter promotes or defends. Sometimes, the tables are turned and the exhibition organizer must coax the artist to let others see early or digressive works he or she has turned he or she back on out of embarrassment or frustration. In cases where the artist's work is well known, such persuasion can reopen consideration of his or her achievement in important ways or at least keep the exhibition from looking like a textbook account. By contrast, the artist may sometimes decide suddenly that certain canonical works have been seen too often and push for their exclusion. In such cases it is the duty of the organizer to remind him or her that a large part of the nonspecialist public may *never* have seen these works, and that the only alternative to "decommissioning" the dreadnoughts of his or her career is to surround them with a fleet of other vessels in proportions that diminish their tendency to overshadow everything else.

The misconception that the best one-person show consists more or less entirely of the best-known works by that artist is fairly widespread. For those on the outside looking in, it may indeed seem that the selection of works for such a show is in effect a "no brainer," and that all the exhibition-maker does is to round up the usual suspects. To the contrary, the thing that makes it a "brainer" is first, the foreknowledge that some, if not many of the usual suspects will prove to be out of reach, and second, the awareness that a mere parade of canonical works, as impressive as it may be, sheds little light on the subtexts of the art in question. It is as if one made a film with a thoroughly predictable plot, and only stars doing star turns, in such a situation there is nothing that gives dimension or nuance to works that are supposedly "great" by consensus but may pall when installed cheek by jowl, or tend, as "masterpieces" can do, to blind people rather than open their eyes, because of the fame or glamour attached to that status—factors usually touted and exacerbated by exhibition advertising and thoughtless talk of rarity and cost, that is to say, the discourse of "treasure" hunts. Minor, but substantial works

that crystallize key aspects of an artist's sensibility and development are as necessary to the one-person show as indisputably major ones. A scattering of such works often engages the viewer first by virtue of their salient and readily accessible qualities, qualities which, when initially seen in relative isolation, teach the viewer what to look for in more complex or more rarefied works. A surfeit of showstopping art stops the show.

Other questions regarding selection have to do with the vested interests of dealers, collectors, and patrons. More than one recent retrospective has been diluted to the point of terminal blandness by the overstock of works forced on the exhibition-maker by the artist, his or her estate, or his or her representatives. The impulse to use a retrospective to upgrade unsold works, or simply to clear the warehouse, is nothing surprising; but the short-term advantage is likely to be just that—short term—and the ultimate costs to the reputation of the artist can be devastating. The exhibition-maker is not in business, but sometimes a businesslike warning about the dangers of such strategies can help fend off such pressures. If push comes to shove, however, then the exhibition-maker must refuse to give in, and to do that effectively must count on the backing of the institution. If the pressure comes from patrons of the institution in which they are working, then he or she must be assured that a clear separation of powers exists and that regardless of how friendly or insistent the suggestion that he or she include certain works in a show, it is finally up to the exhibition-maker and no one else, to decide. Just as artists may sometimes come to the aid of an exhibition-maker to obtain a loan from a reluctant source, so, too, they may help an exhibition-maker to decline an overly eager one. The intricacies of such dealings constitute the inner workings of art diplomacy, for which there are no reliable scripts. It is worthwhile restating here that under such circumstances, focus, transparency, and candor on the part of the exhibition-maker with respect to his or her overall purpose, are in every way preferable to dissembling and guile in this domain. However, on either side of the never-fixed line between these approaches, agility and humor count. And, as with dealers and artists, accurately assessing the downside of the collectors' getting what they want in situations where, in their own best interests they shouldn't want it, is all in the exhibition-maker's favor. Gently pointing out that a particular work in their possession might look out of place—not to say redundant or lesser—in the company of other works already selected can be a useful argument. Object lessons can be found in exhibitions that have been heavily amended when they traveled to their second and third stops, where local professionals lobbied too successfully to add work that duplicated things already on the checklist, only to find that direct comparison between the work originally chosen and the one tacked on exposed the weaknesses of the latter. Since such comparisons stick in mind, the risk to the proud owner of the good-but-not-best work is hardly worth taking. This holds true

of works belonging to the participating museums that someone may think of substituting for or inserting among those originally in the show. What might legitimately hold pride of place in their collection could well pale next to the top-of-the-line works gathered for a once-in-a-decade retrospective. All in all, it is the responsibility of the exhibition-maker in conjunction with the artist to agree on an irreducible but also uninflatable group of works. After that, any tampering with that selection must be regarded by all parties as strictly out of bounds for the sake of the coherence of the whole, as well as for the sake of those who might wish to wiggle an "extra" in only to find that it stands out like a sore thumb. Exhibition-makers are not always right in their choices, but they are almost always wrong when they yield to special pleading.

Now to the basics. The primary means for "explaining" an artist's work is to let it reveal itself. Showing *is* telling. Space is the medium in which ideas are visually phrased. Installation is both presentation and commentary, documentation and interpretation. Galleries are paragraphs, the walls and formal subdivisions of the floors are sentences, clusters of works are clauses, and individual works, in varying degree, operate as nouns, verbs, adjectives, adverbs, and often as more than one of these functions according to their context. Ordinary people are sensitive to their surroundings and what is in them if you let them be. Based on that basic aptitude they are or can become visually literate if you lead them into and through spaces filled with things in a manner that encourages them to heed the clues they are consciously or subliminally picking up, clues that the exhibition-maker has left for them.

People are generally afraid of things that are unfamiliar to them, and when it comes to art they are most afraid of the embarrassment of appearing not to get it. This is normal, but it should

Louise Lawler, *I Don't Have a Title For It, Maybe We Should Have a Contest?*, 2002/2003, silver-dye bleach print (museum box), courtesy of the artist and Metro Pictures.

not cause the exhibition-maker to underestimate their basic intelligence or their ability to learn. Neither should the exhibition-maker forget that the reason people come to a museum or exhibition is to expose themselves in measured doses to just this sensation of not knowing for sure what things are, or what they think of them. In short, they like the estrangement that art precipitates so long as they are not needlessly caught off guard. The exhibition-maker's job is to arrange this encounter between people and what puzzles them in such a fashion that they will derive the maximum benefit and pleasure from it—that is, from the particularities of the work, their own uncertainty, and their innate drive to exploit to the fullest extent their own imaginative and intellectual resources—and make something out of new experience.

Honoring their audiences' needs and desires, exhibition-makers should refrain whenever possible from preempting that process—which is never a matter of just one visit to an exhibition-event-entertainment in which all is accounted for—by explaining the work away before viewers have had a chance to see it with their own eyes, and engage it with their own minds. If people read labels instead of looking at the work, it is the exhibition-maker's fault, not theirs; he or she has made the labels too prominent, too plentiful, too wordy, too graphically arresting, or in any other way too "interesting" in the general field of vision. We have all witnessed people in museums running up to read a label before stepping back to look at the work beside which it has been affixed, and then move to the next object before ever really seeing the first one for themselves. And if the behavioral pattern holds, they bob from stop to stop through room after room of art which is experienced largely as a vista rather than as a series of specific discoveries. Curators should do nothing to encourage and everything to interrupt this is information-gathering, art-obliterating choreography.

Correspondingly, audio guides have become the bane of exhibitions by unfairly competing for the attention of the viewer by piping words into their ears when they should be using their eyes. In a gallery context, sound almost invariably trumps sight. Moreover, inasmuch as audio guides function by directing the listener to duly marked "key" works in a gallery, they cause crowds in front of these works, making it impossible to examine them in any careful or sustained way. Worse, they spur the crowd to skip everything in between. No compelling sequence of works can overcome this herding effect, which means that there is little chance that the viewer can "read" the installation as an ensemble of discoveries, the positioning and pacing of which inform each other and instruct the viewer by example in how to "read" the whole of the exhibition. Meanwhile, the audible whispering of such guides substitutes itself for conversation and arguments among viewers, and the taped voice of authority—whether art expert or mellifluous actor—drowns out the voice in the viewer's head that struggles to articulate its own ideas and feelings.

The case made for audio guides is that they help members of the public to enter into the artist's world, but the fact is that they are more likely to keep them out, obscuring not only the work but the viewers' spontaneous reactions. Ostensibly democratic devices, they are the opposite insofar as they once and for all interrupt the crucial first acquaintance with art and assign the job of synthesizing sensation and thought to a disembodied interpreter. One can take and consult a brochure or information sheet at one's discretion and in one's own good time; an audio guide sets its own agenda and mesmerizes the person carrying it, by being so "user friendly" that to abstain from using it seems like a waste. The combination of sound and moving images upstages every other kind of image, such that interactive video screens in the gallery become the unavoidable centerpiece of the room, a little like a TV in a living room or a bar. Information is essential to understanding art, but firsthand experience precedes it and also reasserts it powers where didactics surrender their claim on the public's attention. Experience is, in fact, the subject of art and establishes the subjecthood of the viewer. Anything that supplants it, regardless of how valuable in its own right, or how well-intentioned on the part of the provider, is, ultimately, art's nemesis.[1]

Sequencing of works in the first rooms of an exhibition becomes a primer for learning how to read other, perhaps more complex material that follows. Cacophonous beginnings or stately and contemplative ones set a tone for the whole installation that may be borne out by what comes after, or contradicted by it. However, once that tone is set in the viewers' minds it will condition the way they see everything else. Varying the density of rooms sets a cadence; breaking that rhythm by placing critical works in unexpected or dramatic spots accents certain aspects of what is on view. That said, it should be possible for the viewer to circumambulate a room in more than one direction rather than follow a lockstep progression of displays. Wherever architecture allows, it should also be possible to enter a gallery from more than one angle and still grasp its contents, indeed, as a result of tracing these alternate paths, to grasp them in different intersecting ways. Neither in its chronological or formal unfolding should the installation of a room or suite of rooms ever point exclusively forward, nor should the viewers ever feel that they are in a regimented progress from one thing to the next. Indeed, to the extent that most intricately nested exhibitions tend to resemble mazes, then, like Theseus hunting for the Minotaur in the labyrinth, the viewer should have the means to retrace his or her steps at any juncture. However, it is the exhibition-maker's responsibility, not the viewer's, to lay the string that marks a trail in and out. Or, to revert to the movie analogy, viewers ought to be able to rewind the exhibition at any point, pick up the thread of "the story" not previously dwelled on, or savor the effects of a few frames, and then fast forward at will to resume their experiences of the exhibition's main flow. From any gallery there should, if at all possible, be something to see in the gallery before it as well

1. In making the case against the use, or, at any rate the overuse, of audio guides, I am under no illusion that the practice will cease. In all probability it will grow. Neither am I innocent of having made such guides. As is expected of curators organizing major exhibits, I have written and recorded several and was happier being the one to do that with the option of determining the content and setting the pace as best I could than handing the job over to a media expert or educational generalist. Nor do I wish to disparage the skills of the professional primarily responsible for putting such sound packages together. In fact, my personal experience of those who specialize in the field has been very good, and I respect their seriousness about art and their understanding of the public needs. Nevertheless, in hastening to provide the public with "facts" and "interpretations" in this manner, museums and their collaborators deprive individual viewers of something crucial to their own independent experience of art, namely surprise, wonder, difficulty, and the realization that they can make sense of much of what they see and take active, untutored interest in the things that still puzzle them.

as the gallery beyond, and perhaps from more than one gallery in either direction. And from different vantage points different works should be framed by doors and corridors in relation to what is in the gallery where the viewer is standing. Thus, the subtexts of an artist's work—such as recurrent themes and motifs, or sharp contrasts otherwise smoothed out by the work's gradual evolution—are brought to light by architectural jump-cuts.

Exhibitions are commonly said to tell stories, and in one-person shows they tend to follow a biographical narrative line, or a teleological formal one; first he or she made this then that; or first the medium was developed in this way, and then in that way. In most such cases, the story told telegraphs a foregone conclusion or climax, the triumph (and maybe tragic death) of the artist, or the triumph (as if inevitable) of a governing aesthetic idea. Anything the exhibition-maker can do to arrest the rush toward that denouement, to digress from the main events in order to concentrate on the overlooked aspects of the work's character and, finally, to eschew closure so that on leaving the exhibition the viewer doesn't think so much of how it ended (even in cases where the artist died) but how it might go on or might have gone following not only the further development of dominant traits but also of recessive ones. Artists such as Jackson Pollock are perhaps most subject to being presented in trajectories that emphasize the dramatic finish. Nevertheless, the irony of his case is that the last works he made plainly bespeak someone trying to get traction for a significant stylistic redeparture. In other words, the narrative of his personal misery tells one story, and that of his confused and fitful work tells a related but essentially different one. The former is that of a man in a hellish psychological cul-de-sac; the latter an artist probing for the way out of a creative impasse and finding that he had a variety of choices in front of him. The second, inconclusive story is the one that a Pollock exhibition should tell.[2] The older an artist gets the more the exhibition-maker has to be on guard against mounting an apotheosis, which by implication suggests that the artist's work is complete and that the audience is merely in attendance at the public celebration of fulfilled promise. Good artists always have more work to do, great ones spring surprises. In 1982 the seventy-year-old Louise Bourgeois had a retrospective at the Museum of Modern Art. In the two decades since, she has had countless other career surveys around the world, most of them weighted equally between old, pre-1980, and new, post-1980 work. Wisely, none of the shows has been predicated on the idea that Bourgeois was summing up, heading in a predictable direction, or ready to rest on her laurels. By virtue of her extraordinarily protean old age, she, more than anyone, has insisted that her shows be open-ended.

That is the way one-person shows should be. In all circumstances and at all costs, exhibition-makers should shun the temptation of making exhibitions that purport to draw ultimate conclusions about the work—especially with a living artist, but even with a dead one.

2. To its great credit, the most recent Pollock retrospective organized by Kirk Varnedoe did tell this second story.

26

Blockbuster retrospectives most frequently go wrong through hubris. Inflating the size of such exhibitions and making undue claims for their historical importance on behalf of the organizer or host institution is usually the root of such trouble. Viewers should not come with the idea that they are about to have a once-in-a-lifetime experience, but rather think of an exhibition as the beginning of a renewable acquaintance with someone or something it will take a long time to know well and whom one will never know completely. Correspondingly, the viewer should exit exhibitions energized rather than exhausted, and convinced that there is more to be seen, and other ways of seeing it. Thus, the old adage about not overstaying one's welcome applies to exhibitions as it does to social encounters: "leave longing not loathing."

Incidentally, this principle bears on catalogs as well. The editorial equivalent of the blockbuster is the paper brick. While some of these volumes are handsome and informative, in their sheer bulk many are a threat to the forests, and in their glossy, self-consciously designed contents little more than coffee-table books with intellectual pretensions. Art and artists are not well served by books that no one reads. Oversized books that intimidate, and may even physically handicap the potential reader, are a disincentive to genuine engagement. Generally, this is compounded by their being overpriced as well, despite the large subsidies required to publish them, with those subsidies often being a drain on the overall exhibition budget. Accurately reproducing the works in the exhibition, and useful supplementary images are enough, though recently some exhibition catalogs have been expanded to serve as catalogs raisonné to very good effect, mainly because the production was modest as is appropriate to that genre, and the information well researched and cogently and concisely set forth.[3]

The question of what audience (as distinct from market) exhibition catalogs are created for is central and decisive. While some exhibitions are quite correctly intended primarily for aficionados, most are mounted with a general and diverse public in mind. Accordingly, the catalog should reflect that diversity by being written in language the common reader can understand and with respect for what the common reader is likely to know about art coming in. To give priority to such a reader is not populist pandering, it is democratic respect. They have come to see the show and then sat down to learn about what they have seen—which is always better than being lectured or asked to read too much standing up in the galleries, as argued before. Consequently the author or authors should not indulge in exclusive discourses, take any essential facts or theoretical constructs for granted, use this as the occasion to fight intramural battles with other writers without setting the stage for such arguments, or indulge in the professional vice of slinging jargon. On the other side of the equation, the author should never talk down to the reader or oversimplify difficult issues in ways that limit the reader's ultimate grasp of the aesthetic, cultural, or social

3. Edited by Joan Simon, the catalog raisonné of Bruce Nauman's work that accompanied his 1994–95 retrospective organized by the Walker Art Center is a prime example of how this can be done economically and to a high scholarly standard, in a format that is also manageable for the general public.

complexity that account for them. As the modernist composer and incisive newspaper critic Virgil Thomson said about writing for general circulation publications, "Never overestimate the information your readers have, but never underestimate their intelligence." In the matter of introducing an artist to that public, and to almost the same degree in representing a large and complicated body of work that has heretofore been seen in pieces or chapters, a clear point of view is as essential to a catalog as it is to the exhibition upon which it is based. Often, this means a single author with a distinctive and engaging writerly voice. If the situation argues for multiple authors dealing with differing aspects of a varied production, or tackling contested problems from differing theoretical positions, then the exhibition-maker in conjunction with lead writer or editor (who may be one in the same person, if not the exhibition-maker him- or herself) must convene this symposium or debate in a manner that will permit the reader to grasp its rationale, and otherwise gauge the proceedings against the background of a straightforward description of the art under discussion and of its generally understood place in the world. This is true even if it is precisely that general understanding that the catalog contributors and editor aim at unraveling or superseding.

To insure that catalogs for one-person exhibitions not be, or are not be perceived as being, uncritical testimonials to the art and artist in question, the exhibition-maker and catalog writer/editor should maintain complete authority over its design and contents. They may, if the artist has a gift for bookmaking, enlist him or her in the conception or layout of the catalog, but they must never abandon their role as project coordinator and final arbiter, much less surrender any part of their control on demand. Catalogs are not vanity publications, nor are they made primarily for the aesthetic satisfaction of the artist. Rather they exist to convey in the optimum manner in another medium the basic thrust of the exhibition. Artists may ask for approval of the texts published about them, but they should not be granted it. Nor should catalog writers seek such approval on their own. Friendships between exhibition-makers/catalog-writers and the artists to whom they devote their energies may survive the process of making a show or they may not—in the best case they actually deepen—but the former must insist on a totally professional disconnect in certain areas for the sake of the project's integrity. If required by circumstance, they must be prepared sacrifice easy relations for a better result. If the artist does not trust the professional working on his or her behalf, then whatever personal bond may seem to exist is one-sided or illusory. Given human nature, it is thus unwise to turn essays over to artists in any form prior to publication; a good editor will be on the lookout for facts that need checking and those can be handled by either the editor or the writer on a detail-by-detail basis. It is not the artist's prerogative to pass on opinions and interpretations, or for that matter which facts get attention.[4]

4. A recent controversy over a text I wrote for the retrospective of Lee Bontecou organized by Elizabeth Smith and Ann Philbin highlighted the issues of curators showing artists and their supporters catalog essays prior to publication. In this instance Bontecou and her husband took me to task for not interviewing the artist before drawing comparisons between her work and that of other contemporaries. Bontecou's concern was to eschew such connections in order to emphasis her dependence on nature as a source and her debt to a few friends and her husband. Her husband's attack on the piece seems to have been prompted by longstanding animosities toward the art world and a desire to treat her work as essentially sui generis but for the example of his own and the same few friends. As a critic and historian, my aim was to show that whatever influences she may have felt or exerted on others, her work was of importance precisely because of the way in which it both related to and altered our prior understanding of the context in which it was made. Had the curators not stood their ground on the principle that such exhibitions are not merely the occasion for artists to put forward their interpretation of their work but also the moment for other complementary or even competing views to be heard, the essay would have been removed from the catalog by Bontecou and her husband.

28

Artist participation in the installation of an exhibition follows much the same guidelines but is a more delicate affair. Some artists are very good, flexible, and creative in their approach to hanging or siting their work. Quite a few are not, but only some of them are aware of it. On the assumption that the exhibition-maker is good at installing, or, alternatively, that he or she has a clear idea about what he or she wants and skilled preparators and designers to realize it, installation should be done solely by the exhibition-maker after having discussed with the artist the strategies proposed for the project, and the principles to be referred to in choosing backup options, or solving problems that inevitably arise when the sketch or model of a show is arranged in physical space. In explaining their plans, exhibition-makers should be mindful of the fact that they know the ins and outs of the architecture of their "house" or venue better than the artist and many of the possible differences between them and the artist may arise from that reality. Clearly, interpreting to the artist the perceptual gestalt and the advantageous or disadvantageous quirks of the spaces in which the exhibition will be located is therefore of great importance. A good exhibition does not ignore the idiosyncrasies of its site: it either exploits them to unexpected effect, or makes them disappear to the measure possible. Not having repeatedly reconnoitered, as well as mapped the galleries prior to making those plans is suicidal for the exhibition-maker, and if special walls, bases, and other structures are being built for the occasion, close supervision—and when necessary, on-the-spot revision—of that construction is, likewise, of the highest priority. Slackening attention on the part of the audience may result from inattention to such matters on the part of the exhibition-maker: for the one as for the other, impatience is in the details.

Except where he or she is actively involved in the process of installation at the exhibition-maker's invitation, the artist should politely be told that he or she is not to come on the floor until the show is fully in place and lighted. As a rule of thumb, artists who do participate in installations should be there from start to finish, so that things are not done in their absence that cause incidental friction. In the ideal scenario, the dialogue between an exhibition-maker and an artist in this context is much like that of two musicians exchanging improvised phrases, where agreement or disagreement, proposal and variation are dealt with almost entirely by audible, or in the situation under discussion, visible example. For many exhibition-makers, installation is the true reward for all their other labor. It should not be made an ordeal by the intrusion or second-guessing of other parties, but the greatest pleasure of all is to work harmoniously toward the same goal with the creator of the work. Robert Ryman is an example of a painter who brings his whole being as an artist to bear on the installation of his paintings, but who, as a former jazz musician, thoroughly appreciates the contribution of the exhibition-makers with whom he has collaborated, and the nuanced differences among his

5. I worked directly with Ryman on the installation of his 1992 retrospective at all three of its American venues, and I am aware that some colleagues have had similarly collaborative experiences.

shows are owed to this responsive and cooperative sensibility.[5] In any case, artists should understand that if they agree to do a show they have entered into a contract with the exhibition-maker and his or her institution which cannot be rewritten piecemeal. Artists should not sign on for an exhibition if they lack faith in the craftsmanship and critical orientation of the exhibition-maker. Exhibition-makers should not work with artists who do.

Politics, it is said, is the art of the possible. While not an art form in its own right, exhibition-making is likewise a matter of making the most out of what necessity, opportunity, and canniness allow. If much of the politics of exhibition-making centers on the administrative and aesthetic contracts negotiated between the exhibition-maker and the artist with whom he or she works, the institution which puts its resources at the disposal of the project, and the specialists who devote their expertise to the it, then the most important contract of all exists between the exhibition-maker and the public. It is unwritten, but breaches of that contract are immediately apparent, and their consequences for art and all those committed to it, beginning with the public, cannot be exaggerated.

At stake is the meaning of the work, and who determines it. Not for all time and not for everybody, but in the present tense of the individual's direct exposure to it, and the past and future tenses of his or her changing recollection of what he or she has seen and his or her developing expectation of seeing it again, with the subsequent confirmation or correction of those mental traces. Whereas many people have thought, and some still think, that every work of art has an essential meaning vested either in cultural ideals and conventions, the history of the medium, the materials and their spirit or formal imperatives, or the artist's intention, the fact that this irreducible essence is judged by different constituencies to be located in such different places argues that it is located in all of them to some degree, and none of them absolutely. Whereas adjudicating disagreements about meaning once fell to officialdom—the State, the Academy, university-trained scholars, and self-made men and women of taste who rose to lofty posts in museums or journalism—or was sometimes handed directly to the artist, it is plain both as a practical matter and as a matter of principle that the ultimate decisions are made by the viewer. The job of the exhibition-maker is to do all that can be done so that those decisions will be well informed, rooted in perception and, in a positive sense, inconclusive. To borrow the terminology of contemporary literary discourse, this means granting the reader power equal to that of the author, who is not "dead," as theorists have argued, and therefore should be heard, but who can no longer lay claim to absolute authority over the import of his or her work and should also refrain from standing between it and the reader. Insofar as this shift in balance between creator and audience is staged by the exhibition-maker and hence is itself an act of mediation, it is incumbent on the exhibition-maker to make

Louise Lawler, *Nude*, 2002/2003, silver-dye bleach print (museum mounted), courtesy of the artist and Metro Pictures.

those interventions as transparent—that is, self-evident, and at the same time as unobtrusive—as possible given the thrust of his or her overall conception of the show. Above all exhibition-makers must not usurp the autonomy of either of the primary parties in this dynamic, or propose to speak to either of them in the name of the other, or in the name of an overarching authority. Exhibition-makers convene the parties and offer proposals for meaning but they must not presume to impose it.

If the art is truly important, it will necessarily have many facets and set off many trains of thought. The responses it may prompt and the lessons that can be drawn from it correspondingly multiply by the number of people who come to look, the number of times they do so, the number of objects offered to them, the number of facets if presents, and the number of angles from which they are encouraged to examine it, as will be the passage of time and changes in the world context. The mathematics are simple; the sum infinite. Exhibition-makers contribute by facilitating this expansion of meaning rather than by containing it. Given that infinity is impossible to contemplate, they assist the viewer by focusing hard on specifics, while reminding that same viewer that they constitute only a fraction of a larger whole. If they do that generously, and thereby increase the viewer's appetite for art by making it keener and more discerning, then they have done a lot.

In Lieu of Higher Ground

Lynne Cooke

Beneath the subheading "The Undeclared Struggle between Artist and Curator," the graduates of the 2003 class in Curatorial Studies at the Royal College of Art in London muse on what they perceive to be a growing infringement on the traditional role of the curator. Identifying recent artistic practices that, they believe, will increasingly encroach upon their professional freedom and proficiency, these fledglings assert that "a subtle and undeclared territorial war is in progress,... [a] rush for the division of power." All is not lost, however: the apparent cession of professional ground and authority to contemporary artists may be tactical. "The curator's role has in fact furtively shifted onto a higher ground," their catalog introduction concludes. "His or her competence is relocated from a direct relation with selection and display to an ability to generate narratives and direct a sequence of experiences."[1] Implicit in this statement is the notion that those key narratives need no longer be generated by the artworks themselves, nor by their selection and installation. Rather, the exhibition's subject and raison d'être—"thematic" is no longer quite the right term—will be articulated by the curator and transmitted via various channels, not least through the choreographing of immersive environmental experiences. Both conceptual structure and logistical implementation will henceforth be subordinated to the exhibition conceived as a scripted event to be staged for its recipients, the spectators. Essential to this foregrounding of the visit as integrated occasion are a nexus of diverse components among which the assembling and presentation of a group of artworks is but one: other ancillary mechanisms include exhibition design, social interaction and debate, screenings, performances, souvenirs, and inaugural festivities. The encompassing weltanschauung that replaces the sequence of one-on-one engagements with individual works that traditionally formed the ground of the audiences' experiences and from which they might speculate on larger issues or a governing metaphysic, now provides the point of departure through which and from which they engage with the works of art and related activities. As the curator hones the recipients' responses, exhibition-making in and of itself theorizes issues deemed central in contemporary cultural debate.[2]

Accepting, for the moment, not only the currency but the validity of such claims, this scenario posits a radical shift in the officially sanctioned role of the curator as commissioner of new work: for it

1. Introduction, "The Straight or Crooked Way: Curating Experience," *MA in Curating Contemporary Art*, Royal College of Art, 2003, 11. The author of this catalog text, Francesco Manacorda, is one of the group of students on the course in 2003 who collectively curated the eponymous exhibition and therefore may be assumed to be speaking for the group as a whole.

2. For a fuller discussion of these issues by James Meyer, Francesco Bonami, Martha Rosler, Okwui Enwezor, Yinka Shonibare, Catherine David, and Hans-Ulrich Obrist, see Tim

redefines the consensual nexus of activities which once constituted her relationship with the artist to that of host (who hands over the gallery or institutional space), or producer (who provides the resources, financial and other), but, above all, of publicist (who delivers the textual narratives), and impresario (who stage-manages the exhibition as event). Much that pertained to the traditional dialogue in the planning and presentation of a new work—beginning with a sense of mutual trust based on the curator's deep knowledge of and regard for the artist's oeuvre, followed by the close monitoring and supervising of the proposal, its fabrication and installation—is preempted: according to this new model such concerns occupy a relatively minor, even incidental position.

While shifting artistic practices in large part contributed to this marginalizing of normative curatorial functions, museological pressures are also relevant. More and more young artists whose practices fall under the rubric of "poststudio" today tend to conceive of producing a work as does a film director. Rarely do they fully determine its technical presentation (since this generally lies outside their area of competence and requires specialists hired for the task); and rarely can they preview it (since they lack adequate studio space or equipment to test it in private). In this era of so-called postproduction artistic practices, both artist and curator often encounter the newly commissioned work in its definitive guise for the first time at the moment of the exhibition's inauguration. Subject to many of the same pressures that have produced what is termed an "experience economy," institutions too are ever more committed to the staging of a series of interconnected leisure attractions which supplement and enhance the exhibition experience. As if in self-protection, curators, when faced with such potential constraints on their areas of competence, have appropriated methodologies employed by artists involved with what has come to be called "relational aesthetics"—and compete with them in delving into the social/institutional domain in order to construct experiences.[3]

To commission a new work from an artist under these conditions requires a radical shift in the exercise of the curator's skills and competence—a shift away from those skills which have pertained since the later 1970s when commissioning new projects became, if not de rigueur, at least a highly desirable way of working. Over that decade certain key developments can be traced in the course of which commissioning new projects came to be considered among the preeminent options, the most engaging and challenging terrain on which a contemporary curator could operate. The consolidation and canonization of this trend can be charted in the three episodes (to date) of Skulptur Projekte Münster. First launched in 1977 in a modest form comprised of eight outdoor projects, by 1987 the exhibition had grown to include approximately fifty new interventions in the urban environment, and from that it expanded again in 1997, when some eighty projects and maquettes were unveiled at

Griffin, "Global Tendencies: Globalism and the Large-Scale Exhibition," *Artforum* 42, no. 3 (November 2003): 152–63. The most sophisticated instance of this to date is Documenta11, with its five platforms devoted to such subjects as democracy. Director Okwui Enwezor's essay in the publication accompanying the fifth platform, in Kassel in summer 2002, entitled "The Black Box," offers an alternative reading of modernism's trajectory, one which informs the selection and presentation of works shown in the accompanying exhibition [*Documenta11_Exhibition Catalogue* (Ostfildern-Ruit: Hatje Cantz, 2002), pp. 42–55]. A more representative case is "Poetic Justice," the 8th International Istanbul Biennial. In the catalog, curator Dan Cameron discusses at length the thematic underpinning the exhibition, proposing a key role for contemporary artists in constructing a global community. Nowhere does his impassioned account address the selection process, the range of work, the sites used in the exhibition; or any individual artist's practice, suggesting that the works function primarily as catalysts to speculation on the larger issue. The 8th Biennial thus became bifurcated into the exhibition as an event which may be experienced but not glossed, and a catalog that functioned as a supplement and aide-mémoire.

3. The influential notion "experience economy" was coined by B. Joseph Pine II and James H. Gilmore, in their widely debated book *The Experience Economy: Work is Theatre and Every Business a Stage* (Boston: Harvard Business School Press, 1999). Business consultants and marketing strategists, they argue that the fast growing experience sector, for which the scripting and staging of memorable experiences and events has become primary, will supersede the more conventional offering of services or commodities. Art institutions are increasingly responsive to the implications of this trend as it impacts on the leisure, tourism, and retail services they provide.

the opening jamboree to a vast horde of art world aficionados, tourists, local residents, and foreigners of all kinds. Building on what initially had been a limited and exploratory venture occupying a rather conventional selection of outdoor parkland sites, the second manifestation of this citywide presentation invited more self-consciously experimental works from a broader base of artists, both more intergenerational and more international in scope. They in turn tested more rigorously the boundaries and premises of site-specificity than had the first group of participants. Intimately engaged with the particularities of their site, their projects, at their best, responded eloquently to the social, religious, cultural, political, historic, economic, and other factors shaping the fabric and infrastructure of this small German city. The tasks of the commissioning curators were multiple and manifold; they conceptualized the exhibition, identified opportunities for intervention, scoured potential sites, selected the artists, supervised the proposals, negotiated with the relevant authorities, handled the funding, oversaw the realization of individual works, and coordinated the public presentation. That both curators, Kasper Konig and Klaus Bussmann, were thoroughly familiar with the city, its history, its infrastructure, and built environment was an enormous advantage in refining and facilitating this most ambitious and polyphonic of shows. No longer docile, the spectator was galvanized to search out the artworks which revealed, critiqued, and problematized issues relating to place and site in unprecedented ways: in addition, the project provided many studio-based artists with novel avenues to circumvent normal institutional confines. Narratives were woven from multilayered encounters with individual works. No larger thesis was proposed, and no predetermined itineraries were established for encountering the works. In addition, there was no requirement that the artworks be apprehended as an ensemble, and no pressure to assiduously track down every single contribution spread throughout the city and beyond: "The ideal visitor to the exhibition is not the participant in international art tourism," the commissioners contended, "but the flaneur who idly walks through Münster and follows the interplay of art and city."[4] Dispensing with the scholarly apparatus of a conventional catalog, they produced as the primary manual a *Rundgang*, or guide, which contained only a brief preface, an apologia from the organizers who, discounting all didactic and pedagogic aims, solicited an introductory essay from an unaffiliated colleague, followed by short detailed texts on each proposal. As flaneurs, spectators would be left to tailor their own, often idiosyncratic trajectories, generate their own private pleasures from what was on offer, and conjecture overarching narratives.

A more elaborate variant on this publication comprised the companion volume to the exhibition in 1997, and included a sponsor's foreword, theoretical essays on questions relating to public art and attendant urban themes, as well as entries on individual proposals. In its third reprise, the focus of the Skulptur Projekte expanded

4. Klaus Bussmann and Kasper Konig, "Preface," in *Rundgang/Guide* (Cologne: Skulptur Projekte Münster, 1987), 7.

to embrace the spectacular—the media event—which became the subject of a number of works as artists responded directly to, among other changing circumstances, the growth in audience numbers and shifting demographics, the increasing mediation by the press, and the legacy of the previous two incarnations including their multiple offspring, elsewhere, in the intervening years.

For this seminal strategy had rapidly proliferated and mutated, quickly becoming a preferred paradigm, one which could be applied in a miscellany of situations, indoor and outdoor, institutional and ephemeral, large and small. In addition to the novel challenges it offered artists, it proved an ideal—a desideratum—for freelance curators who were thereby empowered to engage artists to an almost unprecedented degree from the earliest moments of conceptualization through the extended process of realization.

Functioning in the prototypical instance as the facilitating conduit, the curator subsequently morphed into the spokesperson—at once authoritative and authoritarian—of a multifaceted event whose mandate and justification were less the individual artistic contributions than the presumed redemptive or compensatory benefit to the community, albeit community as a mythic unity. Given such goals, the relationship binding artist and commissioner changed again, until in the most extreme cases the curator served both as the guardian protecting community relations and the censor monitoring approved strategies of intervention.[5] Spectators were no longer blithe flaneurs but carefully monitored and prepped attendees who were subjected to a socially engaged didactic pedagogy. Common to all such ventures however was the conviction that ambitious shows of contemporary art staged outside the traditional museum portals demanded the commissioning of artworks and, moreover, of works made specifically for those circumstances in order to ensure the requisite levels of critical attention and audience attendance by which success is currently measured.

The intensely "hands-on" collaborative relationship that had evolved between curator and artist in the commissioning of new site-related work in the mid-eighties marks a special moment in a history that has many previous chapters. For previously, the realization of an ambitious project that required large resources and an exceptional situation had usually depended less on a curator than on a patron. The cusp of the 1970s marked the critical moment in this transition as vanguard artists' practices simultaneously took them outside the conventional institutional framework and into what is often called poststudio production. Arguably, no single artist's practice charts and defines these volatile protean relationships with more ingenuity and boldness than that of Robert Smithson.

Ranging from paintings and drawings executed in the early sixties, followed soon after by sculpture inspired by minimalist precedents, Smithson's early works were created for the traditional circuit of display and acquisition: the gallery, the collector, and the museum.

5. In her recent book *One Place After Another: Site-Specific Art and Locational Identity* (Cambridge, Mass.: MIT Press, 2002), Miwon Kwon brilliantly charts the evolution of site-specific art from the model exemplified in the Skulptur Projeckte Münster, and related ventures, to the transformation of the site conceived as a literal, physical venue to a discursive terrain. Inter alia, she traces in detail the complex custodial role that curator Mary Jane Jacob played in closely determining the selection and implementation of artists' proposals for "Culture in Action," in Chicago in 1992, under the subtitle "Community of Mythic Unity" (See Kwon, *One Place After Another*, chapter 4, 100–137).

In the mid-1960s however he began to produce ephemeral works or multiples designed for distribution through other channels, notably as articles in art magazines and more mainstream publications. At the same time he reconceived his gallery-oriented production to take the form of "non-sites": diagrammatic, textual, photographic, and map-based works that were umbilically linked to locations elsewhere which they cited and charted through documentary means rather than through recourse to conventional modes of artistic representation. Still other works took the form of temporary interventions in the public domain: *Partially Buried Woodshed* was executed in 1970 at Kent State University, Ohio, in response to an invitation to a creative arts festival, and later donated by the artist to the institution; and *Broken Circle*, in Emmen, Holland, 1971, executed the following year on a far grander scale, was commissioned for the Sonsbeek exhibition. Rejecting the selector's proposed sites in a park, Smithson sought a more distant uncultivated landscape, eventually choosing a fully operational sand quarry. Funded by the organization as a temporary installation, his pioneering earthwork proved so popular that the local townspeople voted to preserve it as a permanent piece. On yet other occasions he either commandeered or acceded to the role of curator, as occurred when he and Virginia Dwan produced the landmark exhibition "Earthworks" in 1968 in her New York gallery. More ambitiously, in 1967, he undertook the role of consultant to one of the engineering firms bidding to construct the Dallas–Fort Worth Regional Airport, proposing an aerial artwork himself in addition to works by his peers, Carl Andre, Robert Morris, and Sol LeWitt. Still other projects depended on contributions from a patron, as was the case with the *Spiral Jetty*, whereby his gallerist provided the funds for the realization of the land artwork, and for a companion piece, the film also titled *Spiral Jetty*, which had its debut at the Dwan Gallery in 1970 and has since been transferred to video and freely distributed to educational and other institutions. Just prior to his untimely death in 1973 Smithson initiated negotiations with a number of mining companies whom he considered likely sponsors for pioneering projects involving land reclamation and/or the reuse of polluted industrial wastelands.

The patronage that individuals like Dwan or Robert Scull, or such private entities as the Dia Art Foundation, provided to Smithson and his peers, notably Walter De Maria and Michael Heizer, made possible works that would not otherwise have come to fruition. That these patrons were or had sometimes been gallerists may not be incidental. But whether disinterested or not, patronage of this type offered unparalleled opportunities. A commission, by contrast, is usually executed for a particular situation: a site, an event, a program. Thus once the Dia Art Foundation became a public institution it abandoned direct patronage in favor of the commissioning of works to be presented in a newly acquired exhibition facility, a former warehouse in New York City, beginning in 1987. Like

their precedents realized under the aegis of private patronage, such commissions not only solicited proposals of a notable ambition or singularity but once again encouraged proposals that might not otherwise have been conceived. What had formerly resulted in occasional projects that typically were realized in perpetuity in remote or peripheral locations became, in this shift of policy, a mandate to produce on a regulated schedule a series of works for a designated situation, an exhibition program presented in a metropolitan venue. In contrast to the relationships that had made possible the realization of Heizer's *Double Negative*, 1969, or LaMonte Young and Marian Zazeela's *Dreamhouse*, 1979, De Maria's *New York Earth Room*, 1977, and Joseph Beuys's *7000 Oaks*, 1982, the commissions for Dia's New York program on West 22nd Street were clearly framed by the institution.[6] Not only did artists now undertake to work within a series of predetermined parameters, but this was anticipated to be a one-time engagement, in contrast to the ongoing or open-ended situation that was integral to much previous patronage, where the artist could expect continuing support from the benefactor. As an instigator, seeking out artists, extending an invitation, and monitoring and facilitating the project once agreed upon, the institution plays a role very different from that played by the patron, whose allegiance is thought to be unequivocally bestowed: subject to no extra-aesthetic considerations, whether practical, logistic, or financial, and hence disinterested, it is typically delivered from afar, from a deferential distance. By contrast, as an institutional commissioner, the curator acts as an intermediary between artist and institution: responsive and responsible to each, she is a conduit, an intercessor, and an arbiter.

Even when broadly limned as in the above account, these two models reveal a gamut of subtle but significant differences. Since 1987 Dia has undertaken an ongoing series of individual commissions in the guise of site-related presentations as temporary exhibitions. While contingent on and expressive of the sensible, social, and cultural phenomena particular to the site, most of these commissions have nonetheless treated this venue as thematically or conceptually undefined, that is, as a variant on the white cube: neutral, insulated, autonomous.[7] By contrast, in 1987 and again in 1997, Münster witnessed, under the auspices of a temporary organization, the full flowering of that intensely collaborative relationship critical to the production of site-specific public works in a plethora of different venues, each of which was conceived independently of all others and in relation to local conditions and thematics.

Since Münster's first iteration twenty-five years ago, the norms underpinning commissioning have substantially changed. Today, site-related commissioning does not play the central role it once did: it remains a norm and staple in a repertoire of presumptive tasks and roles. Huge budgets and complex technical production can rarely be supplied by the initiating institution whether biennial, Kunsthalle, or museum. Increasingly the means of production come from else-

6. The collector Robert Scull acted as a patron for several of Heizer's projects. The New York *Earth Room* was initially intended to be a temporary installation. Although not all Dia's early commissions were for rural locations, all required self-contained situations, and, arguably, could be apprehended outside a narrowly aesthetic framework, hence in large part devoid of traces of institutional mediation. By contrast, organizations that today work "off-site," creating temporary site-related works, such as Public Art Fund in New York City or Artangel in London, operate similarly to museums and Kunsthalles since there is an implicit frame around the work they commission analogous to those which more formalized institutions inevitably generate.

7. The two exceptions to this program of temporary commissions have been Dan Graham's *Urban-Rooftop Pavilion*, which was initially a temporary installation but later acquired for the collection, and Robert Irwin's *Excursus: Homage to the Square 3*, which was only acquired after the exhibition closed, and it will be reinstalled again in the future.

where, whether from a strategic pooling of public resources, or from commercial galleries which are not only more flexible and financially endowed, but may pre-sell the work, or from the artists themselves, a growing number of whom act as producers of their own large-scale multimedia creations. Assuming the mantel of surrogate patrons, sponsors develop increasingly self-promotional agendas while collectors also are becoming more venturesome, to the point where they too directly instigate commissions on their own behalf. Increasingly many artists' practices are centered almost exclusively in large-scale projects. Rather than responding to singular challenges, to what formerly had been a relatively rare opportunity to engage with site in some guise or another, many are now overwhelmed with all too similar invitations, pressured to respond to increasingly demanding schedules and cajoled into addressing the perceived needs of mainstream audiences. It is almost incumbent upon them as producers of large-scale multimedia art-forms to negotiate or exploit the potential for spectacle. For backed by sponsorship, the commission tends to be transformed into a media event; a status quo best exemplified in the complex morphing history of Pierre Huyghe's memorable "Streamside Day Follies."[8] The monumental scale, theatrical form, high visibility, and rigorous accountability which this and related projects typically entail tends to mean that commissioners opt for artists with a proven track record who have previously demonstrated the kinds of ambition, resilience, and rhetorical skills mandatory in resolving such ventures successfully; the projects unveiled in the Unilever series in the atrium of Tate Modern over the past four years provide a classic instance of privileging the already sanctified. This inherent conservatism raises the question of to what degree programs based in commissioning remain viable. Is there, for example, any longer a need, or justification, for Skulptur Projekte Münster to continue? What would be its goal in 2007 outside the economic gains to the city from cultural tourism? How and should it distinguish itself from a generic cultural festival, or a temporary theme park? Similarly, if the recent commissions nurtured at Dia could in principle be realized elsewhere, that is, if they could be shown under similar circumstances if not necessarily for the same extended duration, what does a commission of this kind now offer to a mid-career artist? Should the program cater less to the artist, once considered the primary beneficiary, and more to the perceived needs to the audience: and if so, how should those needs be defined—by the introduction of narratives and the orchestration of immersive experiences which filter as they insert themselves between the spectator and the work of art, defining and negotiating in advance the viewer's relationship with whatever it is that the artist has produced? Such a radical shift would inevitably foreground the role of the curator, wresting authority and power from the artist who formerly was placed center stage.

Among the more fruitful alternative strategies to have emerged in this same quarter-century as the two models sketched above have

8. For a fuller account of Huyghe's project, see my essay in Dia's forthcoming publication on this project.

been certain ventures based on a notion of partnership, a shared endeavor uniting artist and curator in relation to a third element, namely one or more preexisting works. The seeds of this type of alliance lie in an exhibition model which was generated at the end of the seventies whereby an invitation was extended to an artist to present works from a museum's collection in ways that would allow viewers to experience artifacts long familiar to them in new speculative relationships. Inaugurated by the National Gallery, London, in the late 1970s, "The Artist's Eye" has been a series of presentations by a number of senior British artists acting as onetime curators, notable among whom are Richard Hamilton, Bridget Riley, and Anthony Caro. While many of these veterans elected to include an example of their own work alongside that of the old masters, a few abstained. Representative of the subsequent segue of this mode of site-specific commissioning into various forms of institutional critique is the similarly modest series "Artist's Choice," launched by the Museum of Modern Art in New York in 1989. Several of the participants in this occasional series have adopted a more proactive role than that played by their British counterparts. Elizabeth Murray, for example, used the opportunity to excavate overlooked women artists whose works in MoMA's collection were rarely if ever exhibited, whereas Scott Burton, in the inaugural exhibition in 1989, explored the potential for Brancusi's bases to be read as sculpture in their own right. One of the first artists to engage in what has become known as institutional critique, Hans Haacke took a more tendentious stance vis-à-vis the institution in his 1996 project "Viewing Matters: Upstairs" for the Boijmans van Beuningen in Rotterdam and more recently, in 2001, when he reinstalled objects from several departments in the Victoria and Albert Museum at the nearby Serpentine Gallery in a trenchant critique of the underlying ideologies on which not only those collections were made but the institution itself was founded. On other occasions similar strategies have permitted curators to explore premises and postulates underpinning their own institutions through the vehicle and voice of an artist who may possess an interpretative license that they themselves do not have, or do not wish to assume. Paradigmatic of this ventriloquizing approach is "Mining the Museum," a project that involved Fred Wilson, commissioned by outside curator Lisa Corrin on behalf of the Maryland Historical Society in 1992, in a reinstallation of that collection. Other more restricted partnerships have delegated to the artist the task of exhibition installation but not of selection, as occurred in 1987 when Dia invited Imi Knoebel to oversee its inaugural exhibitions in its new exhibition facility in Manhattan. Thus Knoebel installed *To the People of New York City*, the last work executed by Blinky Palermo before his premature death. In a separate gallery, on another floor of the same building, Knoebel then installed a group of works, also in Dia's collection, by his former teacher and mentor, Joseph Beuys. On a third floor he made an exhibition of his own works, all of which again came from

Dia's holdings. In a comparable undertaking in 1991 Remy Zaugg was invited to install the Giacometti retrospective at ARC in Paris, and in 2002 the Swiss duo Fischli and Weiss oversaw the presentation of a Picabia retrospective, once again in consultation with the art historians selecting the show.

Among the most inventive reprises on this kind of collaborative commission, in which an artist is invited to assume some of the functions traditionally exercised by the curator, was the partnership between James Coleman and the art historians planning the exhibition devoted to Leonardo da Vinci's drawings and manuscripts that was held at the Louvre in Paris in the summer of 2003. Crucial to this memorable and illuminating intervention was the fact that Coleman neither inserted a signature work of his own into the selection nor altered the presentation of the works chosen and arranged by the professional organizers in what was otherwise a standard academic enterprise. Exceptionally, he entered that "higher ground" identified by the young Royal College graduates; generating (alternative) narratives and orchestrating visual experiences. Seen within the framework of institutional critique, his response to the commission was twofold. In each of several galleries he inserted a group of three tiny monitors into a wall. In addition he worked with the curators and technicians to project large-scale footage of that most elusive and fugitive of Leonardo's masterworks, his fresco of the *Last Supper*. When it finally proved impossible to secure a live digital feed from Santa Maria delle Grazie in Milan, Coleman used as his source material various types of reproductions of the work, including both scholarly books and coffee-table publications. A computer-driven projector then randomly scanned details from this footage which appeared on a monumental scale in a program that lasted several hours. In the final gallery of the show, carpeted at his request, and hence offering a comfortable arena in which to watch the footage, ravishingly beautiful swaths of luminous color slowly shifted across the screen. Magnifying imagery in extraordinary detail, imagery that is no longer available to the casual visitor, or even to the initiated since so much has been altered in the recent restoration, this hypnotic projection offered scholars and aficionados as well as religious and more general audiences not only information but also experiences they would not have otherwise been able to have, whether for technical, financial, conceptual, or administrative reasons. Counterpointing the close reading of a quasi-forensic art historical examination with a hallucinatory immersion in celluloid fantasy reminiscent of Hollywood extravaganzas, Coleman conjured a seductive experience delicately poised between the spectacular and the pedagogical. Thus he addressed that highly mediated trope, the blockbuster exhibition celebrating the singular genius, and simultaneously, invoked the counter-trope, the revelation of the intimate creative processes of the exemplary public figure through the vehicle of a private aesthetic language

manifest in sketches, manuscripts, and studies amplified by the addition of his tiny luminous monitors.

Revealing a work in miniature, and hence once again at a scale very distinct from that of the original, the choice of monitors as reproductive means highlighted the fact that they represented something that was unavailable, absent, ideational. Conjuring metonymically what could not be present, what could only be perceived in the imaginary, they underscored not only the (necessary) partiality of the selection but the fact that Leonardo almost never brought a work to closure, that most of his projects either remained unfinished, or morphed into others, or were but one element in a larger exploratory sequence; in short that the finite objet d'art was antithetical both to his working process and his protean mind. Yet, how these subtle interventions ultimately affected the dominant curatorial narratives and exposed their determining methodologies was left open for the viewer to supply or surmise.[9] Coleman's remarkable contribution fulfills the tenets of what is currently discussed as postproduction work in that he takes as his raw material preexisting cultural artifacts and, in addition, he deploys this material in ways that incorporate display and presentation. By inflecting the organizer's narratives, he created metatexts that slyly revealed the limitations of a canonical scholarly methodology when applied pro forma to the specifics of a singular case study. And, by means of a spectacular, dramatic, and visionary intervention in the final gallery, he stage-managed viewers' experiences preparatory to their exit via the bookstore cum souvenir concession. If by these means he might be said to have claimed the "higher ground," he did so in ways that are deeply ironic, even possibly subversive of the very venture in which he had thoroughly immersed himself for a protracted period, of almost six months' duration.

9. Coleman read closely Paul Valéry's essay, "Introduction to the Method of Leonardo" as he engaged this project (in *Paul Valéry, An Anthology* [Princeton: Princeton University Press, Bollingen Series 45-A, 1977], 33–93). Valéry conceptualizes his project in crucial ways that seem to inform Coleman's approach: "I propose to imagine a man whose activities are so diverse that if I postulate a ruling idea behind them all, there could be none more universal." (I am indebted to Lauren Sedofsky for my analysis of this project.) The engagement of Coleman in "Leonard de Vinci, dessins et manuscrits" continues a tradition of highly stimulating and imaginative commissions made by the Prints and Drawings Department at the Louvre to philosophers, artists, and others, from Peter Greenaway to Jean Starobinski, in what has proven one of the most compelling series of exhibitions in recent years.

Jorge Pardo, foyer renovation project, 2000, Dia Center for the Arts: Chelsea, New York, installation in three parts: view of bookshop, courtesy of Dia Art Foundation.

Jorge Pardo, *Project*, 2000, Dia Center for the Arts: Chelsea, New York, detail of foyer, courtesy of Dia Art Foundation.

If Coleman does consider his contribution to this show to be a work in its own right, that is, a work in his oeuvre, then his role here has affinities with that of certain younger artists whose practices involve the supplying of services. Such strategies are exemplified in the project of Carey Young, who customarily takes on extra-aesthetic functional tasks such as management and public relations training for the institution in response to its commission, as occurred at the Kunstverein München in 2002. It also has affinities with the contribution made by Jorge Pardo to an invitation from Dia to renovate its foyer, design a bookstore and participate in its gallery program in 2000. Not only did Pardo treat all three components equally, fusing them by the introduction of a brightly colored tile for the floor and columns in each area, but he replaced the solid interior walls with glass paneling, thereby creating a continuous vista from one part to another. For the design of the lobby and bookstore he consulted with the appropriate members of Dia's staff in order to address the requisite functions they oversee. For the first installation in the gallery he collaborated with Dia's curator to present a model of the new Beetle car, plus a wardrobe by Alvar Aalto from a sanatorium designed in 1932. Pardo has continued to be engaged in a variety of ways with subsequent presentations, sometimes of his own work, and sometimes that of other artists, notably Gerhard Richter and Gilberto Zorio, weaving discursive narratives out of an ongoing exhibition program.[10] As with Coleman's Louvre commission, the partnership between artist and institution evolved and opened the parameters of so-called institutional critique into a broader forum—and each substituted a dialectical or Socratic mode of questioning for the

10. For a fuller account, see my essay in Dia's forthcoming publication on this project.

confrontational relationship too often anticipated in such cases. Yet where Coleman's intervention is ultimately best read as a metanarrative that critiques protocols and premises inherent in exhibition-making today, Pardo's register, by contrast, is polyvocal: the roles and relationships of the constituents remain ambiguous, the narratives inextricably imbricated.

In different ways Coleman's and Pardo's projects could be said to privilege the discursive while yet embedding it in a compelling materialist guise, since each involves an interrogative discussion, collaboration, and negotiation far removed from the typically consensual interaction generated under the older models. If in these instances the artist has strayed into the terrain once traditionally accorded the curator, then this has been at her invitation, at her behest. This is, and should remain, a one-way process: the curator should no more flirt with the notion of becoming an artist than fancy herself in the shoes of the patron. Instead, through such a collaboration, she may gain a partner who, like herself, also wishes to play by other rules—and to devise other paradigms.

You Talking To Me?
On Curating Group Shows that Give You a Chance to Join the Group
Ralph Rugoff

Shortly before beginning to write this essay, I asked an artist what he thought curators needed to take into account in order to organize engaging and stimulating group exhibitions. "Well, that's a no-brainer," he replied. "All you have to do is show some really good works of art together."

It is an answer that, initially at least, seems almost impossible to disagree with. How often, after all, have you heard anyone complain about a group show including too many outstanding artworks? Yet for curators the task of selecting compelling works for an exhibition is only a first step (albeit one that often proves more difficult than it sounds). While a lineup of stellar works will no doubt provide an audience with a series of rewarding experiences, it will not necessarily make for a memorable exhibition. A show featuring an unrelated succession of artworks, no matter how good they are, is always going to be a bit like listening to Top 40 radio: it gives you nothing else to do, in the end, but stand there and admire how marvelous it all is.

A great group exhibition, on the other hand, asks its audience to make connections. Like an orgy, it brings things together in stimulating and unpredictable combinations. It immerses us in an experience of shifting yet interlinked viewpoints, and multiple climaxes. It juxtaposes works whose overlapping concerns resonate in ways that transform our experience of them. And it invites us to explore a seemingly newly discovered territory of art that contains within it more than we can hold in our heads at any one moment. Providing us with a context that enhances and abets our ability to appreciate the works on display, it complicates, amplifies, and enlivens our encounter with each object while encouraging us to seek out the ways they fit together as pieces in larger puzzles. In short, it thickens the plot in a fashion that gives us, as viewers, something else to do besides simply look and applaud.

So while a show that is littered with wonderful art can, oddly enough, be less than satisfying, it is possible to make a remarkable exhibition that includes some less-than-brilliant contributions. One of the common hallmarks of a well-curated show, in fact, is that it seemingly elevates and enriches our experience of all the art that it presents. It provides lesser works with a setting in which they shine, and in which their most interesting, and sometimes neglected, aspects are lucidly illuminated. (A potentially perilous consequence of this phenomenon for curators is that we may be led to make an overly gen-

erous, or even misguided, appraisal about the worth of a given work when we come across it in a provocatively curated group show.)

None of this is to suggest that curating is an arcane science, or that a good group show needs to rival the complexity of the novel (as Okwui Enwezor, curator of Documenta11, once suggested). Instead, I think that the closest analogy to what curators do can be found in the field of consumer packaging. I offer this comparison not to belittle the work of curators (although I think we can certainly do with a less high-faluting discourse around curatorial matters), but, on the contrary, because I have a profound respect for our vulnerability to packaging of all kinds. Far more effectively than the noodlings of speculative philosophers, the consumer research industry has demonstrated the ways in which our experience of an object, and our subsequent interpretation, is shaped by the context that frames our encounter—even if that context is no more than the label on a bottle and all the associations it conjures. (In one of the consumer research industry's classic experiments, unwitting test subjects routinely assigned vastly varying qualities to the exact same brandy when it was poured from differently designed containers).

For better or worse, our experience of art is not exempt from our susceptibility to the power of packaging. And a themed exhibition is ultimately a type of packaging. But it is a form that, unlike the packaging of commercial products, is not solely concerned with grabbing our attention or arousing our desires (though if exhibitions do neither of these they are clearly failing us). While the themed show inevitably influences the way we make sense out of the works that it packages, it can also provoke us not to simply consume but to question the experience on offer.

Making a similar point, Vito Acconci has spoken about the unavoidable "fascism" of architecture—that despite a designer's liberal

Olaf Nicolai, *Portrait of the Artist as a Weeping Narcissus*, 2002, installation view in Sydney Biennale, 2002.

Miguel Angel Rios, *Toloache: Mapping with the Mind #1*, 2002, installation view in Sydney Biennale, 2002.

intentions, the spaces we inhabit tend to shape our perception and behavior. Yet Acconci also maintains that an architect can nevertheless provide us with instructions on how to escape that delimiting of our experience. I think exhibitions can likewise provide us with loopholes and escape hatches from the packaging they impose on our encounters with art.

To do so, group exhibitions need to be packaged in ways that include significant roles for their visitors. A truism of curating holds that the different works in a group show should engage in a dialogue with one another, but what is often neglected is the question of how your audience can engage in conversations with your exhibition. Instead of seeking to make a statement through a given show, curators would do well to remember that while an artwork may be an act of communication, their exhibitions are essentially structures for communication, as well as arenas of experience. An exhibition is not, in the end, a *fait accompli*, whose work is done once it is installed in a gallery; on the contrary, that is precisely when its work begins. Rather than presenting a predigested cultural experience, a stimulating group show conveys a sense that it is reinventing the way we think about art, on however small a scale, in a negotiation in which each visitor participates. In short, group exhibitions can aim to remind us, as Marcel Duchamp insisted, that the viewer is responsible for half the work in creating art's meaning.

In this respect, curators can profit by following the lead of artists. One of the very valuable gifts that artists offer us is their talent for making unexpected connections. They do so largely by asking questions, rather than taking things for granted. Likewise, exhibitions need to ask interesting questions, even unanswerable questions, instead of handing us tidy answers. A successful group show never insinuates that the exciting work of discovery has already been carried

Susan Hiller, *Witness*, 2000, installation view in Sydney Biennale, 2002.

out by the curator, and that all that is required of the audience is an ability to read and comprehend the wall labels and point our eyes in the indicated direction. Instead its own interrogatory spirit imbues visitors with a sense of permission to explore and chart their own route through the assembled works of art, and to freely ask the questions and pursue the connections that they find most intriguing.

Over the past decade, however, these kinds of concerns were largely overshadowed by the rise of the international biennial as the dominant model for large-scale contemporary exhibitions. (That Francesco Bonami chose to subtitle his 2003 Venice Biennale "The Dictatorship of the Viewer," is an irony that I still am unable to fathom). Typically, international biennials in this period have been based around an assumption that showcasing a universalist ethic, or representing the world of art in the fashion of the United Nations, is the only credible raison d'être for any truly serious exhibition of contemporary art. Proceeding from this conceptually unwieldy starting point, such shows have often presented themselves as being too grand in scope to be limited by singular themes; instead, they span a diverse array of concerns and issues. Increasingly, they have served as platforms (a term used to describe some of the preliminary events leading up to Documenta11) for complicated and abstruse curatorial pronouncements on world politics. And as a general rule, they seem less engaged with considering the experience of individual viewers before specific works of art than with constructing a global profile.

Compared with the expansive ambition of the international biennial, the single-themed exhibition can seem unnecessarily reductive or restrictive. Part of the argument against such shows, which has been fashionable at times in the last decade, is that they reduce our possible interpretations of a given artwork by forcing us to examine it through a specific (and limited) thematic filter. In other words,

this line of thinking maintains, theme shows tend to make the theme itself more important than our consideration of the art they include.

This criticism is mainly valid, however, only when applied to group shows that are "about" a particular subject or issue (genetics, war, human rights, etc.). In such exhibitions, the art is reduced to merely serving as an illustration of a broader theme. Shows that are "about" a subject—rather than about the connections among the different artworks they bring together—also tend to be dismally disjointed. All too frequently the works in these shows have no relationship to one another, but are only linked by the fact they all address a given topic. Consequently, our possibilities for being surprised by the art on view are severely diminished: as soon as we read the exhibition's title, we already have a clear idea of the limited territory that we are meant to consider.

It may be true that themed shows almost inevitably create preexisting expectations in their visitors, as do most international biennials. But the type of criticism described above—which takes theme shows to task for diminishing the interpretative context of the viewer's encounter—is predicated on an idealist myth that we can approach a work of art from a position of complete openness. Which is, of course, absurd. Our encounters with art are never innocent of expectations and presuppositions, or of our knowledge about how different genres of art have been historically categorized and classified.

And most types of successful theme shows do not, as a general rule, delimit the potential range of our responses to the artwork they present. On the contrary, even while following a focused curatorial agenda, these exhibitions usually develop by examining variations on a theme, proceeding with twists and turns, and elaborating multiple subcurrents that ultimately open up our readings of individual works. Such shows set up resonant echoes within the progression of works on display, so that each new art object we encounter informs our understanding of the one we just saw as well as the one we see next. In this way, group exhibitions can create a powerful accumulative effect, immersing visitors in an experience that seems expansive and also responsive to the viewer's own desires to explore a new world. The best group shows thus take on some of the qualities of installation art: rather than a chance to contemplate isolated objects, they involve us in an implied yet elusive narrative that we end up putting together ourselves as we move through the exhibition.

Finally, and most importantly, good theme shows take risks in how they address their audiences. Part of my definition of a memorable exhibition is that it leaves me slightly confused at first, yet not in such a way that I simply feel excluded or left out of the picture, as though my confusion was merely a result of ignorance. Instead, such an exhibition encourages me to actively seek out uncertainty, rather than simply remaining unsure. And it is precisely when we are unsure of something that our curiosity is aroused, and that we then

tend to regard it more closely, consider it more carefully, and in the end, experience it more intensely.

I had precisely this kind of encounter when I visited the 2002 Sydney Biennale "(The World May Be) Fantastic" (for which I served as a very incidental adviser). Curated by Richard Grayson, it focused on art practices inspired by the hallucinatory and fantastical aspects of quotidian cultures and belief systems. In gallery after gallery, artists served up visions of alternative histories, imaginary societies, invented cosmologies and biographies, dissident theories of physics, and evidence of inexplicable phenomena. The cumulative effect was overwhelmingly persuasive. Organized as a set of propositions, rather than a diagnosis of the current state of art, the exhibition encouraged me to suspend disbelief, and this extended to suspending some of my habitual ways of responding to art. Above all, perhaps, it prompted me to see the world at large (including the world of art) through the lens of uncertainty; to see, in other words, the elements of "play"—of contingency as well as creativity—in things and discourses we normally think of as "objective." It is one thing to speak in theoretical terms of "the end of master narratives," but in viewing this exhibition I had a very visceral experience of the consequences of this postmodern cliché.

It reminded me, in this regard, of what remains the most marvelously disorienting group show I have seen: "Clown Oasis," a 1995 exhibition curated by the artist Jeffrey Vallance at Ron Lee's World of

The Reverend Ethan Acres, *Adam and Eve as Clowns,* installation view in "Clown Oasis," Ron Lee's World of Clowns.

Jeffrey Vallance, *Praying Clown*, installation view in "Clown Oasis," Ron Lee's World of Clowns.

Clowns, a museum just outside of Las Vegas. Vallance presented the contemporary art in the show—which included clown-related contributions by Terry Allen, Jim Shaw, the Reverend Ethan Acres, and Vallance himself, among others—in such a way that it slyly blended into its surroundings. Within galleries teeming with pewter clown statuettes, clown murals, and professional clown memorabilia, he curated what essentially amounted to a kind of stealth exhibition. Admittedly, a few of the more idiosyncratic pieces might have raised the eyebrows of the average tourist, but taken as a package (and I use that word in the best possible sense), the show looked right at home in its garish milieu—so much so, in fact, that the boundary between art objects and their surroundings effectively dissolved. The status of the work on display seemed uncertain, almost clownish, and consequently, my attitude towards it also began to waver. It was as though I had caught the art in the act of becoming something else—*but what?* Vallance's approach created a radical, and fertile, space of doubt: When I left the exhibition, it was with a head full of questions about how—or under what circumstances—variously classified artifacts are designated as art. Those questions formed the most intensely enjoyable part of my experience, and in the context of Vallance's exhibition, they seemed to be on an equal footing to the objects in the show (many of which were memorably disturbing and provocative in their own right).

In their very different ways, both these exhibitions managed to achieve the crucial task with which curators of group shows engage: namely, providing a context for works of art so that they can catch viewers off guard, jump-start unexpected thoughts and insights, and trigger moments of surprise and pleasure. An imaginatively conceived group show can do this, in part, by derailing our expectations, and pulling the rug out from under our assumptions and accepted ideas

about what art is or does. It can help us to see art with fresh eyes by illuminating an emerging aesthetic model that makes new sense of the work of seemingly disparate artists. And by allowing us to confront each work in a novel context, a group show can also highlight key facets of an individual work that we might easily overlook in a one-person survey. In short, rather than shut down the range of our possible responses, a group exhibition can create a context that prompts us to re-imagine and rethink what we already know about art.

For this reason, I tend to conceive of the curator's role as a caretaker. We attempt to provide a meaningful environment in which the objects we work with can thrive—in which their significance can be fully explored, even amplified. We also seek to construct situations in which our audiences can thrive as well—not always an easy task given the inhospitable and intimidating nature of most museum spaces. One way of doing this, however, is to create exhibitions that encourage visitors to recognize that their questions can be aesthetic acts in and of themselves, as well as ways of extending and elaborating their experience of art. When all is said and done, the labor of individual artists in a group show is transformed, through its public display, into a cultural endeavor in which we all participate. That is why our group exhibitions can be truly successful only when we succeed in making our audiences feel that they, too, are an essential part of the group.

The Unstable Institution

Carlos Basualdo

In 1531 Titian bought a house with a garden on Venice's north side near the lagoon, and from here, on a clear day, he could make out the mountains that surrounded his hometown of Pieve di Cadore. Biri Grande, in the parish of San Canciano, no longer exists. The Fondamente Nuove, half a mile of docks along the island's northern edge, was built in its place just a few years after the artist's death. For unprepared pedestrians walking along the docks, the chance of seeing the Alps is but an amusing stroke of luck. And to be sure, the smog and haze seem to conspire so as to limit the landscape to the classic silhouettes of Italian cypresses in the San Michele Cemetery and some campanile or other on Murano Island. But nevertheless, they are there. I can attest that the day we left Venice, we were deliciously surprised to see, from the vantage point of the boat that took us to the airport with all our baggage, the contours of the Alps.

Even things most categorically evident can occasionally seem invisible—not because they do not exist, but rather because, at particular moments, some act of intellectual conjuring, some configuration of action and thought, manages to conceal them from the horizon of perception. Paradoxically, I have the impression that something similar happens with large-scale international art exhibitions. It is not that they literally become invisible, since they are, precisely, a staging of enormous mechanisms of visibility, but rather that the singularity of their meaning seems to hide itself from the myriad journalists, critics, historians, and pundits, who, as one might imagine, come to be their privileged spectators.[1] Of course, I am not saying that these events do not stir up opinion. On the contrary, opinions abound, but not because there exists any set of common criteria that can be used to evaluate this genre of events. For example, a review of critical articles about the most recent editions of the Venice Biennale and Documenta in Kassel reveals enormous discrepancies, not so much in regard to the shows themselves, but rather in regard to the expectations that the realms of criticism and journalism bring to these events. Critics' insistence on setting aside the explicit intentions that, in accordance with the organizers' criteria, are used to justify the realization and subject matter of the shows would not, in itself, be so serious, especially if this was a voluntary stance. But the fact the shows are analyzed from perspectives that ultimately make these intentions invisible is, indeed, something to be taken seriously. One gets the impression, for example, that many critics respond indignantly to any

1. It is important to note that one of the motives for this text stems from my participation, in various capacities, in three of the exhibitions mentioned: as a panelist in the "100 Days—100 Guests" at Documenta X in 1997, and as a member of the curatorial teams of Documenta11 (2002) and the 50th Venice Biennale (2003). In particular, my work in the last two events allowed me to interact intimately with both their organizational and their conceptual aspects. This text largely stems from my embarrassment and grief before the enormous disparity and lack of analytical rigor in many of the reactions by the general and specialized press toward these shows.

"100 Days—100 Guests," Documenta X, 1997, Kassel, Germany, platform with Cabelo, Tunga, and Lilian Zaremba.

suggestion of subordinating the individual works to an overly complex thematic frame—as if the primary function of these shows were to free art from it intellectual overdeterminations. In other cases, it is the absence of theme itself, or its frequent extra-artistic ramifications, given serious consideration—in spite of the fact that, quite often, these side-programs are structurally constitutive elements in the explicit goals of the organizers. Such a survey of the bibliography might be amusing, were it not a truly uncomfortable and even, at times, rather melancholy exercise.[2] Not only can one often reproach journalistic reviews for their numerous errors and omissions, but in many cases, a careful reading allows us to deduce that the author was not even able to visit the entire show. It should be acknowledged, however, that many of these events are simply not designed to be seen in their totality, on account of both their sheer size and the fact that they are made up of a large number of components, so that a comprehensive visit would take much more time than for other shows. Critics tend to ignore this explicit intentionality and merely react with disdain, without stopping to analyze the possible consequences of such neglect. The lack of a frame of reference to help us interpret these events becomes ever more evident, even as its development becomes more urgent. Without a frame of reference to validate it, the kind of specific operation carried out by these shows in the field of art and culture is barely, if at all, perceptible through the opinions of a host of commentators. Titian's mountains blend into the mist that conceals and disguises them. From the printed page, we discern only the repeated, interchangeable silhouettes of cypresses.

In comparison to the rivers of ink these shows unleash in both the specialized press and the mass media, the academic critical literature specifically tackling these events is relatively scarce: barely a dozen books, in two or three languages, published largely in the last decade.[3] Perhaps the two phenomena are related. Shows like Documenta or the Venice Biennale have acquired an unprecedented visibility in contemporary art—a field of culture that, until recently, was of interest, almost exclusively, to a more or less limited group of specialists. Such visibility suddenly turns these shows into desirable and even, on occasion, income-generating instruments

2. For a paradigmatic historical example of this kind of coverage, see Bruce Kurtz, "Documenta: A Critical Preview," *Arts Magazine* 46, no. 8 (Summer 1972): 30, which contains, in a nutshell, most of the usual misunderstandings of such events.

3. Although a profuse bibliography on museums certainly now exists, there seems to be no single publication devoted solely to the subject of large-scale international exhibitions. Some of the more recent publications on the subject of exhibitions and curatorial practice are: Bruce Altshuler,

for the political and corporate sectors. At the same time, it makes them anathema precisely for the intellectual spheres whose analytical capacity should (supposedly) elucidate their current meaning and possible potential. Of the few voices from academic circles that mention these events, the majority tends to be discrediting. Most view these shows as epiphenomena of mass culture, an indisputable symptom of the culture industry's assimilation of the project of the avant-garde—as spectacles, pure and simple, whose logic is nothing more than that of late-stage capitalism, in other words, the progressive suppression of the multiple system of values and its translation into a universal equivalent, namely, exchange value. In a way, this analytic trend implies that the oppositional nature, which characterizes the critical project in modernity, is largely foreign to this kind of exhibition that is unequivocally associated with the realms of marketing and consumption. Following this line of reasoning to the end, we may conclude that the apparent lack of criteria that journalistic criticism underscores when discussing such events is nothing more than a symptom of the expiration of its traditional function in this specific stage of the development of the culture industry.

The emergency of art criticism paralleled the formation of an international circuit in which artists, galleries, and museums each found their own places. Clearly, academic criticism, linked to universities (and, overwhelmingly, to the discipline of art history), finds its place in the same system as yet another institutional mooring. Artistic modernity is thus presented as a constellation of specific practices and institutional settings charged with discerning—and assigning—the relative values that incorporate them. The ensemble is determined by a certain way of representing the singularity of its own history and articulating the value system it produces. These institutional instances regulate the relationships between individual constituent parts, while at the same time restricting their freedom. Naturally, this assembly is not synchronic; it was not produced all at once. Instead, it is a more or less unstable product of a series of historical processes that, like sedimentary strata, eventually paired off slowly in order to produce,

The Avant-Garde in Exhibition: New Art in the 20th Century (New York: Harry N. Abrams, 1994); Emma Barker, ed., *Contemporary Cultures of Display* (New Haven, Conn.: Yale University Press, 1999); Reesa Greenberg, Bruce W. Ferguson, and Sandy Nairne, eds., *Thinking about Exhibitions* (London: Routledge, 1996); Bernard Guelton, *L'Exposition: Interprétation et réinterprétation* (Paris: L'Harmattan, 1997); Anna Harding, ed., *Curating: The Contemporary Art Museum and Beyond* (London: Academy Editions: 1997); Susan Hiller and Sarah Martin, eds., *The Producers: Contemporary Curators in Conversation*, vols. 1–4 (Gateshead, U.K.: Baltic, 2000–2003); Bern Klüser and Katharina Hegewisch, eds., *L'Art de l'exposition: Une documentation sur trente expositions exemplaires du XXe siècle* (Paris: Editions du Regard, 1998); Carin Kuoni, ed., *Words of Wisdom: A Curator's Vade Mecum on Contemporary Art* (New York: Independent Curators International, 2001); Paula Marincola, ed., *Curating Now: Imaginative Practice/Public Responsibility* (Philadelphia: Philadelphia Exhibitions Initiative, 2001); Dorothee Richter and Eva Schmidt, eds., *Curating Degree Zero: An International Curating Symposium* (Bonn: VG Bild-Kunst, 1999).

Interior of the Artiglierie, Biennale grounds, Venice, Italy.

finally, an impression of totality. For their survival, institutions require the illusion of everlastingness, since this is what safeguards them, in the final analysis, against their contingent character. In Western countries, modern art was thought to be structured around the relative balance between a number of institutions founded on a common history or histories, that is to say, on shared values. In this order of things, the tension between production and the market finds a sort of referee in criticism and museums.[4] We could say, very schematically, that the duty of criticism has been to inscribe production into a symbolic field in a way that simultaneously makes it accessible to the effects of the mechanisms of the production of exchange value, while the duty of art history has been to recover the specific differential in the work that hinders its complete subordination to exchange value. Of the two, it was the institution of the museum—which from its origins has had a fundamentally ideological character—that sanctioned the value of the work as exchange value, but not without first disguising it, hiding it in the folds of a particular historical narrative that the museum was supposedly responsible for preserving and intensifying.[5] Clearly, it is not difficult to imagine how any exhibition or production of works that lacks a direct association with galleries or museums—and which, even if it maintains a dialogue with both the market and history, does not really meet the expectations of either—may suddenly become at least partially illegible for the system in which it is supposed to operate.

But at this point I should clarify the types of events to which I am referring. Are we dealing with large-scale shows in general? With the international biennial circuit? Perhaps more importantly, are we dealing with a characterization that exclusively concerns the size of the exhibition—that is, the size of its budget and the number of works included—or could this also have to do with other factors, such as the nature of the institutional framework that generates such events? Although an archeology of the large-scale international exhibition model would include many shows organized by more conventional art institutions, it seems fair to argue that biennials are the most exemplary. At first glance, biennials seem to have only their name in common. The Venice Biennale was first held at the end of the nineteenth century (1895); it was modeled on the world expositions that had been so popular throughout that century. It would take five more decades and two world wars to found the São Paulo Bienal (1951), which like Venice, continues. In the brief interlude of fifteen years, from 1984 (the year of the first Havana Bienal) to the end of the twentieth century, more than fifteen international biennials were established, including Istanbul (1987), Lyons (1992), Santa Fe (1995), Gwangju (1995), Johannesburg (1995), Shanghai (1996), Berlin (1996), and Montreal (1998).[6] Moreover, the specific circumstances under which these shows were established are extremely diverse; the same can be said of their resources and of the attraction they hold for both the specialist press and the general

4. A complementary account of a tension (over such issues of taste and value) between the audience and an institution devoted to public education and the promotion of art can be found in Seth Koven, "The Whitechapel Picture Exhibitions and the Politics of Seeing," in *Museum Culture: Histories, Discourses, Spectacles,* ed. Daniel J. Sherman and Irit Rogoff (Minneapolis: University of Minnesota Press, 1994), 22–48.

5. See Theodor Adorno, "Valéry Proust Museum," in his *Prisms,* trans. Samuel and Shierry Weber (Cambridge, Mass.: MIT Press, 1981), 173–85.

6. See Paula Latos-Valier, "Biennales Big and Small," *Info* (newsletter of the 25th Biennial of Graphic Art, Ljubljana).

media. The Venice Biennale was the model for the São Paulo Bienal, whose initial function was to establish itself, alongside Venice and the Carnegie International (founded in 1896), as a world-scale event that could put its city—and country—on the map of modern culture. In 1984, the first Havana Bienal had a very explicit ideological goal: to stimulate communication between artists and intellectuals of the Southern hemisphere, so as to keep the centers of economic power from monopolizing the distribution of contemporary art. Havana's success was capitalized on by a number of subsequent biennials, which had the obvious function of giving visibility to local production and promoting the cities and countries that hosted them.

Nearly all shows of this type rely on the official financial support of their respective countries or cities. A marketing component is, then, common to all of them; it is a question of publicizing the artistic and cultural potential of a city, country, or region. Few, perhaps, have been as ideologically marked in their origins as the Havana Bienal and, of course, Documenta, which has been held since 1955—initially, every four years, and now, every five—in the Germany city of Kassel. On the one hand, Documenta is a fortunate byproduct of the Cold War, while on the other, it was created from the need for postwar Germany to bring itself up-to-date with the evolution of modern and contemporary art and leave behind the painful excesses and omissions of Nazism—which, among other things, affected the practice and appreciation of modern art in that country.[7] In all these shows, however, diplomacy, politics, and commerce converge in a powerful movement, the purpose of which seems to be the appropriation and instrumentalization of the symbolic value of art. The specific motives change—Venice was originally concerned with updating a universalist ideology clearly related to European colonialism; Havana, by contrast, staged an ideological project that was diametrically opposed to this—but the type of operation is, curiously, the same. Another point of agreement consists in the fact that the majority of these shows emphasize the internationalist nature of cultural and artistic production. This is not a question of sharing a unified vision, but rather of considering internationalism as a term literally in dispute, able to be interpreted specifically in highly diverse ways. The nature of the interests that generate the events and their common commitment to the possible horizon of internationalism seems to associate them in an intimate way with the ups and downs of modernity—and with the range of its possible interpretations. Their unstable nature—somewhat tentative, incomplete, and always subject to negotiation and readaptation—merely reinforces this tie.

In 1983, barely a year before the first edition of the Havana Bienal—the success of which contributed to the subsequent proliferation of such exhibitions—Professor Theodore Levitt of Harvard University wrote in the *Harvard Business Review*: "The globalization of markets is at hand." This was one of the first texts to use a term that would become increasingly commonplace in the years that followed.

7. For a discussion of the connection between the first Documenta and the Nazis' "Degenerate Art" exhibition, see Walter Grasskamp, "'Degenerate Art' and Documenta 1: Modernism Ostracized and Disarmed," in Sherman and Rogit, *Museum Cultures*, 163–94. In Grasskamp's view, the tensions between Documenta as an art institution exemplary of postwar Germany and the questions the Nazis posed to modern art were acknowledged, ultimately, and only by implication, by the curatorial team of Documenta 5 in 1972.

Interior of the Corderie, Biennale grounds, Venice, Italy.

The globalization to which Levitt referred consisted in extending the logic of economies of scale to the planetary level; it was grounded in the presumed worldwide convergence of consumer tastes. In an article written for the twentieth anniversary of the publication of Levitt's text, Richard Tomkins observes: "Prof. Levitt's message was simple. As new technology extended the reach of global media and brought down the cost of communications, the world was shrinking. As a result, consumer tastes everywhere were converging, creating global markets for standardized products on a previously unimagined scale."[8] The publication of Levitt's essay coincided with a period of market openness that continues today, although in a less pronounced way. In predicting a convergence of consumer tastes, Levitt did not seem to take into account the fact that, through the spread of new technologies and the ever more decentralized use of information, the nature of demand itself becomes more specialized. From our current perspective, we could state that the value of Levitt's thesis consists mainly in its symptomatic character. Coinciding with the information revolution that took place with the Internet (and the progressive development of communications possible in general), Levitt's essay foresaw a period of progressive integration on a world level, although not decentralization. In the area of contemporary art, that phenomenon is reflected precisely in the growing proliferation of this unstable institution of the large-scale international exhibition. One could venture the hypothesis that the biennials that have emerged in the last two decades have done so completely in tune with these transformations, as a result of the contrast between the tendency toward centralization, typical of the integration of markets on a global scale, and the increasing dissemination of information, which provides growing visibility for local situations and problems. Such tension, obviously, is an essential component for institutions whose aim, to a large extent consists precisely in its representation and analysis.

It is evident that these institutions have been created with a distinct instrumental purpose: to respond to the interests that brought them about—in other words, to promote the contexts in which they take place, giving them greater international visibility, supplying

8. Richard Tomkins, "Happy Birthday, Globalisation," *Financial Times*, May 6, 2003.

57

them with a patina of prestige, and ratifying the supposed commitment of these different contexts to modernity and, more specifically, to the processes of economic integration associated with late capitalism. The aura of prestige that surrounds art in general—and modern and contemporary art in particular—is perfectly suited to this task. What is instrumentalized in the large-scale international exhibition is precisely the symbolic capital of modern art, tied to its own presumed autonomy and independence from market logic. Following this line of reasoning, we could reach the paradoxical conclusion that the relationship between the supposed aim of art biennials and the traditional function of museums will eventually be one of simple continuity. The symbolic value created initially by museums—as a concealed affirmation of the exchange value of objects and artistic practices—is ultimately transformed by biennials into pure utility. Perhaps this was (and, in some cases, may still be) the (ultimately naïve) reasoning of many of the institutions that founded biennials. And in some cases, such reasoning may even be partially justified. Nevertheless, this equation assumes a total equivalence between what is exhibited in museums and what is exhibited at biennials. Furthermore, it assumes an agreement between the conceptual and ideological frameworks of both types of institutions. Both these assumptions are erroneous.

The configuration of interests at the core of institutions like biennials clearly differs from that which gave rise to the institutional circuit traditionally linked to modernity in art (museums, art criticism, and galleries). The commercial fate of the works, for example, is neither evident nor even strictly necessary in biennials, for the simple reason that the bulk of the financing behind the event and the production of many of the projects is largely independent of art collecting (either private or state-funded). This facilitates the inclusion of practices of a non-objectual nature, as well as works of an interdisciplinary nature and even practices pertaining to other fields of cultural production, such as cinema, design, architecture, etc.; indirectly, this ultimately stimulates the problematization of the notion of art as an autonomous activity. The inclusion of works of an interdisciplinary nature, as well as the persistent integration of discursive elements in these kinds of events, has become increasingly a constant.[9] Moreover, the sheer size of these shows—which is necessary to achieve the marketing impact expected of them—makes their insertion into highly particularized interpretative systems an absolute necessity. Without these systems, the shows would lose their ability to communicate as discrete singularities; that is, they would lack all identity. In many cases, it is even manifestly expected that the conceptual framework charged with giving these events legibility is related to local issues—at lest as far as the inclusion of elements tied to the local culture is concerned. Consequently, the figure of the curator emerges as the event's conceptual organizer. In comparison with the traditional role of the museum curator, this more recent

9. One only need mention the examples of "100 Days—100 Guests" at Documenta X, the four "Platforms" at Documenta 11, and the events surrounding the "Archive of Contemporaneity" at the 50th Venice Biennale.

incarnation seems to be endowed with greater autonomy. It is no longer a question of the discerning critic or interpretive historian examining a specific tradition, but rather of a relatively unfamiliar figure who must negotiate the distance between, on the one hand, the value system traditionally established by critic and art historian and, on the other, the ideological pressures and practices corresponding to the institutional setting in which such events emerge. But this specific incarnation of the curator is no accident; inasmuch as these are art professionals who must respond to a variety of extra-artistic conditions and questions, their work is necessarily different from that of those who preceded them.[10] The type of knowledge they put into practice becomes less and less retrievable from the perspective of the critic or art historian, even if this is still a highly particular and specific kind of knowledge. The chain of meaning that makes sense of the group of practices assembled for such a show will necessarily be constructed around an interrogation of local histories and contexts, though always in terms of their possible relationship to the presumed internationalist horizon. The curator's work is riddled with, and overdetermined by, such problems. Perhaps we could say that the curator's ability to produce a highly differentiated form of knowledge is related to his or her degree of fidelity to the entire matrix of unique situations surrounding the curatorial practice. This type of work thus implies the articulation of a reflection capable of linking forms of local culture and history with the horizon of internationalism that appears as a founding element in these events. Finally, partially freed—or better yet, forcibly liberated—from the constrictions associated with the supposed autonomous nature of artistic production, the curator finds him- or her-self in the position, and with the need, to expand not only the canonical apparatus that articulates the historical narratives linked to the production of modern and contemporary art, but also the very definition of that which constitutes artistic practice in a specific context.[11]

Paradoxically, the presumed instrumental nature of biennials may thus serve as a way to try out a series of operations whose scope is, for the most part, radical when considered within the institutional context traditionally linked to (Western) modern and contemporary art. We could classify these operations synthetically into two types: revisionist efforts, which lead to a reconsideration of the canonical mechanisms established in the historical narratives produced, almost exclusively, in Europe and the United States; and the exploration of the position of the artwork in the wider cultural context in connection with a variety of symbolic practices to which it is not usually thought to be related. An exhaustive revision of the canon and a reexamination of the autonomous nature of the work of art are actually two sides of the same coin, since an inquiry into the mechanisms that structure art history's narrative will inexorably lead us to consider historical discourse as highly ideologized and, therefore, the inevitable result of the intersection of heterogeneous

10. See Karsten Schubert, *The Curator's Egg: The Evolution of the Museum Concept from the French Revolution to the Present Day* (London: One-Off Press, 2000). In the last section of this informative overview of the history of museums in the West, Schubert devotes several chapters to the changes in the role of curators in the last three decades. Although his observations are primarily concerned with museum curators, they could well be inspired by—and, indeed, seem to pertain even more to—the transformation of the curatorial role with respect to large-scale international exhibitions.

11. The consideration of art as an autonomous activity certainly leads to the inclusion of highly specialized practices in historical narratives. When this framework disappears as a prime intellectual motive, it becomes possible—and to a large extent compulsory—to explore an expanded field of cultural production, since it would be a matter of understanding artistic practices in their possible relationships to the systems of power (economic, political, and social) that would support these kinds of shows. To a certain extent, we could say that Documenta X thematized precisely this process of canon revision.

and diverse practices and interests. The relationship with the local context, which is usually mandatory in these events, becomes an opportunity to exercise the historical revisionism that, in the final analysis, inescapably ends with a questioning of the ideological base that articulates the institutions of artistic modernity. With respect to the traditional institutional structure, large-scale international exhibitions can act as a kind of surreptitious short circuit. Their supposed instrumentality, signaled by a sector of academic criticism as a function of their dependence on the culture industry, could, conversely, be revealed as a juncture that facilitates the expansion of the canon and the exploration of an expanded notion of what presumes to be the artistic practice of a specific context. Needless to say, although this range of possibilities appears inscribed in the very institutional structure of such events, there is no guarantee of their realization. The figure responsible for actualizing this range of possibilities is, inevitably, the event's curator. And this is because the determinations that could guarantee the effectiveness of the curatorial practice for this type of show are in no way predetermined by the institutional framework in which this practice is carried out—unlike what happens when a curator joins the traditional structure of the museum. The curator's inevitable lead role in such shows has recently given the position an exaggerated, and clearly equivocal, level of visibility in the cultural field. But this is a question of misunderstood celebrity status. Whether the curator is a mere instrument of the culture industry or a recent incarnation of the model of the independent intellectual, the possible range into which his or her decisions are introduced is at once remarkably vast and dangerously undefined.

The invisibility I spoke of at the beginning of this text clearly applies to the position these shows occupy with respect to the traditional circuit of criticism, the museum, and galleries. Large-scale international exhibitions never completely belong to the system of art institutions in which they are supposedly inscribed, and the range of practical and theoretical possibilities to which they give rise often turns out to be subversive—let's not forget that museums are, first and foremost, Western institutions, and that the global expansion of large-scale exhibitions performs an insistent de-centering of both the canon and artistic modernity. Increasingly, one has the impression that the vitality of such shows seems to be a direct function of the number of visitors they attract and the dissemination they achieve in the media, and in inverse relationship to the appreciation of specialized criticism; in terms of the politics of exclusion historically enacted by the institutions of modernity, large-scale exhibitions could perhaps be seen as occupying a role similar to that of theater in the High Renaissance, namely as "a force for the breakdown of class distinctions, even for democratization."[12] This vitality is, undoubtedly, the best guarantee of their survival. To a large extent, the conceptual horizon opened by such shows as the two most recent editions of Documenta or the first Havana Bienal remains largely

12. William J. Bousma, *The Waning of the Renaissance: 1550–1640* (New Haven, Conn.: Yale University Press, 2000), 131. An interesting parallel could be drawn between the emergence

unexplored. There is no doubt, however, that many aspects associated with such events have been partially absorbed and recycled by museums and galleries—a process that, while not at all recent, has visibly accelerated over the last decade. In this short span of time, for instance, a significant number of artists have, effectively, been incorporated into the canonical narrative of the postwar period. Many conventional museums have resorted to the implementation of biennial or triennial showcases as a way to increase the number of their visitors and attract the attention of the press. In some cases, the international exhibition's clear and direct influence on the traditional institutional circuit can be confirmed; in others, it is more a question of partial coincidences in the development of independent (though undoubtedly simultaneous) processes, inasmuch as that form of internationalism we call "globalization" increasingly determines the financing and programming of a large segment of the museums in Europe and the United States. Beyond these transformations and a sense of the growing interdependence between traditional modern-art institutions and the mega-show, there is still, it seems, no appropriate framework for analyzing all the implications of the large-scale exhibition. These events are constantly evaluated only in terms of the logic of institutions of modernity and not in relation to the challenges they embody. A proper historical account of the emergence of these institutions is still to be written. A clearer understanding of the implications arising from their interrogation of both the canon and the modern notion of the autonomy of art is no less essential. Although the project of the formulation of alternative versions of (Western) modernity seems to have been a driving force for many of these institutions from the start, the implications of such a radical move have not yet been theorized. The development of large-scale exhibitions can be associated with the economic and informational transformation of late capitalism—such as the expansion of tourism on a global scale and the concurrent rise in the number of museum visitors worldwide—in other words, an increasing democratization of culture, characterized by an increasing intermingling of education and entertainment. Large-scale exhibitions could well represent a possible response to these phenomena from the cultural field. Nevertheless, there is little understanding of the role they play in the culture industry and among institutions of artistic modernity. Their contribution to the cultural field has barely been taken into account. Perhaps, it is precisely this sort of inquiry that would give these events the visibility they need if, among other things, we are to articulate an effective reform of the institutions of modernity.[13]

of theater as a cultural practice in the High Renaissance and the position occupied by large-scale international exhibitions in today's cultural landscape. Originally distrusted because of their connections to spectacle and commerce, both phenomena experience artistic evolution partially as a function of their growing popularity; exemplifying the complex relationship between culture and spectacle that the institutions of modernity have traditionally rejected.

13. A number of institutions founded in the postwar period and dedicated to exhibiting modern and contemporary art were once not so different from the large-scale events I have been discussing, at least if we consider their original aims. One particularly remarkable example is that of the Centre Pompidou, which was established as an interdisciplinary laboratory for research on modern and contemporary cultural production. Although while under the direction of Pontus Hulten, the Pompidou's activities seemed headed toward satisfying this goal, the center later began gradually to change into a more or less conventional modern art museum. On rare occasions, some exhibitions still display certain interdisciplinary and revisionist elements, but even so, these do not dominate the program as a whole.

This essay was published in a slightly different form in *MJ/Manifesta Journal*, no. 2 (Winter 2003/Spring 2004): 50–61.

Translated from the Spanish by Vincent Martin.

With our faces to the rising sun...

Thelma Golden with Glenn Ligon

This conversation took place on April 29, 2004, between Thelma Golden, then Deputy Director for Exhibitions and Programs at the Studio Museum in Harlem, and Glenn Ligon, artist, in response to a series of questions posed by Paula Marincola.

Thelma Golden: Glenn, the reason I asked Paula if I could speak to you for this project is because, in many ways, almost every exhibition I have made has evolved in a quasi-collaborative manner, in that most often I have spoken to you about different aspects of my ideas, and your responses, both deadly serious and totally silly, have often informed what I have done. The other part of our ongoing conversation has also been about this general idea of the culturally specific exhibition. Paula has asked me to address this very thorny issue of what makes for an important culturally specific exhibition—What's its relevance? Why does it still exist? Should it still exist? And I've always taken my cues about that topic from artists. So the first question I want to ask you (which I'll answer as well), are there any culturally specific exhibitions that stand out for you as benchmarks? Not just shows of your own work or ones that you might have been included in, but ones that have enabled you to understand the validity of making an exhibition with, and of, people of one race, or one gender, or one sexual orientation that made sense of that kind of focus? Is there one that you saw anywhere or heard of that would have been influential to you?

Glenn Ligon: No. I can't think of any.

TG: You can't? For me a major turning point was seeing the catalog of David Driskell's "Two Centuries of Black American Art: 1750–1950" (1976, Los Angeles County Museum of Art). The exhibition was presented at the Los Angeles County Museum of Art in 1976 and I never saw it, but the catalog has remained in circulation. For me, that exhibition validated the idea that there was a valid but woefully neglected art history that I, an art history student at the time, was not being taught. Yet I have to say it's also an important exhibition to me because it is the exhibition that I have worked against most specifically for my entire career. I needed it to exist in order to know exactly what I did not want to do. Affirmation by negation, maybe.

GL: Well, there's a critical difference between an exhibition that's meant to address a certain kind of lack in scholarship, or more par-

ticularly a lack in museum presence for a certain kind of scholarship, which I think that Driskell's show certainly addressed, and what I look for in an exhibition. I'm not so concerned necessarily about the overview for an overview's sake; I'm more concerned with specific moments of artistic practice that are interesting to me at a given time. And often, those big, ethnically based thematic exhibitions, while they have interesting work in them, are not interesting to me in their curatorial premises. I'm more interested in seeing specific works in them. I loved seeing Rick Powell's exhibition for the High Museum, "Beauford Delaney: The Color Yellow."

TG: Black abstract artists?

GL: Black abstract artists throughout the century. I think that would be an interesting show because it hasn't been done yet, and that's the reason to do it. But ...

TG: You really don't necessarily feel it's a completely justifying force, this idea of the ethnically specific exhibition?

GL: I think the problem is that these shows come about to address a lack, and they get burdened by the necessity to address that lack. There's an argument being made in these shows about why this work hasn't gotten to the forefront, why it's important, et cetera, et cetera, and often that gets in the way of the pleasure of just seeing good work. The curatorial conceit is so burdened that the work gets weighed down by it, and the result is less play in the show and less dialogue with contemporary artists in a historical show, or something like that, and that's a problem.

Alexander Austin, *Spirit of the Dream*, 1994, installation view in "Black Romantic", Studio Museum in Harlem, New York.

TG: It's a question of "then," a moment when perhaps a culturally specific exhibition could seem relevant, versus "now," because obviously, the era of David Driskell's "Two Centuries" in the seventies and this moment represent two very different historical points of view. I always think of these exhibitions as Jackie Robinson moments. You know, the first solo artist show by a black artist, all of that first stuff.

GL: It has a historical importance because of "its moment." But I think the problem now is that some people feel the need to recreate that wheel over and over again. In some ways that's probably a response to a new ethnically specific museum-going public and its funders, who may have little or no historical memory. And so I feel that that kind of recapitulation of "the-greatest-hits-of-the-last-200-years-kind-of-show" is fine, but I believe that we've gone beyond the necessity for it.

TG: You've overcome, but some of us have not! But tell me something, from your point of view as an artist. Let's hypothesize that I am a curator, not me, but someone working in a nice, midsized museum in the middle of the country, say St. Louis or Denver or Milwaukee. And I'm going to actually say that I am not even a black curator. Let's say I am a white curator, a good liberal, I believe in all the right things. And in my museum, I am trying to come to terms with who our audience can and should be, and so I've decided to do an exhibition called—what would it be called?

GL: "Facing the Rising Sun."

TG: No, no, no, not that one yet. I want to do a show called, say "Contemporary Black Artists Now."

GL: Call it, "Word Up."

TG: "Word Up: Contemporary Black Artists Now." And in my mind, I have a curatorial thesis. I want to look at black artists right now who use text in their work to address issues of identity. That's my curatorial framework. And I write you a letter, or send you an e-mail, and I invite you, Glenn Ligon, to be in this show, "Word Up: Contemporary Black Artists Now." What's your response to that?

GL: My response is: show me the checklist and show me the curatorial narrative and then I'll decide. Because the problem with that kind of show is that, even though it has a curatorial premise, often it is just simply a list of artists—it's not a show—and the work gets positioned in such a way that it becomes problematic for me. It gets reduced to a matter of saying: this is the narrative, here's how the narrative is being illustrated, we're done.

TG: Let me give you another option. I am an African American curator, who has been working in the field for over twenty-five years.

GL: So you have a sense of entitlement!!!

TG: I am someone who has come through the multicultural movement. I've worked in museums before there was a multicultural movement, and now I am working in a museum in the South, say Atlanta or Memphis or New Orleans. And my museum has long had a history of showing the work of African American artists, and in our city, we've had African American mayors, there's a power structure and there's a black cultural support network. So, as this curator, I am now going to install a permanent collection which has masterworks of African American art, a major Romare Bearden, a beautiful Jacob Lawrence, perhaps a Norman Lewis, an Aaron Douglas, a Hale Woodruff, an Elizabeth Catlett. Classic works within the American art canon. And this installation is going to be the centerpiece of our museum now. With this installation I'm going write an American art history that centralizes these artists, with major gallery space, major museum presence, gallery guides, school programs, and the whole deal. It will be up for five years. We have a major corporate sponsor. Now, I, as this same curator would like to do a presentation of your work as a contemporary corollary to this exhibition of work from our collection of African American art. I write you a letter that says, Glenn, we have a show of our collection coming up called "Our Spiritual Striving: African American Art in the Twentieth Century" and in response I would like to do an exhibition of your work. What do you say to that?

GL: I'd say yes, but you would have to deal with the work that I do, not the work that you imagine I ought to do in response to a show like this. That's the problem. Clearly it can't be a show of my Richard Pryor paintings! It's going to be James Baldwin paintings. So there's a sort of reduction of the curatorial selection process to "these are my needs; this is the body of work that fills my needs; this is how I'm going to position you in relationship to the masters to create a certain lineage." But that doesn't deal with the body of work that I've actually done; it just deals with a little tiny piece of it that fits the argument.

TG: Let me give you another possibility. I am a young curator working in a big urban city, say Chicago or Los Angeles or New York, at an African American cultural center that does art and music and literature—a multidisciplinary center. We like to do residencies with artists and have their work on view, but also have them engage with the community. So I, this young, eager curator at this space, have written you and said "Glenn Ligon, will you come and do a residency, and while you're here, can we do an exhibition of your work?" How do you feel about that?

GL: Here's the interesting thing about that. I've done a number of residencies, and in most there is a desire for the artist-in-residence to work in the community in some way. But there's a huge spectrum of the possible ways that they imagine that can happen. Sometimes, the institution imagines that you will do the work that they have not done. So you will go out and—say you're an African American artist—reach out to the African American community with whom they barely have any contact, and bring them into the museum by way of these projects. But then sometimes museums are very connected to their community and have lots of programming and have feedback from the community which creates another kind of dilemma. For them, the community in their minds is already formed. So what if the community that you as the artist define, and with whom you want to work, is not the community that they imagine is their audience. But I'm actually more sympathetic in some ways to that kind of scenario because I think there's a lot of interesting stuff for an artist to work with there; it's not all so totally predetermined for you. But the pitfall of that situation is that sometimes the needs of the community and the desires of the institution around its relationship to the community may be diametrically opposed to what you as an artist might want to do. So it's a difficult kind of negotiation in that kind of situation, though potentially very interesting.

TG: But we have always talked about this notion of "community" as both mythic and real and how it complicates the idea of culturally specific exhibition making. This is something I think about a lot now being at the Studio Museum.

GL: Maybe you could talk about this sort of "in-Harlem" versus "of-Harlem" question that keeps haunting the Studio Museum's exhibition programming. What does it mean to have an institution that is located in arguably the most famous black community in the United States with a mandate to do programming that's international, that's not about artists located in that specific community or even in New York City? What kinds of pressures and challenges does that present?

TG: The question for me, still, is that of the validity of the culturally specific exhibition, whether or not it's of artists living in Harlem, or elsewhere in the world, and the concomitant notion that the museum is mandated to perpetuate the idea that there is validity in the ethnically specific in a way that, personally, I know I am incredibly conflicted about. So I think that my own exhibition practice has been about trying to speak to that issue. Can one make an ethnically specific show that does not fall into all of the clichés we—not just you and me, but also in the field generally—talk about as being inherently problematic of this point of view? And my response has been to try to dig into the irony of what I think getting that essentialist can be, because being in Harlem obviously legitimates a certain kind of

David Hammons, *Untitled (African-American Flag)*, 2004, installation on exterior, Studio Museum in Harlem, New York.

obsession with blackness that I would feel uncomfortable with, say, if I were working in a mainstream institution. I've made exhibitions at the Studio Museum I would not have made anywhere else. Now, I say that with some conditions. For me, doing a survey show of a single artist doesn't fall into the realm of the ethnically specific. But with a thematic show like "Black Romantic," for example, I would not have done that show at the Whitney. But "Black Romantic: The Figurative Impulse in Contemporary African American Art" was a response to the idea of the kind of exhibition a museum like the Studio Museum can create, a sort of canon revision or reformation. That's the kind of exhibition that I imagine I should and can do in a space like that. All of my curatorial work is site-specific. So Harlem is a profound site for me.

But as you know, I have always felt both challenged and burdened by these culturally specific exhibitions. When I look at my bookcase, I see a catalog from every single one of them. The ones that were amazing, like David Driskell's, as well as all the ones that make me cringe. I have dissected them down to analyzing the semiotics of the cover art on the catalogs. Have you noticed how they always have a relatively figurative cover that has an image of a black person? The cover for "Black Romantic" was a complete and total ironic dig at that....

Since I know I could never make that kind of culturally specific show of that type, I had to make that kind of a catalog. My take on the "catalog-with-a-picture-of-a-black-person-on-it-so-you-know-it-is-an-exhibition-of-black-art!" And I have thought a lot about these culturally specific shows, down to the titling—I am fascinated with their titles. They always take on that kind of incredibly baroque black overstatement, what we joke about that when we start talking about "Our Faces to the Rising Sun," the sort of James Weldon Johnson (composer of the Negro National Anthem and poet) school of titling, with all the great platitudes of overcoming. From the moment of creation of "Black Male," I have tried to think, is there a way to make a black exhibition that doesn't fall into those old traps? Because some people might see my exhibitions in that same lineage, starting with Driskell and coming right down to my 2004 "freestyle." I don't see them that way, but I realize that I am inevitably replicating certain aspects of the ideals that those shows put out there to begin with.

GL: Well, you can't start from nothing. There has to be a certain kind of response to what's come before. But I think the question is how do you complicate your exhibition practice in relationship to those shows? This is what you've been talking about. And I think the thing that was interesting about "Black Male: Representations of Masculinity in Contemporary American Art," and controversial for some people, though it shouldn't have been controversial at all, was simply that all of the artists in it were not black.

TG: And you know, that is one of the main things that people still do talk about, positively and negatively, to this day. You know, when I have looked at many of the ways in which culturally specific exhibitions are organized I always think of a megaphone. That's the image in my head, and it always seems that these projects start from the wide end of it. So basically, all of these shows have a title and then a colon and it will say "African American Women Artists: Finding Their Truth," so that there really is no justifying principle to put people together other than race or gender. And I thought with "Black Male," what if I go on the other end of that megaphone, the narrow end, and I come up with a subject that way. So I came to the crosshairs of gender and race with the issue of black masculinity. And then I looked for the artists at the wide end, the widest range of the artists (albeit within the parameters of the Whitney's focus on American

artists) who have addressed that issue within the chronological frame of the show. And that, at least in my head, was a possible way to get to another methodology.

GL: Is "Black Male" a show you could have originated at the Studio Museum in Harlem?

TG: It gets complicated to talk about these things because the Studio Museum in Harlem today is not the same Studio Museum as when "Black Male" was organized in 1994 (as the Whitney today is not the Whitney it was in 1994). In 1994, the Studio Museum in Harlem, as well as many other culturally specific institutions, was still deep in the work of canon revision. It's hard for institutions, or even individual curators, to begin to revise their practice when the practice hasn't even been written yet. So I feel like I was revising before things were firmly written into place. "Black Male" revised things that hadn't even happened yet; it was just in response to what I imagined was going to continue—that post-multicultural moment when there was just so much desire to keep holding hands around the table and sing *Kum Ba Ya*, and look-at-all-us-colored-people-together, and here-we-are, we're black, we're strong. I just felt like that was going to keep going indefinitely and I thought let me just get ahead of that.

GL: But isn't that a curator's job? To think ahead of what's already established? This is a problem I have with a lot of ethnically based exhibitions—they don't think ahead of what's already been done; they assume a little tweaking is enough. But I think curators and organizations need to break with the paradigms here because you have to follow the artist, and artists are already breaking with those paradigms. I look at what David Hammons did with his exhibition, "Concerto in Black and Blue, 2002" at Ace Gallery in New York, where the entire space of 20,000 square feet was totally dark and the visitors got these little blue flashlights and you walked through the dark and there was nothing in the space. That is an amazing challenge to the notion of—how do you put David Hammons in a show of culturally specific work...

TG: Well, you can...

GL: You can because he's a black artist, but that doesn't mean anything.

TG: But that's perhaps where it could finally get really interesting. When the cultural specificity can actually get specific, to an idea, an artist's practice, a moment. It's about an exhibition-making that doesn't necessarily define itself with the ruling paradigms of an ethnically specific show, and I would say if there's anything I'm trying to do in my practice, it's to rewrite that paradigm.

Kadir Nelson, *Africa*, 2001, installation view in "Black Romantic," Studio Museum in Harlem, 2002.

GL: It's a practice that's about conceptual practices even in non-conceptual work, and that's the problem. You were talking about the catalog covers of all these ethnically specific exhibitions: the covers represent that they are totally about a certain kind of legibility.

TG: Right.

GL: To make sure that you know there's some blackness.

TG: Do you have a different feeling about an ethnically specific exhibition in a mainstream institution versus a culturally specific institution? I think I do. I know this is wrong and this is my bias but I get more hysterical when I see those shows in a mainstream institution.

GL: Shows that are curated by those mainstream institutions?

TG: Yes.

GL: Because often those shows aren't generated out of the institution; they're generated by guest curators. Which is problematic in and of itself.

TG: Well that's a whole other issue—who produces these exhibitions and who works in the mainstream museums versus the ethnically or culturally specific institutions? In some ways that is the unspoken, but real. The paradigm wasn't always so problematic because there was a time when black curators only worked in black museums or Hispanic curators in Hispanic museums. You didn't have what was

called an "ethnically specific exhibition;" you had exhibitions made by ethnically specific organizations.

GL: Right.

TG: If you get a letter to be in one of these shows, just take the generic kind of show that we know is the problem, just a bunch of Black people in a show. If you get an invitation from a mainstream institution, are you more or less offended than if you get it from a culturally specific institution?

GL: I'm more offended when it comes from a mainstream institution because I usually feel it is politically rather than aesthetically motivated. But it also depends on the institution. Usually, I'm more offended because I feel like there is no commitment in some of those institutions to the single artist of color, and so every five or ten years, these institutions do some sort of big group exhibition and they put a lot of black folks in it. But there's not any spin-off or follow-up show from that. There are no monographic exhibitions organized by that institution of a Black artist's work, or Black artists are not included in any other kind of museum programming. So the only time you get to be in that major institution's space is in a group show—the ethnically specific group shows. Otherwise, that's it. Or, often there's not any sort of corresponding ongoing collecting practice in those museums. So they may buy one little thing out of the group show and they're done with you.

TG: Do we still need ethnically specific museums or art institutions?

GL: Yes, we do. Because the reality is that other institutions don't nurture young Black artists the way that places like culturally specific museums can, just as alternative spaces still provide an opportunity for emerging artists. That's the reality. Those spaces can still have an important role.

TG: So you feel it is still a justified endeavor. But if I told you right now I was going to leave the Studio Museum tomorrow and start my own museum, Thelma's Museum of Black Artists Forever, what would the letters of that be? T-M-B-A-F.

GL: Right.

TG: Thelma's Museum of Black Artists Forever. If I told you I was going to leave and start that, would you say at this point that would be a valid enterprise to start up?

GL: No. I don't think that's a valid enterprise to begin anew right now. But I think that there is still a role for places like the Studio Museum

in Harlem because the reality is that every artist needs some place that loves him or her, and in contrast to most institutions that I've shown in across the country, there are very few places that love you like the Studio Museum loves you.

TG: We can't make this only about the Studio Museum.

GL: Well, okay, it's not only about the Studio Museum.

TG: You're saying it's like home.

GL: Right. And the home is always problematic. But there is this certain feeling in other institutions—they're not in your careers for the long haul.

TG: That's where I am most completely engaged in the sentimental feelings I have about these notions of community as they exist in culturally specific institutions, the way in which we use the rhetoric of a certain community-based sensibility, talking about the artists we show as family, and the sort of words that harks back for me to other problematic ways that they play out in the black community. But within an art-world museum sense, I agree with that. I think the role that ethnically specific museums can play now is very different from the one they were founded to play, and if there is a problem now, it's that the role transition hasn't happened. We can't jump up and down and say, "We have overcome completely, there's no need for ethically specific organizations now, because the mainstream has taken up these artists of color." We know that's not the case. But perhaps we can say that there's a different role these institutions can play, and that role is to come in at the beginning of the career in terms of nurturing and support, or at the middle of a career, by providing a welcome opportunity that might fall outside of the notches-on-the-career-belt type show. That can be the focused show devoted to one body of work, or the small project that is something an artist wants to do without it being a major production. And at the end of artists' careers, obviously, we can say we have collected their works for our institution, but also, at that point, report on what would be the history-making legacies of particular artists. But it's not an either/or situation. I guess what I am so conscious of is that there is an underlying sensibility within the realm of the margin/center debate that was so informative to culturally specific institutions in defining themselves, but that sometimes it becomes an either/or—you're either having your retrospective at the Studio Museum or MoMA. And I would like to believe that now it's not an either/or, it's an and/and. You might have your first show at the Studio Museum *and* your retrospective at MoMA, or you might have your first show in MoMA's project gallery and your mid-career show at the Studio Museum. At this point I would like to believe that culturally specific institutions

could better fit into what is a large ecosystem and have roles in that ecosystem that are not always plagued by "woulds" and "shoulds" and having to come back to the racial construct as one that doesn't open out into other things. There was a wonderful moment a few months ago when your work was up simultaneously at the Guggenheim and at MoMA and we had a drawing up at the Studio Museum. I use that confluence as an example of who we can be and who we are in relationship to all these other places and as a way to communicate our many possible roles to supporters and to our audience. There are different ways in which an artist's work can exist in different contexts. And in this example with your work, those contexts were an institution that's written the story of modernism, an institution that was devoted at a certain point to the idea of nonobjective art, and an institution committed to the importance of black cultural specificity. And your work responds beautifully to all three contexts.

GL: But that means that you have to have a bigger view of the institution, or a less territorial line to your institution's mandate, than I think a lot of culturally specific institutions have at this moment. But the other institutions, the non-culturally specific ones, also have to have a broader view of their mandates, not feel as if black artists only belong in the Studio Museum and that's where you must go to see them.

TG: Let me ask you another hypothetical question. Say there's some amazing museum in this country, one of the best—and you've never shown in that museum.

GL: There are lots of them!

TG: And it's a museum that, in terms of their exhibition program, is authoritative and defining—they're great. Let's put that museum in a major city that has major art importance, say it's in Minneapolis or Chicago or LA, and its devoted to contemporary art.

GL: All right.

TG: Now, you've never shown there and they don't own any of your work. And you get a letter from the curator there, an important, legendary curator, who has done amazing shows, worked with artists you admire, produced catalogs and writing that you have referred to yourself in thinking about your own work, and that curator writes and asks you to be in a show at that museum that you respect—this is hypothetical, of course; I'm not speaking about anyone in particular. And say you were asked to be in a show at that museum: "Word Up: Ten Black Artists Now." It's being organized by a guest curator for that institution and you're included in it. Would you be in it? Would you not be in it?

GL: I think it depends on the show. Again, it comes back to the specific show.

TG: Say the exhibition is *not* good—it's a mix of two or three artists that you admire and feel a relationship with, but also it's six or seven artists whose work you don't respect, or don't think has anything to do with your own work, except for the fact that they happen also to be black.

GL: Then I'm not going to be in it. Now that could have negative career repercussions, but why should it? That's the interesting question for me. If I choose not to have my work framed in an exhibition that I feel is intellectually shoddy, why should that have repercussions in terms of my ability to show at that institution ever again?

TG: Well, this is not a question of ever again. I'm just positing that this is how this institution now, fifteen or twenty years into your career, has decided to frame your work. How do you respond to that?

GL: Well, it's a dilemma of artists' careers that sometimes, as far as you might go, sometimes you're basically starting over or starting at the bottom.

TG: And is the "ethnically specific show" the bottom?

GL: No, but these groups shows that are badly curated, and have lots of artists in them you don't respect, are the bottom.

TG: But say it was a big group show that's badly curated of artists from all over the world.

GL: That's a different thing.

TG: So, say it's not "Word Up," instead it's "Voices and Visions: Ten International Contemporary Artists." Would you say yes to that?

GL: No, I would still want to see who's in the show....
 Okay. I'm ambivalent about it, because the reality is that a presence in those kinds of spaces can bring other things. So it would be hard for me to just off-handedly say no because being in shows helps you get into other shows. So it's hard for an artist to say a blanket no to all those kinds of opportunities. But the reality is that that can backfire too, when curators put together groups of artists like that and they're problematic, those kinds of shows cling to you in a negative way. So, there's always a danger.

TG: The reason I'm also so reluctant to even talk about some of this is because I do acknowledge that the work I do now could not be

Eric Wesley, *Kicking Ass*, 2000, installation view in "Freestyle," Studio Museum in Harlem, 2001.

done without some of those shows having happened, because having had them occur means, at least, that the conversation could move beyond the questions of: Are there significant artists of color? or Are there significant women artists? Are there significant ... whatever, fill in the blank.

GL: I know.

TG: So once you get past that, it still seems like you have to have had that initial phase of work to arrive at the present, as problematic as that work might be. The archives that exist at the Studio Museum really document, in a very complete way, this history—just in the exhibition catalogs and brochures that we have in our collection. I realize that, because even though when I look at some of these documents and I think I could never have done that or justified doing that to artists, I see how that work has created the ability to react against it, to do something different or to move beyond it.

Mies's New National Gallery:
Empty and Full
Detlef Mertins

In considering the role of architecture in the display of art, it may be useful to distinguish among the various tendencies in contemporary architecture. The past decade has witnessed a resurgence of modernism in its minimalist, abstract, and ascetic guises, represented by Herzog and de Meuron's Tate Modern, Rafael Moneo's Museum of Fine Arts, Houston, Richard Gluckman's Andy Warhol Museum, and Yoshio Taniguchi's reconstruction of the Museum of Modern Art. The relative neutrality of this architecture—white walls, generous spaces, diffuse lighting—provides an unobtrusive backdrop within which works of art are able to assume the forefront of our attention. On the other hand, the overtly sculptural form of Frank O. Gehry's Bilbao Guggenheim claims its place as art but overwhelms the art displayed within its sinuous spaces. Even the powerful work of Richard Serra appears to be less impressive here than in any of its other stagings. But avoiding both the reductive purity of minimalist form and the self-absorption of expressionist form-making, yet another model may be identified within the heterogeneous field of architecture today. The Kunsthal Rotterdam by Rem Koolhaas/OMA and the current project for Boston's Institute of Contemporary Art by Diller + Scofidio are demonstrative of a neo–avant-garde practice that uses formal, spatial, and technological invention to open new horizons of experience, ways of seeing, and organizations of life. Given the multiplicities of architecture today, its uncertain status as art, and the controversial reception of recent museum buildings, it may be instructive to revisit Mies van der Rohe's well-known but underexamined New National Gallery in Berlin, 1963–68, which challenged habits and opened new territories while receding toward neutrality and invisibility.

When the New National Gallery in Berlin opened on September 15, 1968, the critics celebrated it as a monumental work by one of the greatest architects of the twentieth century, a homecoming for Ludwig Mies van der Rohe, who had left for Chicago in 1938 and was now eighty-two years old, too frail to attend the event. Yet almost immediately there were also voices of dissent, critics who pointed to functional problems in displaying art in the great glass hall under the levitated grid. Dwarfing most paintings and sculpture, this space was colossal in scale, almost entirely open, without walls for mounting art, and was enclosed completely in glass, letting light and views stream in unless the curtains were drawn. Notwithstanding the seri-

Opening of the inaugural exhibition, "Mondrian," at the New National Gallery, Berlin, 1968. Ludwig Mies van der Rohe, architect.

ousness of the concerns, the critics excused these functional difficulties in recognition of the architect's own artistic achievement. After all, the spirit of the commission had been first and foremost to secure a representative late work by Mies in Berlin and to worry about its function secondarily. Many people *still* think that Mies was simply indifferent to his clients' needs, indifferent to the needs of displaying art, imposing on them a work of art to be valued as an end in itself. Moreover, this was a work first conceived for a different purpose and a different climate (the offices of Bacardi in Santiago, Cuba), already once transported to Germany and offered unsuccessfully for a gallery (the Georg Schäfer Museum project in Schweinfurt), now enlarged and transposed to another city and another context. For later critics, the problems of functionality were symptomatic of the problems of universalist ideology, as Mies's quest for a universal space seemed to override difference for the sake of sameness and control.

Yet, the story of these difficulties is not that simple. Mies knew full well what troubles he was creating for the curators, not through indifference, but precisely *because* he cared about art, and especially, it would seem, about the future of art. "It is very difficult," he acknowledged, "to do an exhibition there. No question. But a great possibility for new ways to do it. And I think that I would not want to miss that."[1] For Mies, the task at hand in Berlin was not just to house the art of the past, the great collection of easel paintings and figurative sculpture—which was accommodated quite well, after all, in the permanent galleries and sculpture garden on the lower level[2]—but rather to support and even provoke the emergence of new ways of displaying and experiencing art, perhaps even new ways of making it.

This was certainly not the first time that Mies set his architecture in the service of new ways of living and, thereby, set it against the perpetuation of old habits and forms. In the 1920s he spoke of providing "a ground for the unfolding of life." The artist Hans Richter called him a new kind of architect, a *Baumeister* for a time of transition, a catalyst, and agent of historical change.[3] Theo van Doesburg, too, singled Mies out as a leader among the younger generation whose work was demonstrative of the future, enabling observers to

1. Ludwig Mies van der Rohe, interview, in *Mies*, dir. Michael Blackwood, Michael Blackwood Productions, 1986.

2. The formation of the Neue Nationalgalerie Berlin brought together the collections of the Nationalgalerie of the Stiftung Preussischer Kulturbesitz and the twentieth-century collection of the City of Berlin. The Nationalgalerie had been established in 1861 and became one of the greatest collections of post-1800 art. In 1937 the Nazis destroyed or sold nearly 500 works. More perished during World War II, others were taken to the Soviet Union, and only returned much later.

3. Hans Richter, "Der neue Baumeister," in *Qualität* 4 (January–February 1925): 3–9.

experience it proleptically, in advance of its fuller realization.[4]

The inaugural exhibition at the New National Gallery (NNG)—a retrospective of Piet Mondrian—reveals something of the new paradigm in the arts that Mies believed was unfolding. Recognizing that the paintings were too small to be shown effectively in the big glass hall, Mies designed a system of suspended wall-sized panels onto which the paintings were mounted. The open configuration of the panels created more intimate spaces for viewing the paintings without interrupting the continuity of the larger space. While critics admired the ingenuity of this solution, they nevertheless pointed to the problems inherent in displaying painting in the great hall and found it disconcerting to see the legs of visitors moving beneath the panels. The idea may have been inspired by exhibitions in Cullinan Hall, which Mies had designed for the Museum of Fine Arts in Houston, 1954–58—exhibitions curated by James Johnson Sweeney that had paintings floating in midair without any architectural support at all. Mies himself had already envisioned something like this in a collage for the hypothetical Museum for a Small City, 1942–43, in which a painting by Wassily Kandinsky hovers above the ground next to a sculpture by Aristide Maillol. Notwithstanding this image, however, it is rare to find levitated planes in Mies's work. While Mies, like van Doesburg, took the plane to be a new fundamental element of modern architecture, he preferred the freestanding wall to the floating plane, affirming gravity and the ground while embracing the open plan and spatial continuum.

The most direct evidence of Mies's ideas about new ways of exhibiting art at the NNG is found in his model of 1964 showing a possible exhibition in which two very large wall-size paintings, abstract expressionist in nature, stand as freestanding planes among the wood partitions and marble shafts of the building, and, curiously, a tree. The image recalls a series of collages, beginning with the Court House projects of the 1930s, in which Mies gradually developed a distinctive idea about combining painting, sculpture, architecture, and landscape. Some of the ethereal interior perspectives include rectangles of wood texture pasted onto the sheet to represent freestanding walls, such as the ebony wall of the Tugendhat House with its optically charged grain. Other collages incorporate fragments of a painting by Georges Braque, *Fruit Dish, Sheet Music, and Pitcher* of 1926. By taking only a fragment of the Braque painting and inverting it, Mies dissociated it from the actual work and transformed what was representational into a pure abstract composition of color, enlarged to architectural scale and legible at a distance.

The well-known collage of the Resor House, 1939, combines a wood wall, a fragment of Paul Klee's painting *Colorful Meal* (Bunte Mahlzeit) of 1928, and a photograph of the landscape visible through the floor-to-ceiling panoramic windows—one instance each of an architectural element (the wall), a painting, and a landscape, brought together in an assemblage. This marks a new kind of

4. Theo van Doesburg, "'The Dwelling'; The Famous Werkbund Exhibition" (1927), trans. Charlotte I. Loeb and Arthur C. Loeb, in *On European Architecture: Complete Essays from Het Bouwebedrijf, 1924–1931* (Boston: Birkhaüser, 1990), 164.

Ludwig Mies van der Rohe, architect, Gallery of the Twentieth Century (later named New National Gallery), Berlin, model with hypothetical exhibition installation, 1964.

unity through montage, one that respects, even heightens, the integrity and autonomy of each work and each medium, while bringing them into a structural and proportional relationship to one another. This is not a *Gesamtkunstwerk* (total work of art) in which the operative principle is fusion, but rather an *Einheitskunst* (art of unity) in which a common principle (inner cause) is understood to underpin the different forms of artistic practice and the expression of their inner logic. Moreover, the collage foregrounds the elementary character and material facture of each, which at a certain level of abstraction begins to suggest structural, i.e. organizational, affinities lurking within the surface of appearance. In this respect, the three pieces of this collage share an affinity with the flattening and estranging photography of László Moholy-Nagy, Albert Renger-Patzsch, Umbo, and others who, in the 1920s, developed a "new objectivity" in photography, exploiting the capacity of the camera to reveal a world of secret truths and universal forms unavailable to the naked eye. As vice-president of the German Werkbund, Mies was well aware of the new objectivity and the new optics featured in the Werkbund's "Film und Foto" exhibition of 1929, organized largely by Moholy-Nagy and commemorated in publications by Mies's friends Hans Richter and Werner Graeff as well as the historian/critic Franz Roh.

If the abstracting effect of the close up is most evident at the Resor House in the fragment of Klee's *Colorful Meal*, in the collage of the Museum for a Small City of 1943 it is most evident in the photographs of the landscape—in the surface of water and the pattern of leaves—while the painting, in this case Picasso's *Guernica*, 1937, is shown in its totality. Despite this reversal, the abstracted figuration of the painting is in scale with the building and in proportion with the sculptures by Maillol and even the enlarged patterns of water and leaves beyond. Through careful relationship Mies created ensembles that enhanced the uniqueness, difference, and individuality of elements and works while simultaneously bringing their underlying material organization (elemental, atomic) into alignment.

The combination of autonomy and homology, difference and sameness is paradigmatic of Mies's conception of *Bildung* for people (formation, cultivation, and learning) and *Gestaltung* for art, technology, and buildings (the self-generated creation of form through elemental means, individuation through inner cause). Mies understood autonomy not as an isolated autopoesis but as a kind of self-fashioning that is embedded in and responsive to context. For Mies, the capacity for *Bildung* had been lost with the great detachment of the individual from the community that began in the Renaissance and assumed gargantuan proportions with the advent of mass society in the late nineteenth and early twentieth centuries.[5] Renewing this capacity became increasingly key to his conception of the task at hand.

5. Ludwig Mies van der Rohe, "The Preconditions of Architectural Work" (1928), in Fritz Neumeyer, *The Artless Word: Mies van der Rohe on the Building Art*, trans. Mark Jarzombek (Cambridge, Mass.: MIT Press, 1991), 300.

Mies's collages of the 1930s and '40s belong to a history of avant-garde critiques of traditional forms of art, which underpinned numerous experiments towards a new environmental paradigm that would reunite the arts and reunite art with life. The abstract, coloristic, and immersive environments envisioned in the 1920s by Bruno Taut, Theo van Doesburg, Kurt Schwitters, El Lissitzky, and Le Corbusier are only the most well known of these experiments. The Barcelona Pavilion, 1928–29, demonstrated Mies's own version with a hybrid spatial structure—part *open plan* and part *free plan*. However, Mies rejected the application of colored pigment to architectural surfaces and instead used color only as an integral property of architectural materials. He made freestanding walls (as well as floors and ceilings) not of uniform colors but of uniform material: glass, wood, marble, and plaster. Where El Lissitzky attempted to absorb small paintings and sculptural works into the overall composition of his Abstract Cabinets in Dresden, 1926, and Hannover, 1927–28, Mies understood, as did others of his generation, that framed paintings would ultimately be superseded by wall-sized works, contributing to a new unity of the arts within a new open and fluid spatiality. Having imagined such a possibility in the 1930s, it is hardly surprising that Mies responded as enthusiastically as he did to Picasso's *Guernica* when it appeared in Chicago in 1939–40—at last, a wall-sized painting that demanded to become a freestanding wall in Mies's conception of the museum.

Following the Mondrian show, the history of exhibitions at the New National Gallery reveals a diversity of responses to the building, some consistent with Mies's vision, some brilliant in unexpected ways, and others decidedly awkward. Although the curators found Mies's suspended panels too cumbersome in their size and weight (substantial equipment was required to move them around), they used them for several more shows, including an exhibition of large paintings by Roberto Matta in 1974. The 1977 exhibition of work by François Morrellet featured large paintings hung directly from the ceiling, harking back to Sweeney's shows at Cullinan Hall. As an alternative, however, an exhibition system of demountable wall panels with overhead structure and lighting track was commissioned in 1977 from designer Walter Kuhn of Hannover in order to facilitate

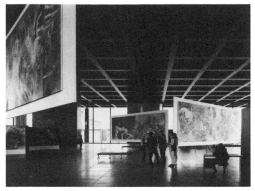

"Roberto Matta," 1974, New National Gallery, Berlin, installation view.

variable configurations of more intimate spaces for smaller works. Although it too was awkward for the display of art and competed with the larger architectural frame, it was used for over seven years. Beginning in this period, but more consistently later on, extensive walls and even rooms were constructed directly on the floor within the great hall. Examples of this include the A.R. Penck exhibition of 1988 and "Art Spaces—Visiting the National Gallery" in 1987. In 1997, Frank O. Gehry used a similar strategy for the installation of "Exiles and Emigrés"; here, Gehry put aside the free-flowing curves that have become his current signature in favor of a more restrained orthogonal arrangement of walls and display cases, reminiscent of his earlier exhibition designs.

In the 1970s the space began to be used for installation art as well as multimedia installations. Panemarenko's blimp was shown together with smaller inventions and wall-mounted works in 1978, and Mario Merz's *Drop of Water (Igloo)* of 1987 was featured in the show "Positions in Contemporary Art." The Douglas Gordon show in 1998, featuring projection screens suspended in the air for his *5 Year Drive By*, 1995, and *Bootleg (Empire)*, 1998, was consistent with Mies's desire for large-scale works, albeit now in the medium of video. For his show in 2000, the architect Renzo Piano created a richly layered installation of suspended horizontal vitrines punctuated with floating prototypes of roof elements and structural joints, revisiting the

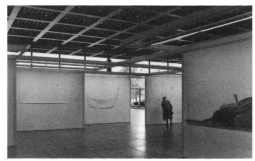

"New Painting in Germany (Neues Deutsche Malerei)," 1983, New National Gallery, installation view. The show employed a display system designed by Walter Kuhn.

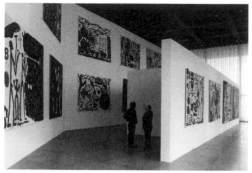

"A.R. Penck," 1988, New National Gallery, installation view.

idea of suspension from the Mondrian show but without subdividing the great hall into smaller spaces and achieving a heightened sense of lightness, transparency, and theatricality.

The space has also been used for performances, including the Metamusik Festival in 1974, the circus that was part of the exhibition "Circus" in 1978, a performance by La MaMa Experimental Theater, and *21 Pianos* by Daniele Lombardi. The installation of Alberto Giacometti's attenuated existential figures in 1988 also had something of the quality of a performance when seen in silhouette or in relation to visitors moving through the gallery.

More recently there have been several solo exhibitions of site-specific work in which artists have actively engaged the architecture in dialogue. This is not a kind of work that Mies anticipated, although his building lends itself especially well to those that enter into its logic or respond—be it affirmatively or critically—to his desire to manifest the deep structure immanent to creation. While Matt Mullican's *Banners* of 1995 clearly belong to the building in their scale and proportion—their graphic language echoes the universalist ambitions of the building—they are at the same time entirely alien to it, blocking its transparency with sheets of bold, colorful icons that radically transform the image of the building outside and render the experience inside almost claustrophobic. More subtly, Ulrich Rückriem's installation of 1999–2000 placed stones that were exactly the size of the building module on the floor in a pattern generated through

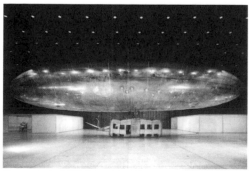

"Panemarkenko," 1978, New National Gallery, installation view.

"Matt Mullican Banners," 1995, New National Gallery, installation view.

a locational formula that was both random and rigorous, thereby stretching the logic of the grid beyond the limit of pure rationality. Where Rückriem took over the floor, Jenny Holzer took over the ceiling with *SMPK* in 2001. By attaching lines of moving electronic text to the underside of Mies's dark artificial sky, Holzer transformed the grid's implied extension to the horizon on all sides into a one-way flow of information. Like soldiers marching in formation, row upon row of provocative yet enigmatic slogans rushed by overhead, at times so quickly or with the lights oscillating that their messages could only be read a few words at a time, becoming abstract, a wave flowing through and beyond the grid.

Most recently, in 2003 the exhibition "Content," Rem Koolhaas and OMA took aim at the pristine purity of the glass box and filled it up with the scattered material from designing their most recent buildings and urban projects—models and maquettes in different materials and scales, graphic presentations of research data and imagery, material studies, engineering calculations, and even the media spectacle of global politics. If in Mies's time the production of difference or events required emptiness, today, Koolhaas implies, it requires the fullness of content, the entropy of junk, and the flows of information and politics as much as matter.

The variety of shows and events held at the NNG, beginning with the raising of the roof and the celebration (*Richtfest*) that followed, points to its function as a framework or infrastructure for an experimental approach to art and life in which the question of autonomy extends to the curators and artists themselves. It is something like a black-box theater, a flexible tool capable of being adapted to different functions and desires, not unlike Cedric Price's Fun Palace project, 1961–64: a giant Erector set in which British workers were to realize their "potential for self-expression by dancing, beating drums, method-acting, tuning in on Hong Kong on closed-circuit television and action painting."[6] In this respect, the NNG also shows an affinity with Coop Himmelb(l)au's Large Cloud Scene, 1976—a temporary structure in Vienna, four framework towers thirteen meters high with an image of clouds stretched between them, an open setting for events,

6. Ruth Langdon Inglis, "Architecture: The Fun Palace," *Art in America* 54, no. 1 (January–February 1966): 69–72.

"Content: Rem Koolhaas/OMA," 2003, New National Gallery, installation view.

mobile performances, circuses, and street fests, hoping to increase the vitality of urban life in order to precipitate urban change.

As with Price, there is no set script for Mies's stage, nor is there a teleology to be performed. Instead its extreme openness anticipates dramatic events. Mies captured this spirit in a sketch that diagrams life in the universal space, the open-yet-lightly-structured space within which partitions, furniture, and installations can be configured and reconfigured with ease. With a few strokes of his pencil, Mies marked the edges of a square box within which a squiggly line circles around the empty center, an event whose form and character remain indeterminate. The swirling flux has yet to settle or harden into forms or striations, is still in the process of becoming, is smooth, even chaotic, little more than a potential. Mies's squiggly line depicts the potentiality of becoming, the potential to actualize being in a multiplicity of contingent concrete configurations over time. This is the spirit of Mies's quest for the "almost nothing" that takes us back to what, for millennia, has been understood as the original nothingness and potentiality of existence. Like Kasimir Malevich's *Black Square*, 1915, it is all and nothing. If people are disturbed and unsettled by its ascetic emptiness that is precisely its point: to create within the world—the world that is already fixed in form—a clearing, a radical negation, an open space that demands and facilitates the production of being, as close to pure presence as possible. Mies's glass box is so minimal, it's infrastructure so well integrated and its elements so reduced and simplified that it is little more than a recessive, neutral, and empty architectonic in which to play at a modernity whose realization is continually deferred.

However, the palpable discomfort of many of the installations in the NNG suggests that it's architecture is not, after all, the same as Price's more accommodating Erector set, or for that matter, the neutral white box that has become paradigmatic of galleries for contemporary art. While open to change and new ways of doing things it is not neutral after all. In Mies's phrase, it is "*almost* nothing," and if we put the emphasis on the "almost" rather than the "nothing" then we realize that it is something in fact, something material and

tangible that operates between us and nothing, that points to nothing, plays the role of nothing, allows us to imagine nothing and even experience its terror, keeping the chill of nothing at bay while harnessing its catalyst agency. The NNG is, in fact, a resolutely fixed and unchanging frame that is charged with symbolic, even metaphysical, implications, like the dome of a cathedral. And like a cathedral, the purpose of its analogy to the heavens is to take us outside ourselves, beyond the human—to contemplate and experience alterity without appropriating it. At the NNG, this extension occurs in the floor as well as the roof, as the building opens to and frames the plaza, the city, and the horizon beyond. Mies did not offer technology as tool, empirical, functional, and transparent. Instead he transformed technology into an architectonic image that was at once technological, artistic, historical, and cosmological. This image provides a stage—almost transparent—on which the homelessness and nihilism so central to the experience of modernity can be enacted as both a crisis *and* an opportunity for constructive self-fashioning. On this stage, some performances succeed better than others, and some fail and are seen to do so. The more the exhibitions at the NNG have pushed beyond the conventions of traditional art and the more they engaged the scale of the building and the problematics of modernity, the more successful they have been. Nor is the NNG the same as Coop Himmelb(l)au's temporary event structure. Mies's dark artificial sky is not only durable but enduring, heavy in both the literal and figurative sense of the word, less optimistic and lighthearted, more demanding but also galvanizing in its evocation of the plane of unity in cosmic memory.

Of course the NNG is a singular work, not a model to be reproduced. But then does the world of art need such a model from the world of architecture? Isn't art sufficiently irrepressible in its capacity to generate new works and unexpected turns that every architecture will be inadequate in some way and for some works. For that matter, what would constitute adequacy? Isn't it more telling that the same artwork produces different effects in different architectural settings as well as social and cultural contexts? This is not to suggest that free license be given to architects, most of whom are, in any event, inclined to take their clients' wishes seriously. Rather, it is to suggest that some tension in the relationship between contemporary art and contemporary architecture is productive for both. Without some friction, each tends to collapse into its own hermetic formulas.

This text was originally commissioned by The Philadelphia Exhibitions Initiative (PEI); it was published as "Mies's Event Space" in *Grey Room*, no. 20 (Summer 2005), 60–73. The author would like to thank Andres Lepik for his generous support during research visits to Berlin and the staff of the Neue Nationalgalerie for providing access and guidance to the NNG archives.

Design and Architecture
Paola Antonelli interviewed by Bennett Simpson

Paola Antonelli, curator, Department of Architecture and Design, Museum of Modern Art, New York, was interviewed in winter 2004 by Bennett Simpson, then an associate curator at the Institute of Contemporary Art, University of Pennsylvania.

Bennett Simpson: In response to your "Workspheres" exhibition at the Museum of Modern Art in 2001, the critic John Thackara wrote that museums were bad news for design because they tended to foreground objects and products over the uses and relationships facilitated by them. Do you think this is true?

Paola Antonelli: No, museums are not bad news for design. Design is still totally underestimated. Museums are a real opportunity for design to gain, I wouldn't say, more respect, but at least to get people to pause. Museums are places where you're supposed to change speeds. You can have the visitor go much faster or slow down. And in the case of design at MoMA, I'd like the visitors to pause.

Especially in the museum's early days, when Philip Johnson organized the "Machine Art" exhibition in 1934, design required an extreme act of conceptualization. Johnson took springs and ball bearings and put them on white pedestals against white walls like sculpture, and that act was necessary because he wanted people to be jolted and surprised and to think of design in a different way.

"Workspheres" was a particularly tough exhibition because it dealt with the real world and how people live and work, and when you get into such territory, everyone has an opinion to vocalize. The criticisms it provoked were part of its success. It caused a conversation. That's why I think museums can be really good news for design. "Workspheres" was a show about the way we customize and adapt our own workspace in different situations. And at that time—remember, it was 2001, before September—we had just come out of the dot.com boom. There was no end to the nonsense one could read, hear, and debate about different workstyles, especially working at home, for instance. I remember articles suggesting that people who work at home simulate a commute by walking around the block on their way to the office across from the kitchen. Or advising them to put their computers on timers, so after 9 p.m. they would be forced to stop working and be reminded to spend time with their families. That was all crazy. It was important, I thought, to take the common sense and the intelligence of designers and allow them to shed light on the real nature of how human beings manage the balance between private

"Workspheres," 2001, Museum of Modern Art, New York, installation view.

and public life. I think that, with distance, the most successful aspects of the exhibition were the experimental projects. The products were a little bit polluting.

BS: Why did you include so many products?

PA: Because I wanted to show that there was goodwill on the part of manufacturers and designers dealing with the issues of work and working. These were things already being produced at risk by companies, essentially to accommodate necessity and flexibility.

BS: What is the greatest challenge of curating shows at MoMA?

PA: Same as anywhere. The biggest challenge with design shows is to avoid the "trade fair effect." You have to be able to conceptualize your objects. People now have been trained by good structuralists to think in terms of narrative in context, so framing things is crucial. But you have to make sure that the context is not a shopping context. Nevertheless, I like commercial products. To lose the commercial aspect completely would be hypocritical. It's a very, very fine balance.

What I usually try to do is to set up a really amazing scenography so people can distinguish between a museum and a trade fair or a normal store. The museum is not Moss, it's not the Javits Center, and it's not Prada. It's a very special place. Not that Prada isn't special—Prada is already competing with my exhibitions! But anyway, my exhibitions should be places that are very soothing. Now I'm getting to your question. The problem with curating a design show at MoMA—a problem I like actually—is that 80 percent of my public is there to see Matisse and Picasso. They stumble into my show, and I have to keep them there. After looking at painting and sculpture, it's weird for them to be looking at kayaks or chaises longues, or even the paper clips that were included in my "Humble Masterpieces" exhibition at MoMA Queens in 2004. But because the museum's space is so great, and if the exhibition is conceived and installed in a clever way, people consider it time well spent. The

"Humble Masterpieces," 2004, installation view, Museum of Modern Art, Queens (MoMA QNS), New York.

challenge as a design curator is that I always have to be more seductive than painting and sculpture shows have to be. And at the same time, I have to make sure I maintain the dignity and seriousness that the institution demands.

For my 1997 "Achille Castiglioni: Design!" exhibition, for example, I wondered "How do I get people to understand all the rich context and stories that are behind these objects?" And I thought, "Okay, if I give them pictures, people may want to read." So I hired an illustrator to draw illustrations for every single object. I told him what the image was, the joke or the design process, and he invented a character—always black and white with a little bowtie—to carry us through the narrative. The illustrations were fantastic. They really got people to stop, look, and read. It was a trick, but it worked because it was entertaining and the content was very strong.

BS: Do you feel like your audience is more knowledgeable or empowered because design is ubiquitous in culture?

"Humble Masterpieces," 2004, installation view, Museum of Modern Art, Queens (MoMA QNS), New York.

PA: My American audience is in general shy and insecure. Americans know about design but think they don't. At the beginning of the nineteenth century, rich Americans were defined by furniture imported from France, or even by patterns imported from France and realized by manufacturers here. Americans still believe that design is everything that is ornate, too expensive, overtly sophisticated, and therefore non-American. This is crazy, of course. The Shakers had totally original expressions of design, but they were hardly bourgeois or fashionable. At the same time, the essence of practical, affordable, brilliant design is so American. The first thing my audience does is look for reassurance. My job is to make their insecurity disappear.

BS: One heard so much about the "design boom" of the nineties. Aren't people more comfortable with design because of Ikea and Martha Stewart?

PA: I hope so. Design should be a normal fact of life. Like food. Just as people can tell a good steak from a rotten one, they have the power to tell a good design from bad, even if they don't know it. It's just a matter of exercising their analytical skills. So, yes, I think the so-called design boom has been very helpful. The hype that the press has created around it has not been very helpful, but that doesn't really matter.

BS: Has the practice of making design exhibitions changed in the past couple of decades?

PA: Not very much. Although audiences have become more diverse.

One of my favorite design shows was "Design: Mirror of the Century" at the Grand Palais in Paris in 1993. It was such a French show, so arrogant and so great. It took the whole world of modernity, from the Crystal Palace in 1851 to the present, as its subject. It had black-and-white pictures of historical events on the wall to orient the audience. Below the pictures was a row of stunning cars, one next to the other. Then, if I'm not mistaken, there was a row of objects. It was like a flea market, thick with masterpieces of design, all over the floor. The labels were mounted vertically, sticking straight out from the floor, like some kind of forest of information. There were lane-markers on the floor, indicating scientific discoveries that corresponded with designs from each year. There was a row of TV monitors and chairs so you could sit and watch interviews with designers and scientists. It was humongous and encompassing and grand, a flea market of modernity put on display. The entrance to the show was through two big fingers, the kind used to feed passengers onto planes in airports, sort of a "you are here" idea to cut through everything else. I found it so much fun. Visitors would point at different objects and scream, "Oh, I remember that!" The catalogue had something like thirty essays covering everything from steam engines to art deco

moldings to biodesign. And the critics were incensed because they spend their lives trying to make whatever discipline they write about the most important discipline in the world, and here comes this exhibition that just collapses all categories and distinctions.

But I have to say that not much has changed in the way information is presented by design studios. The few exhibitions that have presented objects in a virtual way have not been very successful. The materiality of the objects is almost a requirement. In some exhibitions, people can handle or use the objects. I remember the first time I saw this, at the Design Museum in London, which had and still has a very small collection that is mainly educational. It has all these famous chairs for people to try, and I thought that was fantastic. Perhaps one change is that museums can get some objects more cheaply—but I don't know if this constitutes progress.

BS: Design exhibitions at MoMA have often been, themselves, dramatically designed. The idea of the "total" exhibition design comes from the early Bauhaus shows, but it has had an impact beyond design, on art exhibition-making for instance. Do you see this continuing?

PA: Total design continues because, if you think about it, it has to. More and more one has to overcome the building, right? You have to remake the building every time. Scenography is central in today's museum.

BS: How are monographic shows and thematic shows different for you?

PA: I've done many more theme than monographic shows. They are at once extremely different and not very different. The latter because all exhibitions need a strong idea to begin with. When I organize/curate a thematic show, I try to really shape the idea so that things fall into place and what doesn't belong is shed. But the same can happen with a monographic show. I tend to prefer thematic shows because I'm a little more egocentric! They allow me to speak my own mind more authoritatively. But you can also do that with monographic shows if you pick the right designer. And if you frame things well. You just have to be rigorous within the terms of the exhibition. For example, "Humble Masterpieces," which presented objects that are often overlooked in their simplicity, like Q-tips. The space I had at my disposal in the Queens building we occupied while the Manhattan building was under expansion was very small. The money I had at my disposal was close to nothing. I couldn't fund-raise for this show. So what do you do? Find a good idea that fits the place. I was trained as an architect and I still work like one.

BS: Are some designers easier to curate than others?

PA: With thematic shows you can do whatever you want. With monographic shows, it has to do with personality. I would not select any-

body I didn't believe had a range and variety and depth of work. On the other hand, you have to take chances, as I did in 1998 with "Project 66: Campana/Ingo Maurer," an exhibition that paired work by a super-established legend of design with two relatively unknown Brazilian furniture makers, brothers from São Paulo. Maurer was a real sport, and at the end he was very happy; they've remained friends, they've worked together. It was a gamble, and it paid off. But I think it has to do with personality. There are some designers I consider geniuses with whom I would never think of doing a monographic show. Even though I may collect them for the museum and admire them greatly.

BS: Looking ahead, what do you see design exhibitions needing?

PA: That's easy. There need to be more! Because there are hardly any. I rarely see a design exhibition and think, "Oh, we could have lived without that." Every one is really welcome. From furniture to skin, anything. Design to me is one of the highest expressions of human creativity. There's so much to explore. I wish there were more design exhibitions in New York especially. We miss so many traveling shows. MoMA, for instance, is an art museum, and Architecture and Design is one of six departments. We have to make plans for an exhibition years in advance. My dream would be to have a cube in the middle of the city somewhere, without a collection, that we could just program experimentally. It should be like making independent movies. We should be able to have one or two flops, justified as experiments.

There's so much to explore and there's not nearly enough criticism. I also really hope people will become more critical in the way they select and buy objects. In terms of the presence design has in people's lives and in culture, it is no different from the movies or music, if you think of it in a broad, critical way. But the schism between academic writing and thinking about design and the more popular or journalistic approaches needs to change. Typical scholarly attitudes are obsessively and tediously thorough, but the mainstream media are completely acritical. I cannot believe that so many publications do not have a design critic. If a dance company organizes a picnic, they publish a four-page review of the picnic, but when a new product that changes people's lives is introduced into the world, they do not consider it worthy even of a fourth of a page. Or they assign a-something-else critic—of either art or architecture, in some—to the task, and once again miss the point.

BS: Design and architecture are perennially hot topics in the art world—it was especially so in the nineties era of the Net and the user. Do you think the fascination works the other way?

PA: Well, it's complicated, this appropriation of disciplines. I think that Donald Judd's furniture is not furniture. He was an artist making

sculpture. If I were to consider it design, it would be really lousy design: overpriced, not comfortable, et cetera. It's equally sad when designers attempt to do art and the art is mediocre. Designers need to be disciplined and rigorous. By definition, design is geared towards other human beings. Sometimes designers are weekend artists of course—art becoming a walk around the block or a breath of air. I think it should pretty much stay that way. But conceptually, art helps designers a lot, in terms of just experimenting.

It's been an interesting process rehanging MoMA's collection, which we're just completing. We've mixed art and design on the different floors. I've discovered that when you put art next to design—especially when two objects have surface aesthetic similarities—art always wins. Design automatically gets absorbed, and treated and viewed like art.

BS: Does this bother you?

PA: Yes and no. It's just the way it is. It bothers me when it's contrived. But in the case of our gallery, we're trying honestly to show the breadth of our collection, and there is a lot of exchange, a conceptual exchange between art and design. But what do you do? Do you write a long explanation for the visitor? Do you force the similarities and differences? I think that we will try as a museum to experiment more and more with juxtapositions, but it's tough.

BS: MoMA has always told a story of modernism that encompasses design narratives as well as art. But when that story seeks to hold the two disciplines together, it gets much more complicated. It becomes a story about ideas—which can either be more encompassing and contextual, or it can flatten everything out.

PA: That's very true. I have always had a problem with the word "art" in English. It's very different from the meaning it has in Italian. In English, art is everything. But in Italian, it's so specialized. Design definitely is very close to art in the history of ideas that developed in the twentieth century. It's undoubtedly right to have design in the Museum of Modern Art, and at different moments in the century art has influenced design or design has influenced art, and it's beautiful to see. However, I think the juxtapositions work better in a book or in a lecture than when you put two objects side by side in a gallery, as I explained before. It is too easy for a design object in a museum, especially next to a sculpture, to lose its own functional nature and be perceived as a sculpture too.

BS: What are you working on now?

PA: I'm preparing an exhibition for October 2005 called "SAFE: Design Takes on Risk," about how design responds to crisis and disaster. The

challenge is similar to "Workspheres": how to modulate aesthetics and innovation within the real world. We don't want to fetishize suffering, but at the same time, I have to make sure every single object stands out for how well it is designed and how it's deployed within the thematic framework. One of the best exhibitions I've ever seen was about pain. Can you imagine? A social and material history of pain at the Parc de la Villette in Paris, about 1992. It covered everything from migraines to torture and really tried to narrate and make manifest this concept which, in itself, is pretty abstract. Design should always be approached this way. I would die if I had to always do exhibitions of sidetables from the 1940s. Sure, there are some great examples, but that's just not for me.

BS: You once said it was very rare for books like this one to include curators of design and architecture. Do you think curators of design and architecture have been left out of the new so-called discourse of curating?

PA: When we talk about curators, the first thing we think about is art. Maybe it is also because art curators often come from academia, and moreover from the same institutions.... Architecture and design curators are often architects. They usually do not have Ph.D.s.

BS: Is it easier or harder to fund-raise for design shows?

PA: Harder. Our development people are really good. They know about design, they're knowledgeable, but it's much easier to go to a corporation and ask them to give a million and a half for Picasso than three hundred thousand dollars for a design show. They think that their return is going to be bigger because art is more in the public eye, because people celebrate art more, it has more prestige.

You could also hear that it's harder to fund-raise for design because of the problem of the conflict of interest, but I do not believe that. There have been exhibitions that have given corporate sponsorship a bad name: I won't name names. It just has to do with the authority and rigor of the institution. "Workspheres" was funded partially, but in good part, by a consortium of four companies that made objects that were presented in the show. I asked them. They were competitors. I asked them to all give the same amount of money in a pot, and they had no say about what objects I would choose. One of them had a lot of products, another one had only one, but they didn't hesitate because it was MoMA.

The problem is the perception that design attracts less attention; but you know what, I haven't fund-raised for a major show in four years and it might be different now because of Target, because of Ikea, because of the press, because of the design boom—I hope!

Who's afraid of gift-wrapped kazoos?
Dedicated to David Whitney

Jeffrey Kipnis

I wish I had never gone to Dia-Beacon, I loathed it. Try to imagine
Lou Reed's *Walk on the Wild Side* chanted by Benedictines—"But she
never lost her head, even when she was giving head, doo, do doo,..."
in solemn *cantus firmus* resonating with languorous, parallel fourths.
Gorgeous, but grotesque; that's how Beacon feels. A pantheon, it casts
the reprobate art of the '60s in a morality play that exalts idolatry, the
death instinct, and white flight in a single bound. It's a staging that
grows all the more vile as I think back to the original scene, to its icon-
oclastic rhythms, its impulse to disestablish, to its characters so gritty,
so utterly urban. Warhol, Beuys, Nauman, Flavin, Ryman, Serra, their
once feral stuff here tamed shamelessly by the insidious power of
landscape and architecture to work evil with beauty. Even the name
of the place is unfortunate—did any of these works propose to show
the way? (Okay, maybe Judd's, to his abiding discredit.) Anyway, I
remember the things differently: hunched, fidgety, disaffected, an art
whose vain misanthropy gave permission to mine. Now these winners
of our discontent are made glorious by this son of York.

Yet, Dia B. performs as a show, a great show, dastardly in its vil-
lainy to be sure, but great nonetheless. My vituperations are them-
selves evidence, for, as with any theater, when we consider the visual
arts show, it must be the absolute value of the displacement—how far
from indifference the show shoves us as a sheer quantity—that first
concerns us, before we turn to the particular inclinations or signifi-
cances of the movement. Yet, eventually, the qualities of the disloca-
tion, too, must pester our attention....

Dear Paula,

As much as I find your invitation to submit an essay on the state and future of the architecture exhibition questionnaire alluring, so dear is the subject of exhibitions to me (not just the peculiar problems that attend those about architecture or design) that my every effort to write your essay proves maddening. Not only are the issues too fraught, too snarled, but I am utterly distorted by their weights. Matters of great importance to me may be of little interest to your readers, I fear. How do I dare even whisper of the deliciously intractable problem of the label, for example, which stands to exhibition theory as Fermat's Last Theorem did to mathematics. (Actually worse, since the mathematicians eventually solved their conundrum, though it took them three hundred years.) Or, were I to turn to the immense impact of other museum personnel on a show, I would squander time and space out of proportion. I suppose I could camouflage behind a folksy anecdote an account of the real trench work of the staff, work that at any moment and a dozen times over seems life-saving or fatal. Like the one about the junior installer who saved my ass and my institution's reputation by having the presence of mind to put his hand up and stop a crate from tipping over, one that contained a fragile borrowed glasswork while I, the registrar, the chief installer, and half a dozen others stood frozen. (He was, by the way, the one job applicant whom I most opposed hiring.)

I know that you too care very much about this topic, and therefore are after something much less chatty. But if you will allow me the informality of a letter, I will, amongst my digressions, attempt to address the three issues that mattered most to me during my brief career as an architecture curator. I mention the brevity of my tenure to remind myself of the self-indulgence it permitted. A different, less precious view is required by a career as a curator, as in Terry Riley's impressive string of major thematic exhibitions at MoMA or Aaron Betsky's astonishing fifty plus shows in six years at SFMOMA.

The three issues are these: how to regard the architecture exhibition; how to cope with the peculiar problems such exhibitions raise; and how always to rally anew the physical architecture of the institution, in my case Peter Eisenman's Wexner Center for the Arts.

From the start, I set out to explore the exhibition-as-such as a form of social practice, a singular form to be sure, but, nevertheless, one with strong correspondences to theater. My desire was to exaggerate the experiment, subordinating all other considerations. In part, that desire followed from interests aroused by those French

intellectuals' discourses on representation. In larger part, it derived from a peculiar construal of the museum-building-as-such that I was developing as a defense of conjectural museum architecture, by which I mean the Wexner and its usual list of coconspirators: Wright's Guggenheim; Koolhaas's Kunsthal Rotterdam; Piano and Rogers's Pompidou; Coop Himmelb(l)au's Groninger Museum pavilion, and Hadid's Cincinnati arts center—you know the list—against an increasingly insistent demand from the museum community for a return to architectural decorum in the name of flexibility, an issue that seemed to be receiving little resistance from our own critics, with the exception of Herbert Muschamp. Obviously, as the curator of architecture at the Wexner Center, my work could play an important role in bolstering that defense. If I could make the Wexner sing, I figured, I would have not just an argument, but some evidence—and after all, who better to do that in a so-called difficult building than an architecture curator? By the way, in my argument, "sing" is not merely a figure of speech—but then I said it was peculiar.

Mostly, though, I wanted to do it because I think exhibitions make lousy essays, oppressive sermons, and tediously bad books. I have little patience for exhibitions styled in such fashion and even less for those mounted, almost as an apologia, to disseminate a catalog. I don't think exhibitions make very good documentaries. No, let me correct that. They can make great documentaries, although the abundance of such has reached a glut. Given the surfeit, though, isn't it curious how little experimentation there has been in the documentary exhibition, certainly none that parallels the evolution of the form in film.

When such an experiment takes place, it usually does so as the positing of a radical new theme. Yet, the thematic exhibition still uses the same knee-jerk formula of mustering a checklist qua witness-list such that each exhibited work stands, testifies to, the viability and import of theme (and thus to the brilliance of the curator), then hands the mike over to the next. Was Philippe Vergne's "Let's Entertain" at the Walker entertaining, or just about entertainment? The scandal over that show should not have been about its cynical indulgence, nor even about its roster of usual suspects—ensemble casting in serial exhibitions by an individual curator has enormous potential.

Kitchens curated occasionally, obsessed with dissolving the Kantian criticality that had crept into museums and galleries like *rigor mortis*. One of his exhibitions, *A Poem without Words*, regrettably mounted at MoMA and thus largely ignored, never left her thoughts. In an enfilade of eight galleries, each doorway veiled with curtains of different

weight so as to become the interval between stanzas, Kitchens installed groupings of paintings. Laskers and Rymans in every gallery, Marcaccio in five, Noskewicz and de Kayser in four, these five painters forming the poem's intricate rhyme scheme. In each gallery he added select works by one or another artist, from giants such as Monet, Picabia, De Koonig and Rauschenberg, to other Contemporaries such as Friedman, Ackerman and Reed and gifted unknowns from the same period such as Clifford, Howalt and Creecy, plus a liberal spray of today's Advanced Painters, though none of Janeila's.

As she walked down the axis from stanza to stanza, the rapturous journey of the poem's themes, mood shifts and visual effects tore through her like a barbed wind. Stepping out of the first gallery, its brilliant, riveting repartee transposed into a sparkling radiance that wrapped her in droplets of light. Alighting into the next stanza's chic, nod-knowing cool, a few steps later the poem exploded into hilarity, then, through the next curtain plummeted suddenly into horror. A long episode of resigned thoughtfulness yielded eventually to a depth of serene introspection she never thought possible for painting to attain, so calming she could not tear herself from it, save for Ram's gentle urge. In the final gallery, she sank slowly, inexorably into despair. Ram guided her out through the last curtain trembling, her face mottled and flush, unable to speak.

Down the exit hall, she glanced almost accidentally into a small, dark cloakroom and saw, off on a side wall almost out of view, a single, unassuming Thuymans sitting on a shelf, propped up unceremoniously in a tender caress of light. Not redemption, not salvation, not even hope, just naked affirmation: matter of fact, psychologically aware, beyond denial, almost brutal in its gentility. Regaining her composure in a few moments, she sent Ram home and spent the rest of the day analyzing the poem, slowly coming to the opinion that it had been built from Poe's ideas, if not from one of his poems. She learned later that Kitchens had fought bitterly to hang Whistler's *Symphony in Grey and Green: The Ocean* in the outer penumbra of the Thuymans, a luminosity-echo hiding in a shadow. But the Frick would not hear of one of its masterpieces cast in such a bit part and it didn't help that Kitchens had repeatedly and viciously impugned the Frick for damaging the painting by hanging it with a label that gave the title merely as *Ocean*. Though she later commiserated with Kitchens about his failure to secure the work, secretly, she breathed relief. It would have been too much.

No. For me, the problem with Vergne's show was that it, yet again, and like so many others, sought to colonize a body of cultural production by "understanding," as in over-interpreting, art works that seemed to me to be raging against that particular hegemony. That's why, above all else, I abhor the supposition that exhibitions should be informative or, god forbid, educational. Is the work of Godard or

Hitchcock or Beckett or Lecompte or Adams or Ashbery or Kiley or Gubaidulina or Serra or Koolhaas or Starck or Westwood or Cragg or Reed or Koons educational? These works, and all of their cousins, are full of ideas—bold, provocative, shuddering ideas—but do they teach us something?

We should never confuse the fact that cultural practices affect us, change us, stimulate us to think and see and hear and feel differently with the supposition that they teach us anything. Once something teaches you something, it thinks for you. This is a point that eludes even the promising young mess specialists and punk whippersnappers à la Obrist, who, for all of their bravado, continue obediently to inscribe their work in the service of the Big Idea. Rotten once said, "I may not know much about music, but I know it ain't got nuffin' to do with chords?" Worth remembering.

The lack of ambition in the documentary exhibition tracks with what appears to me to be a broad-based narrowing of exhibitions styles into formulae that often serve the subject matter very badly. I recently saw a comprehensive Hopper retrospective at the Tate that was utterly devastating to a painter I once cared very much for. Obeying the standard conventions of a one-person survey, the exhibition offered encyclopedic coverage of every period, grouped first thematically, and then, within each group, chronologically. The selection and installation, though utterly unassailable as an exercise in contemporary museology, had no regard for the most precious effects of the painting—the precarious balance the best achieve between a quiet matter-of-factness and melancholy, or between the quotidian and the metaphysical, a fragile effect that evaporates when they are relentlessly hung, particularly in thematic groupings. The more I was made to "get" them, in other words, the more I came to hate them and mourn for the loss of a revered loved one. It was the show's fault, but I will always blame it on the paintings.

Across the hall, on the other hand, was a show of Luc Tuymans which I understood to be selected and installed by the artist—a risky adventure, in my opinion, as the lawyer who represents himself has a fool for a client—but in this case a remarkable success. There were chronologies and themes in that show as well, but loosely arranged and always subordinated to a careful choreography of moods and demands on attention. The sequences and adjacencies felt more like rhythms than comparisons, allowing me to think, to rest, to ponder and admire, to doubt, to wander and daydream. I'd not long before seen the most recent gallery exhibit of a dozen or so new paintings of his in New York, a few of which were in this show, and it was fascinating to see them at work in an ensemble, rather than at a casting

call. Obviously weaker paintings, failed conjectures and experiments—(some quite evident ones actually, such as a still life executed for Documenta)—were intermixed with stronger works, affording the show pace, a sense of honesty and intimacy, and most important, a modest provisionality. This was not the Luc Tuymans show, but a Luc Tuymans show, and I came away looking forward to the next.

If I had a quibble with that exhibition, it was with the labels. Set far away from each painting, they deferred to the work and opened space for it beautifully. However, I think the titles of these paintings are especially important, even inseparable, so the distance overly detached the two. Moreover, they are sometimes names, sometimes nicknames, sometimes mottos, sometimes allusions, and therefore badly served by a single graphic convention.

Though I enjoy knowing a work's media sometimes, I've never understood the equation of media with title effected by conventional labeling. It is as if I introduced myself by saying, "Hello, I'm Jeff Kipnis, and I'm made of skin and bones" oh, yeah, and "fat." And, come to think about it, why do we write out Untitled? Then, there's the problem of "le minuet," the hilarious zigzag to and from the wall that labels choreograph, a particular nuisance if you are installing with precise viewing distances in mind.

Exhibitions don't teach if for no other reason than they don't have time to. Even a seasoned, ardent enthusiast will spend at most two hours in an exhibition, and I would guess thirty minutes is more like the maximum attention span of a typical member of the audience. An essay or a book can earn the undivided attention of the reader for tens of hours, thus, the writer has ample time to unfold the scholarship, the considered argument, the conjecture or the story, in complex invention or in considerable detail. Even an expert does not, cannot, pay such attention to an exhibition. At best, then, one has time to get an exhibition's idea, and, in my opinion, "getting it" is the most paltry effect any cultural practice can achieve, with the sole exception of jokes. Thus, the ideas in an exhibition must be served by other, more valuable effects, as they are in all forms of theater.

Each form of cultural production has its own timbre of close attention amidst its own spectrum of attentions: we study, pay rapt or casual attention to, enjoy, or merely scan books, films, live theater, dance, art, buildings, each in its own way. The duration of each performance, part and parcel of its material field, is fundamental to that specificity. After some reflection, I have come to believe that among all forms of cultural production, the museum exhibition is the most fleeting, the most ephemeral. We usually visit them once, our stay is brief, our attention light

and distracted by the dance of the other visitors and the lure of the other things. And though they may travel for a while, once they close, they never, ever return. And, if that were not enough, we cloak them in openings, our euphemism for the cocktail of diversions we offer up to relieve those most important to us from having to suffer the show. Though concerts and theater often have their opening galas, at least there comes a point in them when the audience finally is expected to sit down, shut up, and listen.

It seems to me that quite a few of today's curatorial customs—the heavy abuse of didactics—(as with all powerful tools, in the right hands wall texts and labels can produce wondrous effects; the damage they often do, therefore is not an intrinsic property)—the increasing emphasis on the catalog, the urge to comprehensiveness, the assumption that the exhibition must make a point—can be understood as efforts to counteract what is tacitly acknowledged as an essential defect of the exhibition: its transience. Not hard to understand, either. As a curator, you work for years; you develop a concept; you comb through and scrutinize innumerable candidates for the checklist; you select sometimes a hundred or more of these; you beg people to lend the works to you (and I mean you beg); you read your butt off so that you know everything there is to know about them; and if the architects or artists you are working with are alive, god help you cope with them; you arrange and arrange and rearrange the works in your head and in model till your eyes bleed, all to get the concept and the experience to mesh in a stubborn set of spaces. And then you pray someone comes to see your show. When they do, if they do, they gossip and pontificate and opine as they breeze through it without the slightest interest in or even awareness of the sacrifice, the heroism, yes, dammit, the genius of your efforts. You begin to despise every single one of the moronic... Uh, sorry, I digress.

I believe that the irreducible, irreproducible effects, the pleasures, the powers, and the possibilities of an exhibition actually obtain from its evanescence. I take a cue from Hamlet. Had the prince wanted to catch the king, to prove his guilt and prosecute him, evidence would have been the thing. But Hamlet wanted something else; he wanted to catch the conscience of the king, and for that he needed theater, a play. I wanted something that requires even a lighter touch than live theater, because I wanted to put king and company and things all on stage as characters in an unscripted play, without them even knowing it; and to score it with the silent soundtrack that only an exhibition produces. The exhibition is the only kind of theater in which actor, audience, prop, set, lighting, orchestra, even the stage itself are on stage all at the same time, and none quite knows which role it plays when.

Frankly, as an architecture and design curator, that's really what I thought my responsibility was, because the only other places you find a situation like that are not in theaters, but in bars and schools and libraries and courthouses, you know—life as staged by architecture.

So, what has any of this got to do with the French discourse on representation? When I first began work as a curator, I found incongruously funny the solemn mantra about the museum's responsibility to respect and protect the integrity of the "art object itself," though I heard it from every art curator, without exception or fail. Of course, I understood the historical and professional issues and shared the sentiment (who wouldn't?), but there was such always a pious cast to those recitals. More to the point, though, is the evident embarrassment hobbling the architecture curator: it's impossible to put buildings inside museums. So we wretched castrati, never able to put our thing itself on display, are forever condemned to representations (models, drawings, and photographs) and simulacra (pretend "buildings" built in the museum) in one form or another.

In the end—it is a definite yawner, I know, but—you can imagine the attraction in that circumstance of compelling theoretical arguments that there is no thing itself. As we all now know, the quotidian achievement of poststructuralism was conclusively to demonstrate that no terminal signified could exist and further to expose the operation of hidden agendas—political, psychoanalytic, metaphysical, et al.—behind structuralism, phenomenology, dialectical materialism, and all the other discourses that engender such a signified. Because of this achievement, as far as I am concerned, no one with intellectual integrity can any longer place the word representation *in italics, quotation marks, or any other device to suggest that it can be recognized, isolated, understood, and domesticated, particularly in the defense of an offended represented.*

If Derrida's thought of the supplement *gently annihilates the origin and thus the original in its metaphysical guise, he is careful to reconstruct a new economy of the origin and of originality. To say that the copy produces the original as the original is not to say that there is no original, nor is it to reverse the role or status of copy and original. Rather, the subtlety of the argument is that both the original and the copy continue to exist in the operational sense of each term, but as collaborating constructions; both are always open to reconstruction.*

Though he refuses Derrida's valorization of semiotics in favor of a much broader and more textured meditation on representation, Deleuze, too, seems concerned to recover the possibility of a new originality in light of the demise of a single

101

guarantor. As I read it, since knowledge does not transcend material practice into ideality, he imagines a thousand knowledges, each irreducible and irreproducible, yet all in raucous communication with one another according to the promiscuous dancing of his "abstract machine." Just listen to the passage from D.H. Lawrence on Cézanne that Deleuze uses to launch his own assault on the cliché via the paintings of Bacon: "After fighting tooth-and-nail for forty years, he [Cézanne] did succeed in knowing an apple, fully; and, not quite as fully, a jug or two...."

For a painter to know an apple fully suggests that, though the painted apple is a representation, it is also an original, the painting-apple, of which the apple I eat is but an inadequate representation. And presumably there will be a novel-apple and a poem-apple and a chemistry-apple and a gastronomy-apple, and a thousand more, each not only a representation, but a re-origination—as long as in its practices it somehow manages to crack the crust of clichés.

I'll leave aside further elaboration of how the writings of these two authors— or at least my understanding of them–shaped my view of curatorial practices for another time. Suffice it to say that it would take us from labels to museum architecture to the role of the exhibition in the ecology of culture, touching on everything in between. I don't blame my work on them, I just like to feel that they are in it.

From a practical point of view, I found the problem of exhibiting design much thornier than architecture, because design has already been, well, designed for display, both in retail and publication. Compounding the problem, design's packaging, marketing, and distribution rely heavily on (damned good) decontextualization (or can bread dough really talk?). To construct my social theater, I generally felt it important to install against type, similar to casting against type (for example, putting Keanu Reeves in any role that requires knowing the difference between acting and pretending). To display something already intended for display and best known out of context, in order that the exhibition display set into motion some unexpected aspect of the item's character, now that takes some cunning. I'd say design outwits us more than we it. Art has its own problems when a curator tries to cast and stage it in a show, but at least it begins life always already as a decontextualization, and comes more or less free of much marketing fiction, other than fame and the investment grift.

Architecture in an exhibition is weird, not because of the representation problem, but because most everyone feels completely familiar with the topic, its problems, and its ambitions, a very different relation than they have with art. Very few grasp even the notion that architecture aspires to a cultural performance distinct from

102

identity, spectacle, and its obligations to a building type—the house, museum, or school. Want a great photograph of a really blank look? Get your camera ready, and then ask someone how architects use a roof to affect art, the family, democracy, the difference between democracy and freedom, or for that matter, to improve orgasms. Imagine trying to stage theater where no one sees the actors as actors or grasps the fact there is even a performance occurring. How does one exhibit the contest between Rem Koolhaas's Villa d'Alava and José Oubrerie's Miller House? Each seeks to underwrite the dissolution of the nuclear as a positive historical eventuality, but brawl over the architecture of that affirmation (José wins.) It should feel like an R-rated affair containing one or more of the following: graphic violence (V), explicit sexual activity (S), or crude and indecent language (L), not a multiple-listings realty catalog. I could not solve the problem, which is why I did not do the show.

Given this thinking, you will understand why I believe that the very worst exhibition I have ever seen in my life—in any curatorial category—was the "Museums for a New Millennium" show that traveled the world for a few years. A collection of some forty or so proposals for new museums, the show exhibited each according to a standardized installation of model, drawings, photographs, and didactics—certainly facilitating its ability to travel. The net effect of the exhibit, however, was to erase the field of architecture as a cultural practice altogether in the service of a banal understanding of the museum as a building type. This particular group of designs, to one familiar with their architecture, contained a vast, amazing, contentious, brilliantly creative meditation on the relationships among art, building, city, and life. Left wing, right wing, wingding, hippy, dippy, tragedy, comedy—it was all there, and totally crushed into silent banality by the show.

And what of the importance of the architecture of the physical facility in which an exhibition takes place? Terry Riley, when lecturing on museum architecture, is fond of showing the Winged Victory *in the Louvre and making the point that, though he knows little about Hellenistic art and therefore the actual merits of the sculpture, the melodramatic staging of the piece by the architecture produces the inescapable effect of assuring him—and most everyone else—that it is the most important of masterpieces. He goes on to tell of the room full of similar works more studiously displayed not one hundred feet away, works that seem to be less important, though he would have been hard pressed to articulate the differences. Listening to him, it occurred to me that Pei's building achieved its effect by placing the sculpture centered frontally on the landing of a grand staircase, looking down on the approaching viewer, i.e., placed in the Roman manner, so to speak. As a*

Hellenic sculpture, however, the likely optimum view is on the same level and from the oblique, all the more in that the work depicts a goddess on a ship's prow, a scene you would expect to see from the side. (If you really want to see her fabric ripple in the wind, next time you are there, press your back as far into each of the corners of the platform wall as you can.) In other words, to achieve its spectacular hyperbole, the architecture had violently to subvert the artwork (Hurray for the architecture!). Stories such as these are legion, of course, and cut both ways.

In the last installment of the MoMA 2000 experiment in reinstalling its collection, Barnett Newman's Broken Obelisk *was placed on the second floor escalator landing, near the shaft running up the escalator core, much like so many hanging decorations or chandeliers in endless malls and department stores. So inured was I to the sight of any object in that spatial context, I barely noticed it, and did a double take to see it only as I was leaving. As we walked out the door I asked my companion, a seasoned museum professional and modern art specialist, what she thought of the installation of the Newman. "Where was it?" she replied.*

Feeding my habit, I see as many exhibitions as I can in multiple venues and the effect of the building on the exhibition—or with the exhibition—simply cannot be overstated. Greg Lynn spent considerable energy designing the installation of the exquisite, multidisciplinary "Intricacy" exhibition he organized in 2003, tailoring it specifically to relieve the gaping maw of a white box Adele Santos designed for the Philadelphia ICA, the show's originating institution. He even designed custom chandeliers for it, to no avail. If you ever want to experience the architectural equivalent of chloroform, go to that building. When the show traveled to Paul Rudolph's Art and Architecture Building at Yale, one of those notorious galleries plagued by architecture, most of Lynn's reinstallation effort grappled with overcoming the problems of shoehorning the show into a smaller space without violating any loan covenants. Yet, when "Intricacy" opened in New Haven, the difference was jaw-drop amazing—it not only looked better, but the thesis of the show became more palpable.

Yet all of this is past obvious, and not really yet even about architecture, just building. To finish off, then, let me drag out one more clumsy analogy, the museum building as musical instrument. I know I'm mixing my metaphors, the exhibition as theater, the building as instrument, but really, who cares? This is just a letter.

I like to think of the museum building as a musical instrument because the analogy goes some distance for me. Great instruments, the likes of a Stradivarius, Steinway, or Fender, all have very particular voices. They're capable of performing

some music well—especially music written for them—some OK, some only so so, and some not at all. Such instruments are easy enough to play, but enormously difficult to play well, and very few performers are able to do so. Kazoos, on the other hand, are incredibly easy to play and anybody can play anything on them—they are "flexible," in the parlance of the moment. Instruments are fussy and difficult and present enormous problems. Think of a screeching, out-of-tune violin, or Mel Schacher's bass guitar work for Grand Funk Railroad. In the hands of a master, though, the result is utterly transporting—and for many of us, life-defining. On the kazoo, however, there is no such thing as bad playing, good playing, or great playing. No matter what the song, no matter who's performing, it all sounds the same. What many museum directors seem to want today are gift-wrapped kazoos.

Who's afraid of a gift-wrapped kazoo? Me.

While I already mentioned a few attendant effects of a museum building on an exhibition, it goes without saying that what any architect of interest produces is much more than a building with some good effects here and there. It is in that augmentation that the museum has a unique and coherent voice. And I believe the preeminent responsibility of the architecture curator is to become a virtuoso at his or her instrument. It's not about docenting the building, for god's sake, making it the subject or subtext of every show. It's about making it do things it was meant to do and not meant to do, playing it as the architect imagined, but also as the architect never imagined, as Cage did with the prepared piano. The curator should certainly test the limits of the instrument, though there's a difference between knowing when to teeth the strings on an electric guitar and dumbly blowing into the hole of a cello. (I know, it's a lift from Woody Allen.)

Think of Mies and the 1962 National Gallery commission. The architect was faced with the task of conceiving a building that imagined a role for art and a future for a nation still suffering the nightmares of its own abject devastation, a building to be located in Berlin, site of some of the country's deepest scars—and, as if that weren't enough, the Wall had just been erected. It is an easy analysis to read the building as a tragic opera about art, one that starts on the street, climbs to the Parthenon to find nothing but a ghost, descends into the crypt to find art, buried, but waiting for a better future in which to be reborn. Every nut, bolt, beam, cantilever, view, every ounce of the building, contributes to that architectural lament. There is not yet another slip of metaphor here; I am not saying this building is an opera, but that its architecture produces an instrument with a grave operatic voice. It would be easy to do a Rothko or Giacometti or early Ando show in it; more

difficult, though not impossible, to do Jeff Koons or Atelier van Lieshout and still work with the voice of the museum. Mostly, though, from the shows I've seen there, the curators don't engage the building in these terms. It's as if not having enough room, they fill up the pavilion with dividers and temporary walls, not inelegantly, but in relation to the architecture, utterly hamfisted. They blow into it.

No one alive today knows that building better than Rem Koolhaas. It is inside him. He not only used it, abused it, and copied it, he ate it, drank it, snorted it, and shot it up. So when he decided to open his recent "Content" exhibition there, rather that at the NAI (against much Dutch protest), he knew what he was doing. As far as I'm concerned, the installation was near perfect; a perfect mess, to be sure, but perfect. The show, as you can imagine, was another of his insult comedies, and another brilliant one at that. But he used every inch of the architecture of the building with adroit cunning to set off his optimistic counter-thesis. It would be a stunning episode of cultural production if Rem would design the installations of all the exhibitions at the National Gallery for a few years.

And make no mistake about it, the Eisenman Wexner Center has every bit the voice in its totality and its details that the Berlin National Gallery has, albeit one in a different register. It endeavors everywhere to contest the exhibition's right to the attention of the viewer, and to challenge the works on display to an intellectual debate, whether they want to argue or not. And does it present difficulties: It's visually noisy; it has clusters of columns cluttering the floors of the galleries; important display walls slope; it violates the no-return principle (twice); it casts moving grid-shadows on the works as the day passes. Yet these are not merely cranky stunts, they add up to something, to its architectural idea for critics and students, but also to its voice as a curatorial instrument. I didn't have enough practice to become a virtuoso, but I found it exhilarating trying to learn to play it. It could really sing.

So, that is why I could not write your essay,

Love,

Jeff

Handy-Crafts: A Doctrine
Glenn Adamson

I thought to have given these Exercises, *the Title of* The Doctrine of Handy-Crafts; *but when I better considered the true meaning of the Word* Handy-Crafts, *I found the* Doctrine *would not bear it; because* Hand-Craft *signifies* Cunning, *or* Sleight, *or* Craft *of the Hand, which cannot be taught by* Words, *but is only gained by* Practice *and* Exercise; *therefore I shall not undertake, that with the bare reading of these* Exercises, *any shall be able to perform these* Handy-Works, *but I may safely tell you, that these are the* Rules *that every one that will endeavour to perform them must follow; and that by the true observing them, he may, according to his stock of Ingenuity and Diligence, sooner or later, inure his hand to the* Cunning *or* Craft *of working like a* Handy-Craft, *and consequently be able to perform them in time.*

—Joseph Moxon, *Mechanick Exercises*

Thus, in 1677, did one British writer explain to his readers the title of his new manual of artisanry. Those familiar with debates about the role of craft in the arts may be amazed to see familiar leitmotifs so far back in the historical record. Already in the late seventeenth century, evidently, it was possible to conceive of craft as beyond words, or outside of discourse: something learned with the body rather than the mind, and therefore extraneous to the intellectual exchange that has increasingly constituted the content of fine art since the Renaissance. According to this logic, which Moxon takes as a given, "handy-work" operates not according to ideas, but rules— inflexible, perfectible, and unchanging. In the eighteenth century, academic painters such as Joshua Reynolds maintained that while the artist might begin his studies with "the attainment of manual dexterity," the process of his maturation consisted in advancing to a trade in concepts: "The wish of the genuine painter must be more extensive: instead of endeavouring to amuse mankind with the minute neatness of his imitations, he must endeavour to improve them by the grandeur of his ideas." Art, in this view, must be a matter of concept rather than facility. This dichotomy has been more or less maintained in the intervening centuries, and has been, if anything, intensified in the late twentieth century. The revelations of pop and conceptual art, the surprising resilience and flexibility of readymade strategies, and the demands of operating at increasingly large scale have all militated to further marginalize craftsmanship. The curious result is that, while seemingly every other term in art-making is subjected to analysis, the know-how of making itself has

for the most part lingered in the wings, conspicuous in its absence from the stage.

Meanwhile, in the nether margins of the art world, the studio craft movement has taken on much of the job of promoting and preserving traditional hand skills. Members of this community often insist that their relegation to a lowly tier is a matter of prejudice. The truth, however, is that most studio craftspeople have been, and remain, suspicious of and uninformed about contemporary art. The reasons for this are not far to seek. First, the postwar craft movement inherited the legacy of late-nineteenth-century design reform, particularly the arts and crafts movement, which was typified by a moralizing insistence on transparency and honesty, and a populist impulse to improve the texture of life through useful objects. From this limited ideological perspective, avant-garde art, even when it deals with matters of process and material, seems irretrievably distant from "real life," both in its formal autonomy and its social elitism. Ironically, an even bigger stumbling block in the craft establishment's ability to deal maturely with contemporary art is its declared goal of "eroding the line between craft and art" (to paraphrase a million and one publications since 1950). This ambition seems ridiculous from outside of the hothouse craft scene, not least because it is obviously self-contradictory. If the craft-art boundary were somehow magically erased, then the category of craft would be vacated entirely—that is, the erasure would require destruction of the ostensible framework of inquiry. Recently, the American Craft Museum dramatized this problem in a highly public manner by renaming itself the Museum of Arts and Design. This is an apt description, but only in the sense that the institution evidently has no means of defining itself that leaves it unembarrassed. The livid reaction on the part of many craftspeople has given the lie to Elbert Hubbard's wonderful line: "To avoid criticism, do nothing, be nothing." Many people are indeed quite upset by the museum's fervent embrace of nonidentity. But the real problem is not that a few highly placed people in New York aren't sure what they're doing; it's that craft movement partisans in general don't think of "art" as meaning "contemporary art" at all. They tend to think it means something expressive, or nonfunctional, or expensive. But all of these are aspects of art that were long ago subsumed by disciplinary self-critique on the part of contemporary artists themselves. Until the craft scene can get over the question of art status, its marginalization will be assured.

Curators are well versed in the craft/contemporary art divide, because it is so neatly mapped in the museum establishment. Both in terms of departmental division and gallery space allotment, it is hard to think of an American museum that has credibility in both fields and also mixes the two together. The few welcome exceptions—a Robert Arneson ceramic bust at the San Francisco Museum Modern Art, handmade gallery seating at the Boston Museum of Fine Arts— tend to be accompanied either by regionalist justification or implicit

curatorial apology. The apotheosis of the latter trend, surely, is the proliferation of Dale Chihuly's vulgar chandeliers in museums across America and Europe. From the perspective of the crafts, Chihuly's work is a poor banner to fly from the rafters, given that it explicitly undermines the mission of contemporary art to challenge its audience. His kitsch baubles are the vanguard of a raft of equally suspect "glass art" placed in otherwise respectable institutions through an industrial-scale charm offensive. Usually the path of acquisition runs through moneyed trustees and over the metaphorical dead bodies of contemporary art curators.

When the climate is so militantly hostile to an intelligent handling of craft, how is a curator who is interested in craft to navigate the shoals? The answer is disarmingly simple: treat craft as a subject, not a category. Curators cannot assume that the most relevant provocative thinking about craft, or the most relevant satisfying art, will necessarily come from studio craft circles. Indeed, to be fair to the Museum of Arts and Design, this seems to be part of the expressly intended program of that institution. What MAD fails to realize, however, is that craft is not something to be pushed into the background, or seen in relationship to other objects, but rather a topic for conceptualization. They should have kept the name and made the programming live up to it, not the other way around. As it is, the name change poses the implicit question: can craft museums survive? The answer is yes, but only in the same way that regional museums, museums devoted to ethnic identity, or other narrowly defined museums can: by focusing on their mission so intently that they begin to peer right through it. Craft ought to be treated as a target of inexhaustible, skeptical inquiry, just like any other artistic term. Just as minimalism concerned itself with seriality and industrial manufacture, or feminism offered propositions about the socially constructed subject position of the artist, or neo-expression addressed the legacy of history painting, artists could subject craft itself and its constituent parts to rigorous inspection.

It is not hard to imagine such artists, because they are all around us. The well-made thing is exerting a new fascination on our leading contemporary practitioners. In the early 1990s, the only place

Anne Wilson, *Errant Behaviors*, 2004, video still, courtesy of the artist.
Wilson puts intricate lacework configurations through the paces of an animation process, rendering them into weird entities that operate somewhere between the conditions of cartoon characters, drawings, and how-to video diagrams.

Gord Peteran, *Prosthetic*, 2001, courtesy of the artist.
In this curious variation on the *objet trouvé*, a broken-down ladderback chair is "restored" through the agency of a brass structure that holds it rigid and returns it to functionality. The prosthetic device can be removed from the chair without leaving a mark. As in much of Peteran's work, a mundane trope of wood-working is here the pretext for an elaborate and somewhat sinister invention.

for craft in the art world was as an abject and affecting curiosity, as in the work of Mike Kelley, Janine Antoni, or Kiki Smith. Now, as was much remarked in response to the 2004 Whitney Biennial, skilled hands are being employed in a much broader and more positively framed way. Some of this new interest in craftsmanship is practical in nature, or at least is encouraged by a shifting context of display and manufacture. The increasingly public role of contemporary art, in which it is expected to participate in a populist shift in museums and galleries, has motivated artists to see fine workmanship as potential ammunition in the battle for attention and

acclaim. Meanwhile, at the supply end of art's food chain, there is unprecedented university support for artists with traditional hand skills to engage the wider curriculum. Schools like the Rhode Island School of Design, the School of the Art Institute of Chicago, and the California College of the Arts (formerly California College of Arts and Crafts) are cross-training their students, who may have a home in a craft discipline but spend much of their time wandering about in the sculpture department. While this sort of crossover would be a bad premise for an exhibition, it's a very good way for the ceramics, wood, metal, textile, and glass departments to deal with their own inherited retardataire positions.

The result will be a new breed of post-disciplinary artists, who have hard-won craft skills but regard them as somewhat problematic. Signs of this attitude are already emerging in the work of some wide-open-minded artists with extensive training in craft media. Previously, people who worked in craft media but yearned for contemporary art acceptance tended to fight against their association with craft. The best of them drew energy out of their own categorical predicament, as was true of Peter Voulkos and Robert Arneson early in their careers. Others tried to short-circuit the art system by entering it through other means, as Chihuly has done. By contrast, the craft-savvy artists who are worth watching today do not seem to care much about their category. If you call them "craftspeople," as if that were some sort of insult, expect a knowing smile in return, not an argument. They see their skill not as inherently valuable or ideologically correct, but as a neutral tool—a way to invest their work with authority—and also as a topic, which can be submitted to the same introspection as any other term in the artistic equation.

Eventually, historians will doubtless look back on the present moment and wonder at the fact that "craft" seemed so firmly planted on the outskirts, in much the same way that one looks back at photography of the 1950s and wonders why it was so hard to anticipate the importance that medium would have for the art world in the next decades. In the meantime, whether curators work from a decorative art, contemporary art, industrial design, or studio craft perspective, it is incumbent upon the profession to anticipate and encourage new thinking about craft. This can be done in several ways. The first is through reorganization of permanent collections. Because permanent displays are so crucial in enfranchising art-historical trajectories, this is the most important step, but it is also the most difficult, given the dividing lines in most museums and in the historical record itself. The best way to de-ghettoize craft holdings is through thematic gallery installation, in which ideas rather than chronological and geographic categories guide the display of artworks. In general the thematic approach has been in ill favor recently, following a spate of poorly received installations in the Museum of Modern Art, New York, the Tate Galleries in London, and elsewhere during the late 1990s. These efforts were generally disliked. Partly

this was sheer conservatism on the part of critics, but there was also a justifiable consensus that artists ought to count more than curators. When MoMA presented an all-white gallery of all-white works by Robert Ryman, Agnes Martin, and Lucio Fontana, it was from a curatorial perspective a clever self-referential riff on the institution's own history of display. But to the casual museum-goer it just seemed confusing, arch, or irritating.

The irony is that such well-publicized thematic installations were limited to reshufflings of the canon. As self-consciously experimental as MoMA's thematic project was, it is doubtful that anyone involved even considered including craft material. Yet for the right subject, craft might have been a fascinating counterpoint to the usual suspects. Imagine a gallery, for example, that charts the use of gravity as a compositional principle between 1950 and 1970. One might begin with a Jackson Pollock painting, continue with a fiber work by Claire Zeisler and a ceramic sculpture by Stephen DeStaebler, and finish with cut felt sculptures by Robert Morris and Barry Le Va. This gallery would look good, and it would also make for a smart story. It would concisely present the much-studied artistic tension between authorial control and randomness. The craft objects would assist the fine art works in fleshing out this dialectic, in that they translate the notion of control into a slightly different but obviously related key. Zeisler's fiber hangings exhibit sensitivity to the particular properties of a raw material, and a corresponding fineness in the means of controlling that material. These concerns are simply absent in a contemporary postminimalist sculpture like Morris's, in which a rectangle of purposefully neutral felt is sliced into strips and hung from the wall like a diagram. Zeisler braids and drapes, while Morris cuts and drops; and this difference makes her work seem messy and poetic, while his is manifestly abstract and demonstrative. In years past this distinction has meant that Zeisler's work is not only shown in a different gallery as Morris's, but in another museum entirely. Today, though, if curators are truly looking for ways to broaden the understanding of postwar art, craft works like Zeisler's might be seen not as a problem, but as an opportunity to present key ideas in their finer shadings.

A somewhat less challenging course is to pair craft with modern design or with historical decorative arts. Craft is a kissing cousin to design, and the liveliness of contemporary craft objects is a help to dusty old artifacts, which tend to come off as remote and elitist to most museum visitors. Yet this must be done carefully. It's all too obvious that the turned wood bowls of Bob Stocksdale, the neo-constructivist jewelry of Margaret DePatta, or the Bauhausian weavings of Anni Albers fit right into almost any array of midcentury industrial objects. What could be lost in such insertions, though, is the subtlety of the craft objects. Alongside Herman Miller and Knoll, the likes of Stocksdale, DePatta, and Albers might seem to be in good company. In some ways, though, it is patronizing and misleading to tuck

Claire Zeisler, *High Rise*, 1986, courtesy of the artist and the Milwaukee Art Museum.
This monumental late example of Zeisler's ceiling-hung fiber artworks exemplifies the way in which she—
like better known process artists such as Robert Morris, Richard Serra, or Eva Hesse—visually dramatized
gravity's pull. The composition revolves around a tension between controlled braids and spilled individual
threads. There is no expressive gesture, but the material is nonetheless made to express its own properties.

their works into the canon of high design. Craft's distinctiveness is
often ideological, regional, or theoretical in nature—and all of these
background stories are lost when objects are put together because
they have a shared "look." Equally facile, potentially, is the place-
ment of contemporary craft objects next to antiques for purposes
of an enlivening contrast. Is the appeal of a staid historical artifact
actually unveiled through such a juxtaposition? Or does the artifact
just seem all the more staid? Here as elsewhere, a targeted curatorial
message is crucial. Just as craft should be shown against or in relation
to design, not just alongside it, contemporary craft objects should be
shown with historical precedents only to make a point. The subject
need not be recondite; indeed, a simple explication of the "how-to"
craft process itself is among the most satisfying ways to mix old and
new material. Video or photography of a living, breathing craftsper-

Robert Morris, *Untitled (Tangle)*, 1967, 1 in. thick felt, installation dimensions variable, The Museum of Modern Art, Gift of Philip Johnson.

Unlike Zeisler, there is little skilled work in Robert Morris's hung felt works. The industrial felt could not be in starker contrast to Zeisler's dyed, wrapped, and braided sisal yarn. Yet the works exhibit a similar dichotomy between a fixed upper part (braids in one case, a point of attachment to the wall in the other) and the gradually chaotic descent to the floor.

son who has mastered antique skills can be of inestimable value in bringing antiques themselves to life. Craftspeople who quote historical forms and techniques in their work also constitute an obvious opportunity, in that their work suggests that decorative arts have their own systems of internal reference.

It is probably asking too much of most curators to expect that they will look for such convergences. Permanent collections, by their nature, tend to reinforce previously established categories. And it would be foolhardy to argue that most craft works will speak to other parts of the average museum collection effectively. There has been too much boutique thinking in the craft field for that. Disparities in status and even marketplace value between fine art, craft, and historical decorative arts—even if those disparities are well deserved— are a hindrance, too, in that they strongly discourage cross-disciplinary

comparisons. For all these reasons, future developments in the curatorial handling of craft are much more likely to happen in focused temporary exhibitions than in permanent collections. New material of every stripe is to some extent free from established disciplinary boundaries; and when working within a contemporary art paradigm, curators are free to include whatever work they deem relevant. It should be possible to frame the specific subsidiary concerns of craftsmanship—materiality, labor, skill, and various traditional forms (pot, chair, tapestry), processes (turning, chasing, carving), functions (adornment, containment, comfort)—in ways that are relevant outside of the craft field proper. Again, what will make such exhibitions successful in restacking the deck will be their degree of self-awareness. Far too often, craft curators create shows that are "about" such ideas, but which include only examples, not exegesis. Goodness knows the world does not need another show of things-that-adorn, things-that-are-turned, or things-shaped-like-a-pot. But the world doesn't need another show of paintings either, really, and yet that medium has been revitalized time after time through ever escalating meditations on its own condition. Craft now needs to be handled with the same uncompromising self-regard, on the part of artists and curators alike.

Whatever direction museum work with craft might take in the future, the crucial thing is that discourse be prioritized over disciplines. Curators need to stop conceiving of craft as a field, a movement, or a community, and instead think of it as a matrix. We might return to Moxon and reflect on his decision to call his book *Mechanick Exercises*, rather than *A Doctrine of Handy-Crafts*. Today, more than three centuries later, perhaps we are finally ready to see that the rules of craft are not a straitjacket to be fought against or transcended. Those rules are the content of craft, and they are there to be embraced. For it is in them that one can discern the lineaments of craft's future, as well as its past.

The author would like to thank Stefano Basilico for his many contributions to this essay.

Temple / White Cube / Laboratory

Iwona Blazwick

In the ad hoc library that is scattered between my home, my office, and the plastic carrier bag that always seems to accompany me on the journey between the two, there is a whole new section, which seems to grow by the week. Variously called museum studies, curatorial studies, the cultures of display, institutional critique, exhibition history, or just plain navel-gazing, this burgeoning field is taking on a critical mass, for as American artist Mary Kelly has commented: "In terms of analysis, the exhibition system marks a crucial intersection of discourses, practices, and sites which define the institutions of art within a definitive social formation. Moreover, it is exactly here, within this inter-textual, inter-discursive network that the work of art is produced as text."[1]

Kelly's analysis acts as a benchmark within this discourse. This proliferation of studies has, over the last thirty years, thoroughly dissected the notion of the exhibition space. These analyses and debates, precipitated by artists and rehearsed by curators, theorists, and historians, represent an art history that does not focus on art movements, their objects, or creators, but rather on their modes of presentation. They have interrogated the conventions of exhibition-making; and the transition of the gallery environment from academy to salon, from white cube to site, from space to situation.

From Brian O'Doherty's pivotal *Inside the White Cube* to Mary Anne Staniszewski's *The Power of Display* numerous critical interpretations of systems of display and gallery environments have generated a radical shift.[2] The exhibition space, be it museum or laboratory, can no longer be understood as neutral, natural, or universal but rather as thoroughly prescribed by the psychodynamics of politics, economics, geography, and subjectivity.

The invitation to contribute to this publication coincided with the end of a year of celebrations marking the one-hundredth anniversary of the institution for which I currently work. Inspired by Staniszewski's case study of the Museum of Modern Art, it seemed to me that the Whitechapel Gallery's history and location could yield some fascinating insights into the way exhibitions and their spaces offer an index of the conditions of spectatorship and how they have evolved over a century.

The Whitechapel Art Gallery was founded not by a great patron, or a government, or a community, but by a priest. Its location is not the city center or the grand avenue but the East End, London's

1. Mary Kelly, "Re-Viewing Modernist Criticism," *Screen* 22, no. 3 (1981): 41–62.

2. Brian O'Doherty, "Inside the White Cube: Notes on the Gallery Space, Part I," *Artforum* 14, no. 7 (March 1976): 24–30; O'Doherty, "Inside the White Cube, Part II: The Eye and the Spectator," *Artforum* 14, no. 8 (April 1976) 26–33; or see the book version, *Inside the White Cube: The Ideology of the Gallery Space* (San Francisco: Lapis Press, 1986); and Mary Anne Staniszewski, *The Power of Display: A History of Exhibition Installation at the Museum of Modern Art in New York* (Cambridge, Mass.: MIT Press, 1998).

poorest quarter, "synonymous with poverty and sweated labor, with Cockney solidarity and popular protest ... great social campaigners ... and out-and-out criminals."[3] Add to this, one of the most cosmopolitan populations in Europe—albeit within a hell's kitchen of social deprivation and religious, ethnic, and racial tension.

3. Alan Palmer, *The East End: Four Centuries of London Life* (London: John Murray Publishers, 1989), frontispiece.

From the outset the vision behind the purpose-built architecture of the Whitechapel Art Gallery was evangelical. The Reverend Samuel Barnett and his wife, Henrietta, sought to bring great art to the people of East London, then, as now, one of the most economically deprived areas in Western Europe. And as the historian Seth Koven has noted, their mission was "to use the display of art objects and the creation of a working-class public to promote social reclamation and urban renewal."[4]

4. Seth Koven, "The Whitechapel Picture Exhibitions and the Politics of Seeing," in *Museum Culture: Histories, Discourses, Spectacles*, ed. Daniel J. Sherman and Irit Rogoff (Minneapolis: University of Minnesota Press, 1994), 22–23.

The gallery evolved from exhibitions the Barnetts had been organizing in the parish school, marked by this piece of doggerel published in *Punch* magazine:

Oh! East is East, and West is West
as Rudyard Kipling says.
When the poor East enjoys the Art
for which the rich West pays,
See East and West linked in their best!
With the Art-wants of Whitechapel
Good Canon Barnett is just the man
who best knows how to grapple.
So charge this canon, load to muzzle,
all ye great Jubilee guns.
Pictures as good as sermons? Aye,
much better than some poor ones.
Where Whitechapel's darkness the weary eyes
of the dreary workers dims,
It may be found that Watts' pictures
do better than Watts' hymns.[5]

5. *Punch*, April 24, 1897, quoted in Koven, "Whitechapel Picture Exhibitions," 22.

The gallery that opened in 1901 and its exhibitions were conceived in instrumentalist terms, to provide moral guidance and redemption for a largely illiterate public. Furthermore this public space with no admission charges, founded in the wake of the public libraries movement, was seen as a critical tool in neutralizing class conflict and delivering social cohesion. To quote Koven again, "At a time when the British elite witnessed violent confrontations between labor and capital, the Barnetts argued that culture, shared by all but defined according to each person's own lights, would help rich and poor to transcend class divisions and together forge a nation."[6]

6. Koven, "Whitechapel Picture Exhibitions," 23.

Influenced by the art critic John Ruskin, they conceived of pictures as providing a gateway to God, to the realm of the spiritual.

The building, designed by Charles Townsend Harrison, was described by architectural historian Nicholas Pevsner as epoch

Spring exhibition, "Modern Pictures by Living Artists, PreRaphaelites, and Older English Masters," Whitechapel Art Gallery, London, 1901, installation view.

making. It encapsulated all the spirit and ideology of the arts and crafts movement, bringing together references to Norse mythology and incorporations of nature, with its trees of life, references to the neo-Romanesque in its glass-paneled half-moon window and arched doorway and its dream, never realized, of a commissioned mosaic dedicated to culture and the working classes. The top-lit interior and high ceilings offered a templelike space. Within this almost religious interior, pictures were presented to link art with a morality tale of everyday life.

The spring exhibition of 1901 included paintings by Rubens, Hogarth, and Constable, great masterpieces of British art traditionally shown in the select environs of the Royal Academy or the National Gallery. These works were presented alongside pictures by the Pre-Raphaelites, whose iconic hyperrealism and moral narrative reflected the cultural philosophies of the Barnetts. These Victorian philanthropists aimed to address an almost entirely uninitiated public of working-class people and non-English-speaking immigrants. The show was a blockbuster, and attracted 206,000 visitors. Some say the crowds came to look at the electric lights, never before seen by the denizens of the East End. Nonetheless, the exhibition created a public: predominantly poor, mostly uneducated, yet curious, articulate, and hungry for the Whitechapel picture shows.

The style of installation drew directly on the traditions of the Louvre, the Paris Salons, and the Royal Academy. Presented on dark red walls, the paintings were hung from picture rails, stacked from floor to ceiling.

American critic Brian O'Doherty describes this exhibition system as follows: "Each picture was seen as a self-contained entity, totally isolated from its slum-close neighbor by a heavy frame around

and a complete perspective system within. Space was discontinuous and categorizable, just as the houses in which these pictures hung had different rooms for different functions. The nineteenth-century mind was taxonomic, and the nineteenth-century eye recognized hierarchies of genre and the authority of the frame."[7]

Here exhibition space mimicked the domestic space of the grand country house, where the accumulation of paintings over the centuries was reflected in their accretion one on top of the other. The viewer encounters the work of art, not as a real object but as an illusion, a window onto another world.

When transposed into the poverty-stricken environs of the East End, this method of display and the idealized scenes depicted in the inner world of each painting deflected attention away from everyday reality. Art became a means of transcendence and even escape, presenting working-class East Londoners with a passive, private, and nonconflictual solution to their economic misery.

As Seth Koven comments, "The catalogue descriptions and the exhibitions as a whole strove to create the illusion that workers were actively promoting their self-betterment by viewing art while in fact they were being diverted from directly challenging the basis of power in society."[8]

The Whitechapel Art Gallery picture shows of the prewar period embraced a belief in the democratizing and civilizing power of contact with culture: the possibility of redemption for "the drunken classes," offered by morality tales, communicated not by words but through the "universal" transparency of the image. This agenda also combined a dedication to the global, which, despite its colonial basis, in a way prefigures today's postcolonial emphasis on challenging Western notions of internationalism. The 1902 "Japanese Exhibition" offered a vast display of art and life in Japan and included porcelain, ivory carvings, bronzes, lacquer, metalwork, furniture, books, musical instruments, armor, and 109 color prints by ukiyo-e artists. It reconstructed a Japanese room, a model of a teahouse, and a temple.

This kind of exhibition-making refers directly to the great world fairs of the nineteenth century. The first was held in 1851 in London at the Crystal Palace. When Karl Marx saw it, he called it "a big exam in which all nations had been summoned, the huge world congress of products and producers." The world fairs, which sprang up across Western Europe, provided expositions of the industrialized capitalized West—they emphasized new industrial production and newly conquered territories. They also mirrored the rise of ethnography and ethnographic museums by incorporating exotic cultures. In the Paris fair of 1900 entire African villages were recreated and peopled—some of the exhibits inconveniently died as they succumbed to low temperatures and Western diseases.

In her brilliant essay "Ethnography and National and Cultural Identities," Annie Coombes has paid special attention to the year of the "Japanese Exhibition." "The year 1902...marked the renewal

7. Brian O'Doherty, "Inside the White Cube," Artforum (March 1976): 25; or O'Doherty, Inside the White Cube, 16.

8. Koven, "Whitechapel Picture Exhibitions," 39–40.

121

of concerted strategies by both contending parliamentary parties to promote the concept of a homogeneous national identity and unity within Britain. Imperialism was one of the dominant ideologies mobilized to this end. The empire was to provide the panacea for all ills, the answer to unemployment with better living conditions for the working classes and an expanded overseas market for surplus goods. Through the policy of what was euphemistically referred to as 'social imperialism,' all classes could be comfortably incorporated into a programme of expansionist economic policy in the colonies coupled with the promise of social reforms at home."[9]

A benevolent paternalism making use of empire as a potential "living geography lesson" was transformed into a more specific call for the recognition of the superiority of the European races.[10] The Conference of the Empire League Educational Committee of 1902 noted that "the process of colonisation and commerce makes it every year increasingly evident that European races and especially those of our own islands, are destined to assume a position in part one of authority in part one of light and leading in all regions of the world."[11]

This early example of multicultural display reinforced notions of non-Western cultures as static, outside the trajectories of the Enlightenment. At the same time, within the grim context of early-twentieth-century East London, it also provided a thrillingly exotic form of escapism. And although this integration of tools, icons, objects of worship, and objets d'art reflected an anthropological understanding of non-Western cultures, it can also be understood as, well, rather postmodern, in that artistic production could be understood within a broader cultural context.

In fact this kind of exhibition-making had a tremendous impact on artists in the West. As we know from postimpressionism and cubism, the avant-gardes saw in these displays new formal strategies and modes of representation which offered a rupture with their own art historical and bourgeois conventions. In this way they occupy a key position not only in the discourses of colonialism but also in the story of modernism.

The streets around the Whitechapel lie just outside the ancient boundaries of the medieval city and in proximity to the Thames docklands, making them a destination for successive waves of immigrant communities fleeing religious persecution or seeking economic opportunities. These have ranged from French Protestants, known as Huguenots in the seventeenth century, to Jewish communities of Eastern Europe escaping the anti-Semitic pogroms of the late nineteenth and early twentieth centuries, to Bengali seamen, who sailed for the East India Company and settled in the East End. The gallery program attempted to present the cultural legacies of such diasporas with exhibitions such as "Jewish Art and Antiquities," presented in 1906 (one year after the Anti-Aliens Bill of 1905). Like the Japanese show, works of fine art were presented alongside religious artifacts and domestic objects. The catalog describes the show as bringing together

9. Annie Coombes, "Ethnography and National and Cultural Identities," *The Myth of Primitivism, Perspectives on Art*, ed. Susan Hiller (London: Routledge, 1991), 190.

10. Ibid., 204.

11. *Museums Journal* 8 (July 1908): 12, quoted in Coombes, "Ethnography and National and Cultural Identities," 204.

"rare, costly and beautiful Appurtenances from the Synagogues in London ... [and] exhibits associated with domestic devotion ... rare Manuscripts ... a selection of Portraits and prints of the history of the Jews in England ... examples of works mainly by English artists." This was clearly a didactic project mounted to demonstrate "the civilized nature" of the Jew. As cultural theorist Juliet Steyn has pointed out, "The distinctions between (religious) ritual and ceremonial manifestations and values percolated into the secular domain—the home. The version of Jewishness and Jewish identity offered by the exhibition ... or adduced by the catalog was predicated upon particular notions of high culture, ideas of identity, views of assimilation, middle class moral values, judgments on class and a need to combat anti-Semitism." Jewish culture was represented within the terms of British nationalism in this conflicted collision of "multiculturalism" with social engineering. Of course, the agendas of assimilation versus difference become transparent with hindsight. Yet as Steyn also points out, this strategy was accepted by a people whose very survival depended on acceptance within a host community. She continues, "The Jews of Whitechapel, with all their diverse cultural identities, were invited to become spectators of a culture already complete, presented and represented to them and for them by their trustees. They were given their place in the national culture. They accepted the invitation."[12] The questions raised nearly a century ago by these kinds of initiatives continue to have a relevance today as practitioners and institutions wrestle with the issue of whether and how to represent cultural identity.

12. Juliet Steyn, *The Jew: Assumptions of Identity* (London: Cassell, 1999), 84, 95.

Another moment in the fusion of political agendas with avant-garde aesthetics is marked by a project that took place at the Whitechapel in 1939. The East London Aid Spain committee of the Stepney Trade Union hired the gallery for a fee of twenty-five

Picasso, *Guernica*, 1937, installation view at Whitechapel Art Gallery, 1939. Clement Attlee, MP for Limehouse and leader of the Labor Party, made the opening speech for a private event organized by the East London Aid Spain committee of the Stepney Trades Council.

123

pounds (plus one pound for use of telephone) to stage a remarkable event. Opened by the leader of the Labor Party, Clement Attlee, it presented the work of a young Spanish artist who wanted to raise consciousness and funds around the Spanish Civil War. The artist was Picasso—and he showed just one work—*Guernica.*

Attlee gave a rousing political address in front of the painting, to local people. Huge numbers went to fight the fascists in Spain; many died in the effort. A modernist masterpiece on its way from Paris to New York became, in the space of the Whitechapel Art Gallery and the context of the East End, a potent form of propaganda. The fact that the Stepney Council members, and Picasso himself, were all members of the Communist Party was to have very particular consequences for the Whitechapel in the postwar years.

In her pivotal study *The Power of Display: A History of Exhibition Installation at the Museum of Modern Art in New York,* Mary Anne Staniszewski traces an exhibition chronology within a broader sociopolitical context that takes a particular shift in the 1950s: "An image of the human race that flourished after World War II when institutions such as the United Nations and UNESCO promoted a vision of a like-minded and related global humanity."[13] In its founding years, MoMA's exhibition displays had been profoundly influenced by European avant-garde artists and architects such as Mies van der Rohe, Lilly Reich, Herbert Beyer, and Frederick Kiesler. They represented a modernist ethos where form was informed by function and design was seen as equal to art. These early European avant-gardes also projected utopian ideologies that were to disintegrate in the dystopian realities of two world wars and the transition of revolution into totalitarianism. As the global economic and cultural power base shifted from Europe to America, exhibitions in the postwar period started to celebrate a modernity of the present.

This period also marks the impact of the cold war on British culture. British art historian Margaret Garlake has studied the programs and policies of a number of key institutions in the 1950s to track transatlantic political alliances conceived and implemented by the Central Intelligence Agency for Britain.[14] A new kind of curatorial authorship emerged at the Whitechapel at this time, under the leadership of Bryan Robertson, who rejected the gallery's paternalistic agendas of offering improvement and social cohesion through art. He wanted to embrace both the pessimistic existentialism of a postwar generation of painters such as the abstract expressionists and the exuberant tongue-in-cheek optimism of pop art. He wanted to confront local populations with the modernist project in all its manifestations.

Robertson premiered the work of artists such as Jackson Pollock, Mark Rothko, and Robert Rauschenberg in exhibitions toured by MoMA's international program and reputedly underwritten by the American government through the Central Intelligence Agency. The Whitechapel became a synthesis of the white cube and a platform for

13. Staniszewski, *Power of Display,* 124.

14. Margaret Garlake, *New Art New World: British Art in Postwar Society* (New Haven, Conn.: Yale University Press, 1998).

"Jackson Pollock," Whitechapel Art Gallery, 1958, installation view.

the ethos of Abstract Expressionism and its co-option into cold war ideologies with their emphasis on freedom and the individual. At the same time, the space of the gallery transformed to accommodate the transition of the object of art away from being a window onto another world, away from being an illusion, to becoming a real thing, an object to be experienced in time and space. In 1947 Jackson Pollock wrote, "My painting does not come from the easel.... I prefer to tack the unstretched canvas to the hard wall or the floor. I need the resistance of a hard surface. On the floor I am more at ease. I feel nearer, more a part of the painting, since this way I can walk around it, work from the four sides and literally be in the painting. This is akin to the method of the Indian sand painters of the West."[15]

The Pollock show of 1958 organized by the International Council of the Museum of Modern Art was the artist's first major solo show in Europe. Twenty-nine paintings included the famous *Blue Poles*, 1952. The architect Trevor Dannatt was commissioned to redesign the Whitechapel's galleries—ceilings were lowered, reflecting Mies van der Rohe's emphasis on the horizontal. The influence of Mies can also be seen in the freestanding temporary walls made of breeze block—cheap, simple to build, and contemporary—a perfect modern material. The screens enabled each work in the exhibition to be seen on its own. The gallery became saturated in and activated by surfaces of floating color. The paintings themselves, no longer stacked or suspended from the top of the wall, were installed to emphasize a one-to-one, anthropomorphic relation with the body of the spectator. Viewers were plunged into the physicality of the painting itself, not a projection through perspective and illusion, but an environment in its own right, an expanded field of vision.

In 1955, Mary Quant opened her first boutique, the Conran design group was formed, and the first commercial television channel

15. Jackson Pollock, "My Painting," *Possibilities* (New York) 1 (Winter 1947–48): 79.

"This is Tomorrow," 1956, exterior views of structure by Group Two (R Hamilton, J. McHale, J. Voekcker), Whitechapel Art Gallery

was launched in Britain. There were fears of brainwashing by the advertisers. As the scholar Barry Curtis has commented in his account of the proto-pop Independent Group, "They were interested in the new identities created for the reception of new pleasures and in an aesthetic use and assimilation which was generally complicit with, and expert in, the terms of mass culture"; they were interested "in objects and components which were anonymous, additive, and expendable."[16]

By contrast with the intense, gestural ethos of abstract expressionism and its emphasis on the heroic individual, "This Is Tomorrow," presented at the Whitechapel Art Gallery in 1956, encapsulated a vision of the modern in the mass-produced present of the everyday, created through group activity. The project was "devoted to the possibilities of collaboration between architect, painters, and sculptors."[17] There were twelve groups of practitioners working not so much in collaboration as "antagonistic co-operation." Theo Crosby, the technical editor of *Architectural Design* magazine, was the driving force, bringing together groups that included artists such as Richard Hamilton, Nigel Henderson, Eduardo Paolozzi, Victor Pasmore, and Kenneth and Mary Martin. The architects included Erno Goldfinger, Alison and Peter Smithson, James Stirling, and Colin St. John Wilson. The aesthetic of each of the twelve groups could be roughly defined as neo-constructivist or proto-pop art. The exhibition opened with a full-size model of Robbie the Robot borrowed by Richard Hamilton from the set of the film *Forbidden Planet*. The list of components of one installation created by Group Two—Richard Hamilton, John McHale, and John Voelcker—demonstrate a cultural and phenomenological environment that incorporates the spectator into what would later be termed an installation:

16. Barry Curtis, "From Ivory Tower to Control Tower,' in *The Independent Group: Postwar Britain and the Aesthetics of Plenty* (Cambridge, Mass.: MIT Press, 1990), 23, 26.

17. Graham Whitham, "Exhibitions: This is Tomorrow," in *The Independent Group: Postwar Britain and the Aesthetics of Plenty*, ed. David Robbins (Cambridge, Mass.: MIT Press, 1990), 135.

combined optical illusions inspired by the Bauhaus and Duchamp
images from cinema and science fiction
a jukebox
a sixteen-foot-high image of Robbie the Robot
Marilyn Monroe, her skirt flying
a giant bottle of Guinness
a spongy floor that when stepped on emitted strawberry air freshener
a total collage effect of the Cinemascope panel
a reproduction of Van Gogh's Sunflowers, *which in their appearance on post-cards and calendars were becoming as pop or kitsch as the images of Monroe or Robbie.*[18]

18. Adapted from ibid., 139.

The show was seen by a thousand people a day. It bore witness to the impact of technology, mass media, commerce, and consumerism and voiced a commitment to a dense, ubiquitous culture which challenged the good taste of official British art at that time. "This Is Tomorrow" encapsulates an approach to contemporary culture which hovered, in Richard Hamilton's words, "between cynicism and reverence."

Inspired by new fields of perception and opticality opened up by science, and new structures opened up by developments in material and building technologies, the installations presented in "This Is Tomorrow" marked a revolution in the gallery environment. As Staniszewski comments, "The installation methods instituted during these years, both in the department store and the museum, disavowed the architecture of the site and instead emphasized the displays as creating an environment that promoted interaction between the objects and the viewers."[19]

19. Staniszewski, *Power of Display*, 176.

Gone were the plush wall colors, picture rails, and academy hangs, the windows onto other worlds. Viewers were immersed in the here and now of constructed environments presented against the tabula rasa of "the white cube," as defined by Brian O'Doherty:

A gallery is constructed along laws as rigorous as those for building a medieval church. The outside world must not come in, so windows are usually sealed off. Walls are painted white. The ceiling becomes the source of light. The wooden floor is polished so that you click along clinically or carpeted so

"Richard Long," Whitechapel Art Gallery, 1971, installation view.

127

that you pad soundlessly, resting the feet while the eyes have at the wall. The art is free, as the saying used to go, "to take on its own life."... Unshadowed, white, clean, artificial—the space is devoted to the technology of aesthetics. Works of art are mounted, hung, scattered for study. Their ungrubby surfaces are untouched by time and its vicissitudes. Art exists in a kind of eternity of display.[20]

20. O'Doherty, "Inside the White Cube," *Artforum* (March 1976): 25; or O'Doherty, *Inside the White Cube*, 15.

In the late 1960s, Whitechapel's exhibitions of minimalist art presaged another factor in the conditions of spectatorship. The "Donald Judd" exhibition in 1969 exemplified the jettisoning of the plinth and the use of the floor not only as a support for the work, but as a new field of making and experience. Along with artists such as Carl Andre and Sol LeWitt, Judd understood the floor as a horizontal grid, which offered an organizing structure and principle of potentially infinite growth and democratic intention. The spectator could now occupy the very same space as the work of art, his or her relation shifting from a vertical, retinal experience to a phenomenological one.

In installations by artists Richard Long or Hélio Oiticica, however, the space of the gallery retains a sense of autonomy and placelessness elevated to a rural oasis in the city. In 1971 Richard Long transposed into the gallery marks inspired by walking through natural environments far from the gritty urban environment of Whitechapel. Again, the floor is the stage, the blank canvas activated both by the work and by the spectator. These stunningly bold works recall ritual marks created by lost civilizations. They also reflect the influence of contemporary Robert Smithson and his idea of the spiral as the symbol of entropy, of a dissolution of form. Despite being monumental in scale the installation was also totally ephemeral, swept up and disposed of after the show, completing a life cycle like nature itself.

Writing about the significance of artistic strategies in the 1960s, the French critic Jean-Christophe Royoux commented, "art was conceived as a critical model able to explore various forms of the individual social, psychic, or linguistic integration to a reality informed and deformed by the all-pervasive power of mass culture. The aim of art, broadly aligned with the other manifestations of sixties counterculture was therefore clear: to expose the spectator, within the frame of a precisely defined spatial environment to a theatricalized experience offering the means of access to alternative modes of self-fashioning."[21] The Brazilian artist Hélio Oiticica took the white cube and transformed the gallery into a kind of village or "mind-settlement" as he called it. The writer Guy Brett, a friend and contemporary of Oiticica, described it as follows:

21. Jean-Christophe Royoux, in *Omnibus* (Paris), special edition on Documenta X, October 1997, quoted by Guy Brett, "Helio Oiticica's Whitechapel Experiment," *The Whitechapel Art Gallery Centenary Review* (London: Whitechapel Art Gallery, 2001), 77.

You took off your shoes before stepping into the sand of Eden, as the central environment was called;... Oiticica's Eden was an invitation to play and reverie, whose ends were open and unconditioned. There were bolides to be explored by hand, and sometimes by smell, cabins for solitary reverie and other more communal spaces. There were Parangolé *capes to be worn and danced*

in and there were Nest Cells, a cluster of boxes each about two metres by one, divided by veils, which the visitor was invited to make habitable with found materials of their own choosing and in their own way. Instead of the confrontational, irreducible objecthood of the Minimalists, he proposed open voids to be entered and inhabited.... He allowed a subtle exploration of the relationship between the subjective and the social, the poetic and the material.[22]

22. Guy Brett, in ibid., 77.

Oiticica himself wrote, "structures became general, given, open to collective-casual-momentary behavior; in Whitechapel, behavior opens itself up for whoever arrives and bends forward into the created environment, from the cold of London streets, repetitive, closed and monumental, and recreates himself as if back to nature, to the childhood warmth of allowing oneself to become absorbed: self-absorption in the uterus of the constructed open space, which more than 'gallery' or shelter, this space was."[23]

A separation of art from life represented by the white cube invited a sense of release from the pressures of the metropolis and the bourgeois constraints of city life. In a recent historical survey, the Whitechapel restaged key works of performance art from the 1960s and '70s.[24] The Viennese artist Hermann Nitsch transformed the gallery environment into a banqueting hall and a sacrificial temple, with his *Lecture Action: Basic Elements of the Orgies Mysteries Theatre.* Inviting audiences to drive their hands into carefully arranged "still lives" of dead fish, grapes, erotic fruits, and fresh offal, he then led them into a ritual of Christian sacrifice, paralleling the Crucifixion, with two performers marked with blood to engineer a process of purging and catharsis.

Mirroring Richard Long's transposition of nature into urban culture, the arte povera artist Jannis Kounellis brought twelve live horses into the gallery in this 2002 restaging of his *Untitled*, 1969. Kounellis wished to disrupt the pristine and commercial aspect of

23. *Apocalipópotese* (1969), *Aspiro ao Grande Labirinto* (Rio de Janeiro: Ed. Rocco, 1986), 130, quoted in Guy Brett, "Hélio Oiticica: The Experimental Exercise of Liberty," in *Carnival of Perception: Selected Writings on Art* (London: Institute of International Visual Arts, 2004), 63.

24. *A Short History of Performance*, Whitechapel Art Gallery, Part 1, April 2002; Part 2, November 2002.

Janis Kounellis, *Untitled*, 1969, detail of live performance, "A Short History Of Performance: Part II," Whitechapel Art Gallery, 2002.

the gallery by staging a live encounter between the natural world and its unconscious, unconsumable, and dangerous beauty.

The performance artist Carolee Schneemann also directly challenged the myth of the white cube, exposing the patriarchal power structures inherent within its ethos of universality, neutrality, and objectivity. A pioneer of performance art, she used the gallery as a stage for her remarkable work, *Interior Scroll*, 1975, in which she read a sequence of feminist manuscripts unrolled from her vagina. In 2002, she presented *Meat Joy*, 1964, staged live and in person for London audiences, where a group of strangers stripped off to be covered in paint, paper, raw chicken, mackerel, and hot dogs in an orgiastic rite.

The typical characterization of the museum space by the early-twentieth-century avant-garde was the mausoleum. In his *Futurist Manifesto* (1909), Marinetti denounced museums as "cemeteries... public dormitories where one lies forever beside hated or unknown beings. Museums: absurd abattoirs of painters and sculptures ferociously slaughtering each other...(cemeteries of empty exertion, Calvaries of crucified dreams, registries of aborted beginnings!)"[25] Yet by the second half of the century, artists such as Joseph Beuys picked up from Picasso's propagandist display of *Guernica* to deploy the gallery as political platform, to act as a virus from within the institution itself. He chose speech over object, saying at the time of his lecture given at the Whitechapel in 1972, "Thought and speech should be seen as plastic.... My main interest here is to begin with speech and to let the materialization follow as a composite of thought and action.... My pedagogic and political categories result from Fluxus. To impose forms on the world around us is the beginning of a process that continues into the political field. A total work of art is only possible in the context of the whole of society. Everyone will be a necessary cocreator of a social architecture, and so long as anyone cannot participate the ideal form of democracy has not been reached."[26] Here the exhibition space becomes a lecture hall and a laboratory, a place where in the context of the civil rights movements and the anti–Vietnam War rallies of the late sixties and early seventies, Londoners could reflect, discuss, and agitate.

At the dawning of postmodernism, contemporary artists moved from an avant-garde attitude to the past as something to be destroyed or wiped clean towards a recognition of history. History once again became a subject—no longer a grand narrative, but a series of stories that could be invoked through the lens of appropriation and even irony.

An installation of the photographs of Gilbert and George relates back directly to the salon hangs of the nineteenth century and the 1901 "Spring Exhibition." In Marco Livingstone's words, "Gilbert and George transformed the two floors of the building into a cathedral-like space ablaze with color and teeming with imagery of confrontational impact and heraldic directness."[27] The artists' use of only primary colors, cut across with a black grid, combines with the luminosity of the photographs to suggest stained-glass windows. Yet their images are of

25. Filippo Marinetti, "The Foundation and Manifesto of Futurism," in *Art in Theory, 1900–1990*, ed. Charles Harrison and Paul Wood (Oxford: Blackwell, 1992), 148.

26. Joseph Beuys, "Interview with Georg Jappe," trans. John Wheelwright, *Studio International* 184, no. 950 (December 1972), extracted in *Art in Theory 1900–1990 an Anthology of Changing Ideas*, ed. Charles Harrison and Paul Wood (Oxford: Blackwell, 1992), 890.

27. Marco Livingstone, "Reshaping the Whitechapel: Installations from Tomorrow to Today," in *The Whitechapel Art Gallery Centenary Review*, 35.

"Nan Goldin: Devil's Playground," Whitechapel Art Gallery, 2002, installation view.

the graffiti-embellished East End, and provide a backdrop for naked self-portraits of the artists—or objects of their desire, young working-class men. It is as if they force the history of religious icons to embrace the taboo, the abject, and the quotidian and to elevate those themes in the context of the reverential space of the museum.

Photographer Nan Goldin similarly played with salon and church motifs in the installation of a major retrospective of her work titled "Devil's Playground," 2001. Rejecting chronology, Goldin edited clusters of works into narrative sequences. Her use of deep purple, emerald, crimson, and black, and the stacking and juxtaposition of images were powerful evocations of the bells and smells of Catholic medieval and baroque churches. Friends, lovers, and babies were transformed into Madonnas, pietas and putti, death masks and memento mori. Both projects jettisoned the neutrality of the white cube to reiterate the atmosphere of a white chapel; yet the return of the repressed did not inaugurate a new morality, rather the space was occupied by images of "profanity."

Reading back thus far, I realize that something is missing—is there a moment in the history of the Whitechapel when there is a genuine breaking through of the white cube, an actual, physical bridge with its environs? Of course, *Bridge!* As part of an exhibition titled "Protest and Survive," organized in 2000 by curator Matthew Higgs and artist Paul Noble, the Swiss artist Thomas Hirschhorn built a bridge which punctured the skin of the gallery and led over an alleyway right into the last anarchist bookshop in London. Visitors simply climbed out of the cafe window, walked above Angel Alley (whoever named the needle-filled rat run adjoining the Whitechapel Art Gallery was surely being ironic) and into Freedom Press, where they were immersed in the world of radical pamphleteers and agit-prop activism. Hirschhorn's bridge was itself a characteristically low-tech construction made of the humblest materials, squatters materials—cardboard, parcel tape, tinfoil—light, cheap, yet sturdy enough to allow a steady flow of people moving in both directions.

Institutions will tend towards systems of display that reflect the complex socioeconomic and geopolitical contexts within which they operate. They cannot help but be vulnerable to numerous vested

131

Thomas Hirschhorn, *Bridge*, 2000, installation on exterior, Whitechapel Art Gallery.

interests around which they must negotiate. These forces—be they public or private—may be benign. Government funding agreements and policy endorsements may promote accessibility and cultural representation. But the impulses of democracy can also mask political agendas of vote winning and social engineering. Sponsorship and private patronage might be dedicated to the promotion of freedom and experimentation. Yet it can also promote a connoisseurship which is both exclusive and market driven.

More often than not, it is the artist who will resist these agendas. As we have seen in site-specific and institutional-critique art practices, these acts of resistance may become their own raison d'être. Indeed much of the twentieth-century avant-garde project may be understood as an assault on the procedures and establishments of art institutions, suggesting an oedipal relation of dependency on those very institutions. As the curator Maria Lind has recently commented, "How do you use the support of an institution and still have space for production and circulation in an experimental and flexible way? How do you have a certain continuity without the support of an institution? How do you circulate ideas and artistic projects, establishing an exchange among people from different economical, political and cultural contexts on an equal level?"[28]

The gallery environment continues to mark "a crucial intersection of discourses, practices, and sites." The challenge for the twenty-first century is to acknowledge that exhibition spaces and systems of display are neither natural nor neutral. Perhaps the challenge will be to maintain a sense of where and what the institution is, in terms of its

28. Maria Lind, announcement for a symposium, Curating with Light Luggage, Kunstverein Munich, October 25–26, 2003.

132

own location, history, and audiences, while remaining open to new artistic perspectives on the present and the past. We must ask ourselves, can we create structures that are both robust and transparent? Can we combine continuity—so necessary to build relationships with audiences, other institutions, artists—with the flexibility to embrace new modes of artistic production and reception? To be relevant in the twenty-first century, the gallery must be at once a permeable web, a black box, a white cube, a temple, a laboratory, a situation. It must take the form of a creative partnership, between a curator and the producer, object, or idea of art.

Making Space for Art
Mary Jane Jacob

As curators we are always involved in space: finding the right location, wall, or floor for installing a work of art. Museums build new and bigger spaces for their collections; curators seek out spaces beyond the gallery to present works. An essential reason for making exhibitions—to make spaces where the audience can see works of art and have an art experience—might seem self-evident.

I recently visited the Musée d'Orsay. Now granted, it's impressionism and postimpressionism and we all know those mid- to late-nineteenth-century French masters have ready, mass appeal. But it wasn't so different over at the Pompidou: long lines, big crowds, people looking at art everywhere. Okay, it was Paris, but *still*, in other cities, at biennials and art fairs, even without the queues, the effort needed just to get to the galleries—the spaces for art—can be considerable and I thought: does the art reward the public's effort? What is the attraction? What is the message we are giving about art? What is the experience we are engendering? So I want to address some other kinds of space essential to the experience of art and, though we might not walk into them as we do galleries, we inhabit them nonetheless, and without them, art doesn't happen. They are empty spaces and full ones, quiet and noisy spaces, where art experiences happen.

Museum exhibitions historically have been places to obtain knowledge as well as observe the works of art, or artifacts exposed. These shows depend upon a curator's scholarship and selection process. As a profession, ours is a field distinguished by judgments, discriminations, exclusions as much as inclusions. In the realm of today's art, where the patron once stood at the sidelines making art possible, the curator is often the one who commissions artworks, creates the occasion for, and even takes a part in, their making. Since 1990 I have devoted my practice exclusively to this way of working, making art with artists and participating in a dialogue around questions that generate the context for the work's emergence and (as the projects I am involved with are nearly always temporary) its very existence.

In the mid-1980s, after working together on an exhibition, a new installation work at the Museum of Contemporary Art in Los Angeles, the artist Ann Hamilton said to me "you give permission." This was a confusing, uncomfortable statement for me, connoting a status of superiority from which one bestowed opportunity, funds, space; an identity far from my self-image of friend and colleague to

artists in the process of creation. This remark stayed with me, and it took some fifteen years to understand that *permission* occurs when, as a curator, I make a space—the conditions and circumstances, intellectually, socially, physically, in whatever ways necessary—for the artist to make art: empty space, a space of experimentation, and more than that, a space in which the artist can linger not knowing.

Then I also began to think of her words and about the space we make for the audience. In the later 1980s, as we in the field came to scrutinize who the audience was for art and what publics remained outside arts' institutions, I wondered who has permission to be there, to look, and whose responses are given credence and why. And could space be made for the viewer, an empty space of permission, rather than filling up space with information or amenities to alleviate the profession's perceived deficiency of the viewer? How can we foreground the function of museums as a place for experiencing art's unique ability to move beyond its objectness and out into the world. John Dewey saw this deep and useful connection of art and life when he said: "To some degree we become artists ourselves as we undertake this integration, and, by bringing it to pass, our own experience is reoriented.... This insensible melting is far more efficacious than the change effected by reasoning, because it enters directly into attitude."[1]

I wondered how to nurture the public's experience with art beyond offering classes, lectures, and tours, and the like. I knew, from experience, that our capacity for being with unfamiliar art depends on our capacity to be comfortable with uncertainty and ambiguity.[2] But there are few indicators along the way to guide us in the perception of art, a process that is so unfamiliar to the experience of many; to give us permission to rest—as the artist did before us during the process of making—in what Buddhist practice calls the "mind of don't know." Yvonne Rand, who uses art and museum exhibitions in her Buddhist teaching, offers that this quality exists when "one immerses one's mind in the process of inquiry and experience, giving up any orientation toward outcome or result. The practitioner cultivates the willingness to sit at length with a question and to allow answers to arise as they will out of intuitive understanding, not through willing them forth by analytical thinking."[3]

Key to this concept of "mind of don't know" is the distinction between aims and goals. Now "to have no goals" is anathema to us, irresponsible or wrong, and with moral or monetary implications. (Perhaps this is one reason why the "mind of don't know" is so curious, so radical to our learned way of being.) Aims are underlying directives, notions that answer the "why," why we are pursuing something; goals are the "what," the tangible thing or action undertaken and presented as product. But if we suspend goals, leaving them undefined, flexible, and open to discovery, then anything is possible; and if we are clear about our aims and attentive to them, then no matter what path we go down, exploring where it might lead but

1. John Dewey, "Art and Experience," in *The Philosopher's Handbook*, ed. Stanley Rosen (Random House: New York, 2000), 274.

2. Art as an experience without prescriptive guidelines and didactic outcomes is a major theme of John Dewey's critical, philosophical text "Art and Experience," as seen in such statements as: "It is by way of communication that art becomes the incomparable organ of instruction ... [a way] so remote from that usually associated with the idea of education ... that proceeds by methods so literal as to exclude the imagination and one not touching the desires and emotions"; and "Art is a mode of prediction not found in charts and statistics, and it insinuates possibilities of human relations not to be found in rule and precept, admonition and administration" (Dewey, "Art and Experience," 286, 288).

3. Yvonne Rand at "Awake" meeting, October 5, 2002.

Rirkrit Tiravanija, the land, 1998 ongoing, Sanpatong, Thailand.

guided by our essential aims, it is possible to arrive at the appropriate, perhaps unexpected, and responsive end. If the audience can share in the "mind of don't know" and stay open to experience, then they, too, can arrive at a new, powerful and not prescriptive place. Rirkrit Tiravanija, whose art evades identity and thingness even as it finds its place in museums, sees his method of practice as fluid, living, a place of possibility. He said " I always get asked, 'What are your expectations?' and I say, 'I don't have any,' because I don't predetermine things.... And I think this is quite important in terms of living in a Buddhistic way: not to have preconceived structures or to close off possibilities; but it's not even about being open or closed it's just about being blank, in a way, of course, you can receive more if you are empty."[4] Yet many museums have been attracted to sponsoring projects by Tiravanija, giving him "exhibitions," as if there were a need on the part of museums for what this artists brings, fulfilling something they cannot. For the artist, the museum is a place that we need to reenter to change the preconceived notions of what art is.

Creating this open space for the audience to experience can be the role of museum architecture. Some art museums, like the spaces of Tadao Ando, make the art resonate within; others, even new and much-touted designs, do not. Artists and curators have increasingly turned in the last two decades to site-specific practices as attempts to focus experience and heighten awareness, immersing the viewer in the art-and-environment as one, at times crossing realms of experiences, space, and time. But creating space for viewers also encompasses a mental space that gives room for a wide range of subtleties and ambiguities that parallel the ways of life itself but which we often can't perceive without the clarity of distance...and sometimes art provides that distance. This creating of space is about making room for individuals to find their own place in relation to the work of art. In

4. Rirkrit Tiravanija in *Buddha Mind in Contemporary Art*, ed. Jacquelynn Baas and Mary Jane Jacob (Berkeley and Los Angeles: University of California Press, 2004), 173.

doing so, people may locate what they already know from their experiences—or perhaps intuitively—but that may have receded with diminished awareness, gone untapped for a very long time.

Now this is not to say that there isn't knowledge to impart to the audience. I strongly advocate bridging the gap, disclosing information on an artwork and its context, and sharing in transparent ways the workings and thought processes of art- and exhibition-making. But there is another kind of knowledge important to the art experience and, while it cannot be written on a label, it can be created or curated into an exhibition. The artist Christian Boltanski tells an ancient story in everyday terms of the little girl who desired to have time alone with her newborn brother. With trepidation, the parents consented, then surreptitiously listened in as she asked the baby: "Tell me about god, I am beginning to forget." Some wisdom traditions believe that everything already exists (this is a crisis for the modernist Western mind anxious to claim the avant-garde), that existence comes first and our awareness of it follows, that at birth people are potentially all-knowing and life is a process of forgetting with occasional realization of what we already know; and that certain experiences—including, notably, art experiences—trigger the release of that information and help them to recollect what's "on the tip of their psyche," as architect Michael Rotondi puts it. If we value the viewer as not empty, but instead make an empty, open, and expansive space—and exhibitions can be one of these generous spaces—then the fullness of the visitor's experience (rather than the museum's or sponsor's or curator's experience) can fill that space, fill it with the experience of art. I'll give a couple of examples.

Verandah was an installation, a vision based on a Japanese teahouse, a minimal sculpture, a space for art and for dance and

Michael Rotondi, Hirokazu Kosaka, "From the Verandah: Art, Buddhism, Presence," 2003, UCLA Fowler Museum of Cultural History, Los Angeles, installation view.

artworks but at times hardly visible at all. It was the dream of educator and curator Linda Duke, and the result of collaboration in 2003 between the curator, Rotondi, artist Hirokazu Kosaka, and choreographer Joe Goode. As Rotondi tells it: "We were interested in what would happen if, when people left the room, they could only describe the experience and not the 'object.' Their memory would be of a process (personal experience) not the product (the constructed verandah) if the thing itself had presence but was relatively neutral, if it was a way of modulating space as opposed to putting an object in the space. We wanted to give equal status to the experience of matter and light. Movement would be modulated; the body in space, moving and at rest, would be our frame of reference. The thing wouldn't really exist except for the reflection of the light off all the surfaces. And it worked."[5]

Ann Hamilton makes works that are palpable; we experience her work with our body and senses as well as intellectually. Her own sensations, derived from direct experience, become a starting point for the work. Of *myein*, her installation in the American Pavilion for the 1999 Venice Biennale, a work criticized in the press for its *emptiness*, nothingness, she said: "I have been a live presence in much of my work…there was no live presence in this work yet I realized the live presences were the people who came and moved within it, sometimes erasing it…I learned of the need, perhaps the hard way, for some of my pieces to be quiet and to be solitary."[6]

In 2002 Marina Abramovic made *The House with the Ocean View*. She lived in full view of her audience for twelve days at Sean Kelly Gallery in New York. To the artist it was a direct transmission of energy. "I created space with no time. I created the feeling of here and now. You know how people go through galleries…three minutes here, two minutes there, just go in and out…I had people staying. I had the people who would come every single day, some for hours; some sat

5. Michael Rotondi, in Baas and Jacob, *Buddha Mind in Contemporary Art*, 221.

6. Ann Hamilton, in Baas and Jacob, *Buddha Mind in Contemporary Art*, 183.

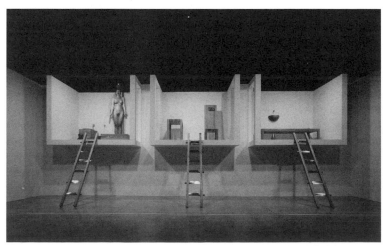

Marina Abramovic, *The House with the Ocean View*, 2002, twelve-day performance, Sean Kelly Gallery, New York.

there for five hours. I had people going to work with their briefcases who would wait in the front of the gallery for it to open, just to be there, like addicts, just to have that gaze, and then go out into the world, because out of that they can get something. It was amazing because I had an incredible feeling of unconditional love toward any person who came there and wanted to look at me in the eyes. Nobody was looking at them the way I look at them, unconditionally." Abramovic realized and acknowledged that this work was completely dependent on the public: "The public and I actually made the piece. Without the public, the piece doesn't exist, so they filled it." She finds her function as an artist to be important and useful. And while the experience during her performances is profound for her, she knows it is transforming for the visitor, too: "They take what they need for their own life to enlarge awareness....[7] I give art unconditionally so that it might have its own function in the lives of everybody."[8]

You find these days, among people of very different economic, social, cultural circumstances, that everyone describes their lives as hectic, burdened, complicated, demanding—too full. Artist Bill Viola, in part, grounds the experiences he creates in the need in our world for quiet time for reflection and re-centering: "We must take time back into ourselves, let our consciousness breathe and our cluttered minds be still and silent," he admonished, offering, "This is what art can do and what museums can be in today's world."[9]

The quiet, contemplative space of art can be a refuge, a remedy, an aesthetic antidote to life. But the full and seemingly fully occupied space of life can also be a space for art. So instead of the quiet and removed exhibition space of the museum, it is equally possible to make an exhibition that presents art that is invisible, seamless with life, or as Tiravanija describes, having "no seams"—an art so neutral that it is not really seen yet has a presence. Exhibitions of artists' projects intrinsically connected to everyday life weave themselves into the fabric—or fray—of our existence. It is no wonder that in recent years this mode of working outside conventional art spaces has been so fruitful in concept and number, and that a multitude of artists and curators have found it invigorating and gratifying to feel how art resonates outside the gallery box.

There are also art experiences that happen in the space of life, with no art objects or art actions at all. They happen as lingering or reignited reflections on artworks seen in the past and later digested... maybe much later, outside the exhibition timeframe and any reporting timetable.[10] This experience is an echo as it reemerges, or leaps to mind more powerfully than the first time, its meaning magnified by intervening life experiences. For Viola, this special power of art evokes responsibility on the part of artists: "I think contemporary artists need to be more cognizant of the spiritual nature of their work, and its place as part of a great tradition that stretches back through time."[11]

Then there is also a way in which we live life informed by art. Art hones our awareness, keeping present in us our relation to other

7. Marina Abramovic, in Baas and Jacob, *Buddha Mind in Contemporary Art*, 191.

8. Marina Abramovic, in Baas and Jacob, *Buddha Mind in Contemporary Art*, 194.

9. Bill Viola, in Baas and Jacob, *Buddha Mind in Contemporary Art*, 254.

10. A related reference from Dewey: "But experience is a matter of the interaction of the artistic product with the self.... It changes with the same person at different times as he brings something different to a work. But there is no reason why, in order to be esthetic, these experiences should be identical." Dewey, "Art and Experience," 271.

11. Bill Viola, in Baas and Jacob, *Buddha Mind in Contemporary Art*, 256.

12. "Works of art are means by which we enter, through imagination and the emotions they evoke, into other forms of relationship and participation then our own." Dewey, "Art and Experience," 273.

things and heightening our sense of place in the world. This is possible to achieve without art as we know it, but in our world art is one of the few instruments with which we can tune our sensibilities of things beyond self.[12]

I'd like to add to this discussion of the spaces of art that, for me, the space of curating is an empty space—not just when I am cohabiting it with an artist during the process of making but in the process of determining the "why" of an exhibition and then, with these questions as my aim, maintaining this empty space so that others can eventually come in, too. When I began in 1991 to work with communities outside museums—constituencies that would become the audience, but that at the outset were the informants and participants in the art process—I began to realize that my background as an art historian and museum curator could not serve me in full. One school of thought would say: seek the right training or read books in community activism, sociology, video production, whatever it takes. I subscribed to another school of thought, using my "unknowingness" and "outsiderness" and, like with looking at art, accumulating direct experience. I had to depend primarily upon listening to others, to the public; I had to work with communities not my own but also outside the contemporary art world to become educated. This was a big shift from picking artists, artworks, and telling audiences about art. As curator, I was not the authority; at best I could become a conduit for ideas of others, translated and transformed by the artist. In the process, I had to reveal that "I didn't know"—about a place or a community, about what the art would look like in the exhibition or what its thesis would finally be. I also had to trust my past experiences with art, the ones that were revelations. I had to depend on anecdotal comments, stories that came back to me over time in response to shows I'd organized, most of all those from unexpected, "unhip" people who got it, and gave back the most profound observations and understandings of so-called sophisticated new art. I was bolstered by the knowledge that for some the indifference, even hostility, to contemporary art had fallen away; that for some, art had made a difference. I trusted that there were others from whom I would never hear, but the art mattered to them, too. And with this trust in mind I had to create a space—a sufficiently wide and empty-enough space—where different publics could listen to and hear themselves as they listened to the art.

What can exhibitions do now and why might they even be important? Open situations for experience don't happen often. They can be disconcerting, intimidating, because we are so programmed to being led to or told the result of our experiences (how we should feel, what we will feel). "Not knowing," being given permission to be on one's own and really have a full experience, can be scary. But we need more spaces for such thoughtful experiences in our society, spaces where experience can take us to a renewed place in our lives, a transformation, a fuller sense of being beyond the limitations of

self. So what we need is to curate the conditions for the audience's own creativity and deep engagement. This requires a safe and empty space for a wider view, for an intense and longer inquiry. Surely those of us in the curatorial field can each recall certain works of art that have transported us and contributed to our desire, in turn, to engender an experience in others. As curators, we make exhibitions as space for experience.

Questions of Practice

Mark Nash

In a recent exhibition "Comme le rêve le dessin" at the Musée du Louvre and the Centre Pompidou in Paris,[1] the show's curator Phillippe-Alain Michaud developed an argument that cinema and the artist's sketch share a common engagement with the processes of dreams: "Film as generator of fundamentally unstable precarious images can be seen as an extension of the oneiric equations of drawing into the domain of time and movement.... In the images in drawings as in the images in dreams, the world of experience has not disappeared: It has been fragmented and dis-organised."[2] This show is ambitious in its theoretical investigation of the manifestation of psychoanalytic processes across different media, as it is in its technical realization. The installation in the Pompidou section was particularly striking, presenting moving images side by side with old master and contemporary drawings: Jean Genet's film *Un chant d'amour*, 1949, juxtaposed with a drawing by Jacopo Vignali (1592–1664), *Pyramus and Thisbé*, or Ken Jacobs' deconstructionist film *Tom Tom the Pipers' Son*, 1969–71 and *Composition with Several Figures, One of Whom Carries a Crucifix*, by Giovanni Battista Naldini (1537–1591). The black-box gallery spaces constructed in the Pompidou functioned elegantly both for the film projections and to display the various old master drawings, which themselves required controlled illumination. There were some unresolved issues of scale in the film presentations—sometimes using small screens suspended like framed drawings from the ceiling juxtaposed to actual drawings, in other cases projecting large to fill a whole wall (Warhol's *Sleep*, 1963). But the originality of the project—to force a contemporary medium up against a "classical" one—remains. It set a benchmark.

Film and video are relative latecomers to art exhibitions. The moving image traditionally had its own dedicated exhibition space—the cinema or movie palace, or in the case of video, the domestically placed TV set. Which is not to say that film and video have been absent from the art scene in the last fifty years—recent retrospectives of the work of Galerie Schum[3] in showing video in Cologne from the 1960s, or Interfunktionen[4] on artistic "border crossing" between different media, both make clear that from the 1960s on, moving images had a significant presence in the art scene. In this essay, I will reflect on some of the issues that arise in working with film and video in an exhibition context. I will refer to a number of exhibitions I have curated

1. "Comme le rêve le dessin," Musée du Louvre and Centre Pompidou, 2005.

2. Gallery notes.

3. "Ready to Shoot: Fernsehgalerie Gerry Schum/videogalerie Schum," Musée d'Art moderne de la Ville de Paris/ARC; Museu de Arte Contemporânea de Serralves, Porto, Portugal; Kunsthalle Düsseldorf; Casino Luxembourg—Forum d'art contemporain, Luxembourg; 2004–5.

4. "Behind the facts: interfunktionen 1968–1975," Fundació Joan Miró, Barcelona; Museu de Arte Contemporânea de Serralves, Porto; Museum Fridericianum, Kassel; 2004–5.

and co-curated as well as shows I believe are key to mention in a discussion of what makes for successful film and video shows.

I have been involved in film and video from the 1970s, writing and teaching film history and theory, as well as programming the occasional film or video series. "Programming" is now rather an old-fashioned term—referring to films grouped in authorial (e.g., Carl Dreyer), thematic (New Portuguese Cinema) or other conceptual categories (American Video).[5] "Curating" has only recently entered the film-programming vocabulary, but in fact I think the two terms—"programming" and "curating"—can sit quite happily together. I use the word "curating" when one is involved in organizing an exhibition with a spatial distribution of works. Within a number of the exhibitions I mention below there can also be a supporting or supplementary film "program," running concurrently with or within an exhibition.

In fact, one of the first exhibitions I contributed to as a co-curator, "Force Fields," in 2000, was concerned with re-examining the language of movement in art.[6] It revisited the various kinetic experiments in modern art between 1920 and 1970, framing them also as modes of speculation on relationships among art, science, and philosophy. The issue of movement in art goes back to the first decades of the twentieth century, when there were big debates about which medium—film, photography, or painting—could best "capture" and analyze movement and perception. This could either be simulated, as in futurist paintings concerned to represent the visceral experience of city life,[7] or could produce illusory perception through actual kinetic movement (e.g., Marcel Duchamp [with Man Ray], *Rotary Glass Plates [Precision Optics]*, 1920).

Guy Brett, "Force Field's" curator, invited me to collaborate with him to locate artists' film and video material, advise on their installation in a gallery setting, as well as design a supplementary film program.[8] Installing moving images in Richard Meier's MACBA Barcelona building, completed in 1995, was particularly challenging. Meier's building employs intense white surfaces that magnify the play of light and shadow. This building's architecture is animated by great swathes cut through it that confuse outside and inside—an architectural tour de force, but not one that has any regard for the problems of exhibiting contemporary media. In that exhibition, we relied quite heavily on film clips running on TV monitors, but it was extremely difficult to avoid light reflecting in the screens in the process.

"Force Fields" trod a fine line between presenting the moving image as artwork, for instance James Whitney's animated film *Yantra*, 1950–57, which was shown in a dedicated black-box space as a DVD projection, and the moving image as supplement, providing information which supported other exhibition strategies, for example Yves Klein's film *Fire Paintings*, 1961, or a twenty-five second clip from Michael Winner's *I'll Never Forget What's 'is Name*, 1967, that includes a scene set in the Indica Gallery in London where David Medalla was exhibiting his *Mud Machine* and other kinetic works at the time.

5. The first two are titles of film programs I organized for the National Film Theatre in London (Carl Th. Dreyer, 1978; Recent Portuguese Cinema, 1989), the last was a touring show for the Arts Council of Great Britain, 1983 (reshown at the New Serpentine Gallery Bookshop, London, 1996).

6. "Force Fields: Phases of the Kinetic," Museu d'Art Contemporani de Barcelona (MACBA); Hayward Gallery, London; 2000.

7. Giacomo Balla's *Abstract Speed + Sound* (*Velocità astratta + rumore*), 1913–14, has a typically straightforward title. NB: "Force Fields" did not show any Futurist work.

8. Interestingly this was at a moment when the Hayward Gallery no longer employed a full-time av technician! Only in the last five to ten years have international galleries and museums begun to address the need for specialist technical knowledge in terms of moving image presentation and conservation.

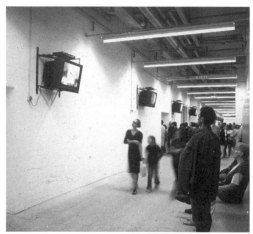

Igloolik Isuma Productions, *Nunavut (Our Land)*, 1994–95, thirteen-part video installation with sound, 30 minutes each, installation view "Documenta_11," Kassel, 2002.

While Meier may not have considered the technological possibilities for moving image installation in his original museum design, technical developments do mean that in a few years it will be possible to bathe both the interior and exterior surfaces of his structure with projected images intense enough to withstand competition from the Mediterranean sun reflecting through the building.

Shortly after collaborating with Guy Brett, I was invited by Okwui Enwezor to curate the film element of "The Short Century: Independence and Liberation Movements in Africa 1945–1994."[9] Here too, the moving image was central to the exhibition concept. There were forty or fifty different film or video items presented on screens or TV monitors in the exhibition proper, together with a small cinemathèque screening a selection of post-independence, African film production on VHS video or DVD. While the excesses of colonial rule often went undocumented, when many African states gained independence in the early 1960s, their struggles and celebrations were most eloquently witnessed on film and television even if, sadly, the records are most complete in the former colonizing countries Great Britain, France, and Portugal.

In the exhibition, therefore, we attempted to represent the plenitude of history and experience by using rows of monitors to present these images as introductory sequences to different sections of the exhibition. For example, Dr. Hastings Banda addressing an election rally, trademark flywhisk in hand, in the then Federation of Rhodesia and Nyasaland (soon to be Malawi), was juxtaposed to footage of the young Julius Nyerere shortly after Tanzanian independence in 1960, and then again forty years on as the first African head of state to voluntarily give up power. Significant film and video works were given dedicated projection spaces, as with an early film by Ousmane Sembene, *Borom Sarret*, 1963, documenting the architecture of colonial Dakar in Senegal in the exhibition section dealing with architecture. Isaac Julien's *Frantz Fanon: Black Skin White Mask*, 1996, was also shown in

9. "The Short Century: Independence and Liberation Movements in Africa 1945–1994," Villa Stuck, Munich; House of World Cultures in the Martin Gropius Bau, Berlin; Museum of Contemporary Art, Chicago; P.S. 1, New York; 2001–2.

144

its entirety in the gallery space, since Fanon's ideas were formative for the generation that achieved independence across Africa, and so on. One work, Kay Hassan's *Flight*, 1995, used a working TV attached to a pedal cycle as part of its installation, and for the version in "The Short Century" we showed a 1980s BBC program on the continuing struggle against apartheid on the bicycle TV.

This was an immensely ambitious, and I have to say successful, exhibition, and the moving image was central both to its concept and its realization. I learnt an immense amount from the collaboration with Enwezor, particularly concerning the range of modalities in which one could use moving images, especially how, if one "liberated" the moving image from a black-box, one could create juxtapositions with other art forms—sequences for the exhibition viewer to move along and thereby develop a curatorial or thematic argument through installation itself.

Harald Szeemann's installation of the Arsenale in the 2001 Venice Biennale provides me with a more problematic, less successful counter-example on the presentation of moving image works. Visitors will remember a sequence of dark, video-viewing rooms on either side of a central section of the Corderie in the Arsenale. Szeemann had made a courageous decision to invite filmmakers such as Atom Egoyan, Abbass Kiarostami, and Chantal Ackerman to make new pieces for the exhibition. As usual with Venice, this was at late notice and on a shoe-string budget, issues which Szeemann had little control over. The resulting presentation as a series of immersive viewing rooms off a central corridor did not work—the rooms were too small, the use of black-drape curtains made entry and exiting confusing. The uneven formal and artistic quality of the filmmakers' contributions also made it difficult to establish dialogue between the pieces.

Whereas in the cinema film program, one film (or projected video) displaces another, in an exhibition, many are co-present, competing with one another and other artworks for the audience's attention. It is sometimes best therefore, to force the issue and confront the viewer with restricted choices. At the 2001 Biennale, Szeemann's installation of Stan Douglas's *Le Detroit*, 2000, was exemplary in this regard. The parcours through the Arsenale complex forced the visitor through the exhibition space, past the screen installed at a forty-five degree angle to entrance and exit. One had no choice but to engage with this piece as one passed through it. In my installation of "Experiments with Truth" at the Fabric Workshop and Museum in Philadelphia in 2005, discussed below, I was similarly concerned to determine and present a single itinerary for the gallery visitor. Possibly it is the influence of my film background, but I think the notion of a series of emotional and intellectual encounters that are montaged[10] to form an organized, thematic sequence is at the heart of every great exhibition and every great experience of an exhibition.

Most curators and museum gallery professionals have some familiarity now with the presentation of moving image media. Ten years

10. Indeed Sergei Eisenstein derived his concept of "montage of attraction" from the fairground and circus that were so important to early Soviet art.

ago, maybe fewer, many regarded artists' interest in the moving image as something of a fashion. I myself thought it would pass, and, indeed, it was only when working with my fellow co-curators on Documenta11 for 2002, all of whom were excitedly espousing work in this medium, that I realized that the paradigms of contemporary exhibition-making were in the process of permanent change. The fact remains that moving image work can be extremely expensive to install—a complex video installation with top-ranking sound and image projection can easily set you back $100K. Installation costs are, however, dropping as artists and galleries embrace new equipment designed for the domestic market. The Tony Oursler exhibition "Dispositifs" at the Jeu de paume in Paris in spring 2005 was a case in point. Oursler pioneered the use of micro projectors, and his installation there of *Eyes*, 1996, in particular was a veritable hot house of small digital projectors taped at odd angles to music stands and camera tripods. The relative cheapness of these domestic cameras today has brought down exhibition installation costs, and presents possibilities for innovative installations which would not have been possible with previous generations of massive and expensive equipment.

Not all moving image installations need to use cutting-edge technology, however. Kutlug Ataman's Carnegie prizewinning *Küba*, 2004, is an example of a mixed use of technology—forty or so ancient television receivers fed by concealed DVD recorders. Or Ezequiel Suárez's *Project E.G.I.S.*, 2000, installed in "Experiments with Truth," which simply required the purchase of a second-hand television for twenty dollars in Philadelphia and then connecting it up to a VHS recorder. Both the Ataman and Suárez employ a quasi-documentary aesthetic which ties the content of their pieces—extensive interviews with the inhabitants of an Istanbul shanty town (Ataman) or a video document of a retired agricultural engineer's improvised

Tony Oursler, *Eyes* (detail), 1996, installation view "Dispositifs," Galerie du Jeu de paume, Paris, France, 2005.

songs (Suárez)—to their use of old-fashioned TV sets. The spaces of enunciation are marked as underdeveloped through the use of older technology. The variable color registration of the TV receivers in the Ataman piece also reinforced a sense of the variability of memory—the sets in many cases are as old or older than the interviewees! Here, content and technology were inextricably linked.

It might be useful here to discuss some of the issues concerning film and video exhibition as the curatorial team of which I was a part encountered them in our work on Documenta11 in Kassel, Germany. This was a formative curatorial experience for me, enabling me to explore in depth my interest in the relationship between moving-image media—cinema, fine art film, and video—and the wider, international art scene. Big international exhibitions are never easy, however, and in a show such as Documenta one is privileged to be part of both a construction and analysis of history. One of the achievements of this particular exhibition was to return the notion of the document and the documentary form to intellectual and artistic scrutiny, through a series of Platform conferences, publications, and the final exhibition itself in Kassel.

I entered that curating process as something of a media purist: Work should be shown in the medium and form it was originally produced and intended for, that is to say, film in a cinema, and so on. Indeed, we did establish a film program that was shown in the Bali Cinema, part of the Kultur Bahnhof exhibition space. However, nearly all the artists whose work was shown there (apart from Jonas Mekas), were also represented in one of the main exhibition galleries of the exhibition proper. This film-specific program did not draw visitors in the way that the other exhibition spaces did, possibly because it was decided that there would be a supplementary charge for the films. More pertinently I suspect, it posed a mode of spectatorship, that of a repertory cinema, which conflicted with the demands of the main exhibition. As visitors to that exhibition will recall, a number of artists such as Ulrike Ottinger and Steve McQueen had purpose-built cinemas integrated into the exhibition parcours. There was a certain logic to Ottinger's request since her *South-East Passage*, 2002, was more than six hours in duration. During our initial installation discussions she had requested three parallel cinemas, like the nave and aisles of a church, to show the three component parts simultaneously. This did not prove feasible, but providing a cinema space with bleachers for seats encouraged the audience to stay for as long as they wished, and worked effectively for the presentation of the piece. The exhibition designers, Johannes and Wilfried Kuhn of Kuhn Malvezzi Architects, told me that the video installation they preferred the best was that of Isaac Julien's *Paradise Omeros*, 2002, since it not only worked with the scale of the exhibition architecture they had installed in the Binding Brewery, but through judicious balancing of sound levels managed to present the work compellingly without the need for visually distracting curtains to block out light and sound.

The Documenta11_Platform 2 conference that took place in New Delhi in 2001, also entitled "Experiments with Truth,"[11] was concerned with issues of transnational justice and the instrument of the truth commission in furtherance of that goal. In support of this, we presented a series of film and video screenings installed in the Visual Arts Gallery of the India Habitat Centre, close to the conference hall. Two rows of TV monitors presented a range of archival documentary material from Claude Lanzmann's *Shoah*, 1985, to Harun Farocki and Andrei Ujica's *Videograms of a Revolution*, 1992. Interrupting the space were two large screens presenting material from the war trials following World War II—Bengt von zur Mühlen's *The Nuremburg Trial*, 1967, and Eyal Sivian's *The Specialist*, 1999. On entering the space, the viewer could see something of all the works presented. In other words, they were provided with some kind of synoptic overview of the project. They could then decide to focus on individual screens by taking a chair and headphones installed close to each monitor. The potential cacophony of low-level sound emanating from all the monitors was replaced by the specific soundtrack a viewer wished to focus on. This approach to installation bears some resemblance to film and TV vid-eothèques where individual visitors can sample works from the local archive. At the same time, however, the large-screen presentations reminded viewers of the symbolic importance of these trials, and also reinforced the immersive potential of this form of exhibition.

We then adopted a version of this approach in the Documenta11 exhibition in Kassel when installing the twelve-part series *Nunavut (Our Land)*, 1994–95, by the Igloolik Isuma group in a line of twelve monitors in one of the axial corridors in the Binding Brewery exhibition space. A visitor slowly walking down the corridor was presented

11. See Okwui Enwezor et al., eds., *Experiments with Truth: Transitional Justice and the Processes of Truth and Reconciliation* (Ostfildern-Ruit: Hatje Cantz, 2002).

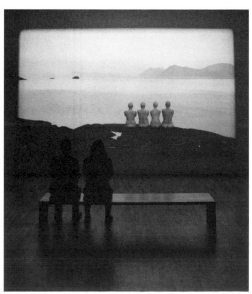

A.K. Dolven, *4 min. at 2 a.m. 22 of July 2003*, 2004, 35mm film, 4 minutes, dimensions variable, installation view in National Gallery in Hamburger Banhof, Berlin, 2004.

full-force with the totality of the project—a series of demonstrations of local traditions and customs amongst the Inuit before the "Great Change" of modernization in 1945. One could, as it were, then intuit something of the whole project before sitting down on the bench that ran along the whole of the corridor facing the monitors, and engage with individual episodes. Headphones and subtitles also helped clarify matters. This part-to-whole juxtaposition again proved effective as an installation technique.

Less successful in my view, was our use of TV monitors in the foyer of the Documenta Halle to show Pere Portabella's *Informe generale...*, 1975,[12] and Collectivo Cine Ojo's *Memories of an Everyday War*, 1986. This most difficult of buildings from the point of view of exhibition design overlooks the gardens sloping down to the Orangerie, and has one wall completely of glass. The result was that these films, already reduced to TV-monitor viewing scale, became difficult to engage with, especially on the rare days that the sun was seen in Kassel that summer. As with "Force Fields," the vagaries of architecture again overcame available technology.

12. The full title is *Informe general sobre algunas cuestiones de interés para una proyección pública.*

Even today, despite the prevalence of DVD projection, and the gradual improvement in projector design, some artists importantly insist on working with projected film. An example is Anne Katrine Dolven's *4 min at 2 am 22 of July 2003*, 2003. Here, a single 120-foot roll of 35mm film, shot above the Arctic Circle in Norway, rolls through a massive horizontal 35mm looper attached to a 35mm projector that was specially imported from Oslo for its presentation in the Hamburger Bahnhof in Berlin.[13] The image is of four seated and apparently naked figures isolated in a northern landscape bathed in the strange aura of the midnight sun. Thirty-five millimeter film may be an increasingly anachronistic medium, but it still produces better definition than high-quality video projection, and the indexical basis which analogic film and photography provide is still important to many artists who want to establish a material link with the place of origin of the content of their images.

13. "Berlin North," Hamburger Bahnhof, 2004.

Sound penetration was another major issue in the installation in the exhibition spaces in Documenta11, and I learnt from this in designing the exhibition spaces in "Experiments with Truth" at the Fabric Workshop and Museum. For that show, I worked with architect Lyn Rice of Open Office, and we were able to establish a similar axial corridor design, but with the surfaces lined with acoustic foam, and all entries having a light and sound lock so that we did not need to use curtains to separate off individual spaces. Coincidentally, another moving image show was presented in London at the same time—"Time Zones"[14]—providing something of a counterpoint to my show. All that work was impressively installed in open-plan fashion in the vast, loftlike spaces of the Tate Modern's temporary exhibition spaces. Sound penetration was not an issue given the size of the gallery space. Fikret Atay's *Rebels of the Dance*, 2002, installed on an oversize screen, was the first piece seen when entering that

14. "Time Zones," Tate Modern, London, 2004.

149

Isaac Julien, *Frantz Fanon, Black Skin White Mask*, 1996, 73 mins., colour 35mm, sound, installation view "Experiments with Truth," Fabric Workshop and Museum, Philadelphia, 2004.

exhibition, followed by Fiona Tan's *Saint Sebastian*, 2001, impeccably installed on a large screen filling the diagonal of the next space. What connections are we supposed to make between two Kurdish boys performing in a cash machine booth and the Japanese girl archers in Tan's piece? Further on came Wolfgang Staehle's *Comburg*, 2001, a realtime relay of a view of an impressive medieval castle—another complete disjunction and another modality of presentation. The Tate exhibition was concerned to demonstrate a range of formal concerns and installation strategies. The content of each video was not irrelevant of course, but clearly secondary.

"Experiments with Truth" in Philadelphia, focusing as it did on work dealing with issues of documentary, required dedicated viewing spaces, so that the audience could engage with each work under the best conditions possible. My concern with the Tate show was that what was a bravura performance in terms of installation did not reveal anything of importance through the juxtaposition of individual works to one another.

As I argue in my essay in the Documenta11 catalog,[15] the contemporary international exhibition increasingly faces viewers with choices as to how to spend their time, especially where moving image media are involved. Through the decision to provide seating or not, to ease or direct movement through the exhibition space, the curator can signal different modalities of engagement. Ulrike Ottinger's *Bild Archive*, 2004, shown in "Experiments with Truth," consists of a bank of five slide carousels, and in thirty or so minutes the viewer is exposed to almost the entire gamut of her image production, so a bench in the space is entirely appropriate. The four pieces comprising Yervant Gianikian and Angela Ricci Lucchi's *Electric Fragments* series,[16] also in that same show are, on the other

15. Mark Nash, "Art and Cinema: Some Critical Reflections," in *Documenta11_Exhibition Catalogue* (Ostfildern-Ruit: Hatje Cantz, 2002), 129–36.

16. *Vietnam*, 2001; *Rom* (uomini), 2002; *Corpi*, 2003; and *New Caldedonia*, 2004.

hand, all short, five-to-ten minute single-screen pieces that rework archive film. This work was installed to allow the audience the possibility of moving between the various screens and engaging in a comparative process, making their own filmic sequence as it were, on the issues of colonialism, voyeurism, and desire that the films encompass.

Film and video certainly can make a major contribution to great exhibitions. However, I think creating media-specific shows is particularly difficult, not so much because of the demands they make on the spectators' time, but because it becomes very difficult to sequence a series of immersive audio-visual experiences once you have more than a dozen or so pieces, which was roughly the limit of "Experiments with Truth." Of course, there are important, specialist exceptions to this, for instance, in those exhibitions which present the totality of a collector's engagement with the moving image, such as "Fast Forward: Media Art, Sammlung Goetz" at ZKM, Karlsruhe, in 2003–4, which presented the collection of Ingvild Goetz, or "Video Acts: Single Channel Works from the Collections of Pamela and Richard Kramlich and New Art Trust" at P.S. 1 Contemporary Art Center, New York, in 2002–3. In "Fast Forward" the vast space of the ZKM exhibition hall enabled both sculptural dialogue between spatially co-present work, and a more reflective engagement in dedicated screening spaces, all attuned to the requirements of individual

Ezequiel Suárez, *Project E.G.I.S.*, 2000, installation view "Experiments with Truth," Fabric Workshop and Museum, Philadelphia, 2004.

151

Vito Acconci, *Claim Excerpts*, 1971, single-channel video installation, 62:11 min., installation view in "Video Acts: Single Channel Works from the Collections of Pamela and Richard Kramlich and New Art Trust," P.S. 1 Contemporary Art Center, New York, 2002–3.

artworks. "Video Acts," on the other hand, decided that it was no longer possible to experience early video art as originally conceived by its practitioners, and instead, more than two decades of work were simultaneously presented in what became at times a veritable tower of Babel. Though here too, there was an inspired presentation of nearly all Vito Acconci's early videos in an underground vault, where their co-existence reinforced the impossibility of entering the paranoid world of this artist, and his strategies for enticing the viewer proved more aggressive than seductive. While the sheer range of artists' work in both shows necessitated a wide range of installation strategies, it may be that the ultimate strength of these shows was their museological nature—that is, they represented a totality of a collector's engagement with historical (Kramlich) or contemporary (Goetz) art. Such exhibitions are obviously less about making a curatorial argument than demonstrating the wealth and sensitivity of the collectors, as well as the amazing amount of interesting, moving-image artwork produced this last half century.

It is clear from my comments here that film and video exhibitions face variable, continuing issues of successfully negotiating technology, existing architecture, and the individual needs of artworks. I would say that the challenges of single-media shows have been met fairly successfully and conclusively, and that continuing in this direction risks provoking a neo-Greenbergian preoccupation with medium and form, rather than the properly artistic preoccupations which are inevitably and increasingly explored across media. In my view, the most pertinent curatorial challenge today is to present moving-image media such that they can be juxtaposed with and establish dialogue with other art forms, as in "Comme le rêve le dessin," the discussion of which began this essay.

However, for this to be successfully achieved with any consistency, we will have to wait for a generation of museum and gallery designers who are able to accommodate the conflicting needs of contemporary art both for darkness and illumination. This is an issue where technology and curatorial hierarchies intersect and overlap. Moving image technology is developing rapidly and we will soon have projectors and screens that will function effectively in the white cube space. Right now, however, you only have to look at some of the attempts at this in the new Museum of Modern Art, New York, designed by Yoshio Taniguchi, where, for instance, a Joan Jonas video piece, *Songdelay*, 1973, was projected in a white-walled space, to see that we're not there yet. The projectors cannot handle the contrast—its like trying to look at prints and drawings under the midday sun. In the case of New York's MoMA, the intention of displaying the fullest range of contemporary practice together (well apart from process-based, performative work) is important and clearly demonstrated in the contemporary galleries. This newly commissioned building is still really best suited to show off the painting and drawing collections. My current conviction is that museum trustees, architects, and chief curators have a steep learning curve to negotiate before these mainly technical issues are resolved, and we can fully explore the conceptual and expressive range of contemporary artistic expression—moving-image and otherwise.

Ingrid Schaffner
Wall Text, 2003/6
Ink on paper
Courtesy the author

THE OMNIBUS

David Hickey's great omnibus of an exhibition "Beau Monde: Toward a Redeemed Cosmopolitanism" was a beautiful argument for banishing wall texts from the exhibition of contemporary art. Held in 2001, Hickey's version of SITE Santa Fe's International Biennial presented the work of twenty-nine artists in a super-customized installation that was created by Graft Design working in close rapport with the curator and a number of the artists. White walls molded and curved around individual works—works as disparate as Ellsworth Kelly's classic abstractions, Kenneth Anger's controversial films, Darryl (Mutt Mutt) Montana's Mardi Gras costumes, and Takashi Murakami's anime-inspired sculpture—so that the entire museum was transformed into one great architectural frame. Appropriately, the label for this picture hung outside the frame, in the form of a boisterous graffiti drawing by Gajin Fujita painted on the exterior of the building. Inside, works were identified by a free catalog brochure with short, informative entries on each of the artists, a map insert, and a curator's statement on the premise of the show. All of the usual didactic material—from the introductory wall panel to the explanatory labels—was rolled into one hand-carried item that afforded viewers a chance to look at art, undistracted by text and labels.

Gajin Fujita with Alex Kizu (K2S Crew) and Jessie Simon (KGB Crew), *Graffiti Beau Monde*, 2001 (right); and Jim Iserman, Untitled (0101) (Silver), 2001 (left) on building façade of "Beau Monde: Toward a Redeemed Cosmopolitanism," Fourth International Biennial Exhibition, SITE Santa Fe.

Edgar Degas, *Mary Cassatt in the Paintings Gallery at the Louvre*, 1879–80, intaglio, Art Institute of Chicago, Gift of Walter S. Brewster.

To imagine visitors at Hickey's show is to travel back in time to Edgar Degas's print of *Mary Cassatt in the Paintings Gallery at the Louvre*, 1879–80. She leans into a *contrapposto* pose, supported by her umbrella, while her semi-invalid sister Lydia sits in study with a gallery guide, both taking in the pictures and modeling for one. This late-nineteenth-century picture evokes the art world of Charles Baudelaire. The poet, art critic, and flaneur may be the ideal visitor to Hickey's "cosmopolitan salon." Profoundly aesthetic and deeply informed, Baudelaire may well have deduced *avant la letter* Hickey's desire to make a show that would "very closely resemble my idea of a 'beautiful world.'" He certainly would have had little use for a curator's wall text.

But let's say that Baudelaire, who was as particular as Hickey himself, isn't your anticipated audience. A critic and writer, Hickey is well acclaimed for his populist and philosophical writings on the value of beauty and visual pleasure—influential writings that cohere like a super-text to the entire SITE Santa Fe exhibition. One might see the exhibition as a culmination of these texts, which, even if you hadn't read them, were elaborated by the installation's shapely architecture and sheer gorgeousness (Hickey described his selection as "art on the verge of design"). Indeed, this show made spectacularly obvious something that is true of all exhibitions: they are constructions dependent on conventions—assemblages of objects composed in space for the purpose of display. And in eschewing wall text, Hickey chose not to deploy one of those conventions.

It was a rare experience to encounter this choice, compared to the more typical scenario in today's museums. According to critic Peter Schjeldahl, exhibitions are now a-jumble with "patronizing curatorial wall texts, the babble of Acoustiguides, and other evidence

1. Peter Schjeldahl, "Art Houses," *New Yorker*, January 13, 2003, 87.

2. Roberta Smith, "When Exhibitions Have More to Say than to Show," *New York Times*, April 13, 2003.

3. Audio guides are also, ostensibly, part of the conversation on didactics. They are the techno-brochure handouts of our day and they are also a topic in their own right. This essay will keep to what's actually on the wall of an exhibition.

4. F.J. North, *Museum Labels: Handbook for Museum Curators*, Part B, Section 3 (London: Museums Association, 1957), 4.

5. Ibid., 5.

of marketing and education."[1] However unkind, Schjeldahl's remark points to a real problem. There is a lack of both rigor and regard paid exhibition wall text, which has become, like wallpaper, something of a dreary necessity, taken for granted even by the curators that write them. Or worse: writing for the *New York Times*, critic Roberta Smith chided curators for producing shows that "between the art, the labels, and the catalogs, are largely talk."[2] However, to therefore deduce that, when it comes to showing contemporary art, all wall text is bad, or superfluous, is to deny the complexity and creativity of a curatorial practice. Hence these remarks. Wall text is a curator's responsibility. It includes the large didactic panel introducing the exhibition, as well as all the various-sized smaller panels and labels, marking specific works or moments throughout the installation.[3] It is an opportunity to transmit insights, inspire interest, and to point to the fact that choices have been made. When there is no wall text, other assumptions are being made, which also need to be read critically. Whether present or absent, wall text is an ephemeral literature. It colors our experience, but it is eminently forgettable. And just as the curator chooses to insert or not to insert it, so the viewer too has a choice: to read or not to read. Thus, paradoxically, wall texts can in effect appear or disappear on command. As a consequence, they can, and should be approached strategically and creatively—or should not be used at all. Bad wall text is, like bad writing, simply bad.

THE OMNIUM GATHERUM

Why are we stuck with labels in the first place? Embedded in the history of museums, labels also originated with private collecting. As recounted in *Museum Labels*, a 1957 publication of the Museums Association, London, the first collections ranged from "the *ominium gatherum* of the individual for whom every 'oddity' and 'rarity'...had a peculiar fascination" to the "Cabinet of the more discerning collector, who was usually a student of some branch of...natural history or archaeology" to the "acquisitions of wealthy patrons of art."[4] In every case, it was the collectors themselves, who—prideful of their possessions and the status they conferred—provided all the explanation on offer to those fortunate enough to be invited in for a private view. A label identifying a group of objects might appear attached to a case; there is a 1719 print of Pope Clement's botanical collection showing a box labeled "rocks and minerals." To keep track of their possessions, collectors kept inventories, and sometimes produced excellent catalogs to document and disseminate information about their holdings to like-minded individuals. As collections evolved a more public purpose, curators assumed the job of on-site explanation. The first keeper of the Ashmolean Museum, for example, did not receive a salary but was paid per tour. This system gave rise to some amusing eighteenth-century complaints. Recipients of a British private collector's tour complained of their guide's "requiring everyone to listen to him as to an oracle."[5] A visitor left to his own devices in an

Italian cabinet remarked, "it is to be wondered at that those who have had the Curiosity, and means to amass so many fine Things together should not have had the care…to add explanatory Remarks on such as are most considerable."[6]

6. Ibid.

The invention of the modern museum brought with it a mandate to educate the masses. Whereas visitors to early collections would have been on social par with their hosts, the Grand Tourist was increasingly finding him- or her-self sharing the museum with the unleisured classes. Entrance fees to the Mechanics Institute, in London, were staggered: ladies and gentlemen paid higher admission than tradesmen, who paid more than the working classes.[7]

7. Ibid., 8.

(Dress and speech declared your ticket price.) Inventory-like tags that had once sufficed for members of those elite groups, whose expeditions and sprees may have given provenance to the objects on view in the first place, raised more questions than they answered. In 1857, the British House of Commons passed a rule that, in national museums, objects of art, science, and historical interest would thenceforth be accompanied by "a brief Description thereof, with the view of conveying useful Information to the Public, and of sparing them the expense of a Catalogue."[8] Attempts to standardize labels throughout the British museum system led, during the 1890s, to a series of reports by the Museums Association. One popular idea was to print labels on basic topics or types of objects for general distribution. Typically over three hundred words in length, these "specimen labels" threatened to turn exhibition displays into textbooks. The uniformity they sought to impose met with lively resistance and debate, as evinced by a swell in literature on wall labels around the turn of the century.[9]

8. Ibid.

9. See the bibliography in North, *Museum Labels*.

THE SO-CALLED GALLERY LEAFLET

The author of the invaluable publication from which I have just extracted this history was F.J. North. North was not a curator of art, but a keeper of geology at the National Museum of Wales. And while he confidently dispenses advice on how to label winkles and lions, he counsels that art is a different matter altogether. "There are, indeed, differences of opinion as to whether the things displayed in art galleries should have labels at all."[10] This question was taken up by Laurence Vail Coleman, whose 1927 American manual for small museums was as serviceable to North in 1957 as it seems today.[11] Coleman parses the problem three ways. Viewers who take only an intellectual interest in what they see are apt to be frustrated by installations that don't provide didactic labels. Art is, by contrast, a sensory experience and labels, however informative, cannot help viewers in their appreciation of art. They can actually hinder its experience. Basically, it comes down to aesthetics versus information, weighted on the side favoring aesthetics. The best solution, Coleman concludes, is to produce short inconspicuous labels and gather "together the real label texts into a so-called *gallery leaflet*."[12] Solid advice that harks back to

10. Ibid., 31.

11. Laurence Vail Coleman, *Manual for Small Museums* (New York: G.P. Putnam's Sons, 1927); see 223–31 for the chapter on labeling.

12. Ibid., 224.

the nineteenth-century Salon and pitches forward to "Beau Monde." But take a moment to consider the context in which Coleman would have been doing this leafleting.

The small museum of the 1920s was a temple for art—modern buildings based on classical architecture are illustrated throughout Coleman's manual. It was a place to see treasures of Western culture, including exotic trophies of colonialism, and, perhaps, some useful decorative arts. All of these could be read comfortably within the conventions of display. But what if your model isn't a shrine, but a laboratory, a lounge, a forum, a *Wunderkammer*, a cabaret? Don't imagine that the maverick director of the Wadsworth Atheneum, A. Everett, "Chick," Austin Jr., kept a copy of the small museum manual at his bedside, while he was fixing to present the avant-garde opera *Four Saints in Three Acts* as part of the museum's program for the Friends and Enemies of Modern Music in 1934. Perhaps your model is not a museum at all: it's a site, a visual context, an intervention. How to label, for example, an earthwork? A colleague says he did not know he was experiencing Michael Heizer's *Double Negative* until he was halfway across the mesa it was cutting through. What if the art on view was created specifically to defy the conventions of the small museum? It should not be assumed that the bottlerack, a task, or a room full of mortuary mist, will hold, or seeks to command, the same complacent authority as a nineteenth-century painting.

On display in a small museum, Joseph Beuys's *Fingernail Impression in Hardened Butter*, 1971, would appear to have more in common with the Ashmolean's "a legge and claw of the Cassowary, or Emu, that dyed at St. James', Westminster," than, say, any one of Alexander Calder's modernist mobiles. Indeed, a lot of contemporary art makes its initial appearance on the level of curiosity—by naturally raising questions. For viewers in pursuit of pure aesthetic experience, who may want to dismiss an object because it does not look like art, wall labels can say what the small museum won't tell: "It's okay that you don't find this pleasing, it wasn't made to be." This is not to say that conceptual art, for example, can never be exhibited without didactics to support it. Certainly a general knowledge of the practices (and myths) that make relics into sculpture, will allow the mesh bag that Lygia Clark made for viewers to wear over their heads, her *Máscara abismo (Abyss Mask)* of 1968, to be seen as a compelling enough artwork. But to know that she intended the interaction as "an experimental exercise in liberty," along with something of contemporaneous Brazilian politics and culture, is to experience the object more fully charged. Particularly in an art world that seeks to be global, this information need not be discretely tucked away in a genteel brochure or distant panel. It can be a straightforward presence, so that without breaking eye contact, one reads both the panel and the object. To wander around organizers Luis Camnitzer's, Jane Farver's, and Rachel Weiss's 1999 "Global Conceptualism" exhibition at the Queens Museum, a gallery leaflet in hand, would have been incon-

gruous with the immediacy of the objects themselves. One wonders, in fact, if without abundant, conspicuous wall texts, how much of the art on view in that groundbreaking show would have been reduced to mere curiosities.

BELIEVE IT OR NOT

Artists have a lot to teach curators about the rhetorical power of text. Turning art into artifacts, and artifacts into displays of institutional racism, all with the switch of a label, has been a major motif in Fred Wilson's art. Since the early 1990s, Wilson's institutional interventions and mock museum installations have shown labels to be less than benign. For his 1992 commission *Mining the Museum*, he juxtaposed objects from the Maryland Historical Society's permanent collection with objects and labels of his own fabrication. A cigar store Indian was declared a piece of racist folk art when Wilson named the anonymous Native American *A Portrait of John Klein*. Elsewhere in the installation, Wilson used spotlighting on an eighteenth-century white family portrait to pick out the black slave child. Originally included as one of the many signs of the family's wealth and status, she became the dignified subject of Wilson's display. Out of this collapse between fact and fiction emerge pictures (and people) that had been typically excised from the official account of Baltimore society. A pair of slave's shackles was inserted in a case of silverware collectively labeled "Metalwork 1830–1880." There was also comment on the peculiar habits of curators: a case full of arrowheads, their accession numbers showing, was called "Collection of Numbers." Wilson's practice stems from his experience inside the museum: he has worked as a museum guard, educator, and director. Indeed, he started his artistic practice in 1987 while he was the director of the Longwood Arts Project in the South Bronx. He used the space to create three different settings—an ethnographic museum, a Victorian room, and a contemporary white cube—in which he showed the work of three emerging artists. Wilson's "Rooms with a View" raised interesting possibilities. The primitivism of Picasso would take on a whole different character when explicated through maps, short films, and other information about the Spanish artist's bohemian tribe. Just as the Mbuya mask appears validated with a new form of significance when it is shown without any of those museum modifiers.

Another example that comes to mind is *The Play of the Unmentionable*, 1992, Joseph Kosuth's monumental installation for the Brooklyn Museum, organized by curator Charlotta Kotik. Staged at the height of the culture wars, Kosuth's installation filled the museum's lobby with "offensive" art culled from virtually every department of the museum and accompanied by didactics galore. There were quotes from sources throughout history silkscreened, like super-texts directly on to the walls; these were painted a museological mausoleum gray. The effect was arresting enough to transform the museum's transitional lobby space into a vault of cascading words and pictures that

streamed like water over the installation's walls. There were also curatorial wall labels of every shape and size. And there were crowds of visitors, quietly absorbed in reading the interplay between words and objects. These included "pornographic" Japanese prints, with an encyclopedia definition of *shunga* or "spring pictures" from a tradition where sex was neither romantic nor phallic, but joyful. There were photographs of male nudes and flowers by Robert Mapplethorpe, whose work was demonized at the center of the then-current debates about inappropriate allocation of state funding for the arts. This quote floated overhead:

The artist does not create for the artist: he creates for the people and we will see to it that henceforth the people will be called in to judge its art.
—Adolf Hitler

There was a classical sculpture of a young male nude with a cape that, the didactics informed us, was draped expressly for the purpose of exposing his godlike physique to an approving Apollo. There were images of iconoclasm. What appeared to be fragments of Egyptian sculpture, ruined by the passage of time, were in fact imputable evidence of an ancient conservative lash-back. Following the fall of Akhenaten, during whose progressive reign art radically evolved, his name and imagery were mutilated and destroyed in order to excise his power.

And yet, given the amount of information Kosuth's installation imparted, its message was far from rhetorical. It showed how the meaning of objects changes not only over time, and from place to place, but also that these meanings are neither inherent, or immediately apparent. They take time to both learn and construct, as well as to impart and challenge. In making our way through centuries of the "unmentionable," we as viewers were impelled by our own relative sense of curiosity to spend time creating a bigger picture of censorship—and its interminable threat to creative freedom and expression—than we arrived at the museum with. By giving expression to (and facilitating) a flow of ideas, labels were essential to this process—an interpretive process not unlike the construction of a work of art, an exhibition, a story, history, knowledge.

Interpretation is everything at the Museum of Jurassic Technology (MJT), an exhibition construct that hovers between the factual and the fantastic, just by the thread of its didactics. The creation of its founding director David Wilson in 1989, this Los Angeles institution presents mundane artifacts—teacups, pincushions, a tatty taxidermied coyote head, a picture of a waterfall, a small bed—in elaborately mounted displays. Wall cases with wooden moldings, text panels, maps, technical diagrams and terms, dimly lit galleries punctuated by dramatic spotlighting, scholarly-looking handouts and small catalogs, the banner and signage outside the façade, all combine to confer a sense of meaning upon objects that are impervi-

ous to such authority. As viewers, we are caught between sensible disbelief and a desire to see the Flemish landscape with animals in the distance—a monkey on elephant back, a bear, a lynx, a camel, stag, etc.—not to the mention the "bearded man wearing a biretta (a long tunic of classical character)" and the "unusually grim Crucifixion" all allegedly carved onto that tiny fruit pit standing before us in that case, which is itself partially obscured by the fronds of a potted plant, placed in front of it.[13] Indeed, the label reads almost exactly like one describing a similar treasure in the Metropolitan Museum of Art. But without an exhibit about "The Stink Ant" in proximity, the Met's pit strains neither our eyes, nor our faith in knowledge. We see as we are told. Unlike at the MJT, where the identity of the entire institution is a question mark. Part conceptual artwork, part dime museum, one thing is certain: this ersatz institution full of elliptical objects is nothing without its wall labels.[14]

TAGS AND TOMBSTONES

In whatever direction there may be differences of opinion, it will be agreed that the label must look good.
—F.J. North[15]

Richard Tuttle is known for making works based on slight, self-effacing gestures. He is just about the last artist one would expect to express interest in wall labels, except to ensure that they are out of view of his art. And yet, for his 2001 installation at the Institute of Contemporary Art, University of Pennsylvania, he specifically requested that the labels hang large. He reasoned that, if this is going to be a museum show, by all means, let's make it so: let the labels signify. And so they did, by being both there (some were almost as big as some of the works) and not there (as much as you were aware of them, they were totally eclipsed by Tuttle's art). The labels themselves were of the variety known as "tombstones": museum jargon for

"Richard Tuttle, In Parts, 1998–2001," Institute of Contemporary Art, University of Pennsylvania, Philadelphia, 2001, installation view.

13. Quoted from the wall label and brochure handout. It's interesting to note that the imprint of the MJT, the Society for the Diffusion of Useful Information, takes its name from a popular nineteenth-century British science magazine.

14. Dime museums, in the tradition of Ripley's Believe it or Not and P.T. Barnum, were freak shows of grotesque curiosities. Barnum famously acted as the barker and curator of his museum, and literally drummed up customers by banging on said instrument outside the museum. David Wilson, incidentally, is known to play the accordion outside the MJT.

15. North, *Museum Labels*, 12.

"Richard Tuttle, In Parts, 1998–2001," Institute of Contemporary Art, University of Pennsylvania, Philadelphia, 2001, installation view.

16. Bruce Chatwin, *Utz* (New York: Penguin Books, 1988), 20.

those labels bearing a work of art's vital statistics—artist, title, date, medium, collection. It's a fitting image, this tombstone. It recalls Baron Utz's decree in Bruce Chatwin's novel: "In any museum the object dies—of suffocation and the public gaze."[16] In taking up its resting place on the wall, the label exists as a physical thing, a stone, that some artists choose to see as part of their work. Felix Gonzalez-Torres, for example, specified that the labels for his stacked paper works be printed as offset, in order to create an overall coherence between the production of the label and the work of art. Similarly, Louise Lawler and Hiroshi Sugimoto have both been known to label their framed photographs right on the mat. The titles of Richard Misrach's photographs are etched, by him, on the frames. For artists for whom titles matter, this measure ensures that curators won't bury your work under the wrong tombstone. It also allows artists to take back the tradition of attaching a gold label right onto a gilded frame, something curators and collectors once did with pride, and which now constitutes a form of museum critique.

For curators of contemporary art, the thingness of labels is more circumscribed. Depending on the nature of the exhibition, labels may work better when blended with the wall as much as possible. Silkscreening is ideal, but expensive; however computers make it possible for virtually anyone to produce a clean label, which, if time and money allow, appears more elegant (less distracting) mounted on a bevel-cut piece of mat board. Typically, they should neither appear too big nor too small when seen in relation to things they are labeling. It's also a matter of taste whether to select a number of uniform sizes or cut each label individually. Independent curator Catherine Morris recalls the ludicrous spectacle of a scholarly exhibition of Whistler's print-marks, in which the tiny stamps were overwhelmed by voluminous wall labels. As tombstones went, it was dead butterflies commemorated by war monuments.

Having coolly dispensed with today's institutional wisdom, it's

17. North, *Museum Labels*, see the chapter "Fabric and Style," 12–21.

interesting to know that labels were once much more idiosyncratic objects. Writing in 1957, North notes that the vogue among better museums for black labels had thankfully lapsed due to their being over-conspicuous and because they are "apt to be depressing."[17] Although, I must say that I was struck not only by the beauty but also by the poetry of those at the Wagner Free Institute. One of Philadelphia's museum gems, the Wagner is a perfectly preserved (and unpreserved) nineteenth-century natural history museum. A case displaying forms of sea life sported black labels with white print, some of which had faded, leaving the SEA LILLIES, CORALS, and LAMP SHELLS, trans-formed into the new specimens of SEA LI IES, CORA S, and AMP HELL. In his book, North advises that, although white is generally the wall color of choice in galleries, white paper labels tend to discolor and show up the dust. He writes of textured and tinted papers, from buff to lilac to dark brown. And he recommends, due to its opacity, "the liquid-white preparation sold for cleaning canvas shoes" rather than white ink. "Blue ink on a primrose background makes for good legibility" and can "make an otherwise dull exhibition attractive." And he personally favors handwritten over typed labels, because they ap-pear less mechanical, more personal. If you must use a typewriter, he says, make sure that the ribbon is "unfading," the alignment is good,

18. Ibid., 19.

and that the small enclosed letters are not blocked[18] (a museum label should not look like a ransom note). From the 1927 *Manual for the Small Museum*, comes this tip: "It is customary to print four copies of each label: one on board for immediate use, two on board for reserve and on one white paper for pasting in a record book."[19] If not in a

19. Coleman, *Manual*, 230.

record book, wall labels should be kept on computer file to document this ephemeral feature of the exhibition.

The standard placement of labels follows this simple rule: be-cause we read from left to right, the label should appear to the right of the object, at eye level, where it appears like a footnote to the work of art. To make the "reading" of art appear even less anno-tated, when he joined the staff of the Museum of Modern Art as a curator, Robert Storr introduced a new approach determined to further enhance the viewer's aesthetic experience of the collection. He took the "tombstone" labels out from between artworks and po-sitioned them in rows, or clusters, at the end of their respective wall. Longer explanatory labels on groups of works, or a relevant theme, are set off by themselves, ideally on a short wall, or column, not visu-ally connected to the art at all. To subdue the visual crackle of print, Storr prefers a somewhat grayed-down black ink. The desire to free walls of text has lead to some further interesting solutions. Curator Jennifer Gross at the Yale University Art Gallery says that for a show on color, she color-coded parts of the wall and supplied viewers with a map. Not the most successful experiment she found, as "people have trouble with maps." Maps do seem more trouble than they're worth. The walls are rid of labels, but so what: you're busy looking down at a piece of paper, away from the art, struggling with the ori-

20. A checklist with numbers can work, unless the numbers are sequential in space and the checklist is alphabetical, as sometimes happens, to result in excessive paper turning.

entation of the room.[20] Far better was Gross's plan for a small show of modern bronzes. Unless it's on a pedestal, sculpture is always attended by the problem of sitting in space with no immediately apparent place for labels. At Yale, viewers carried the labels with them, like keys on a ring; a reproduction on each card made it easy to identify works, read the tombstone, and find some interpretative text. These are just some variations on the what and where of wall labels, which when treated as objects, can assume more (or less) of a presence in relation to the art on view.

WHAT SHOULD A LABEL SAY?

There should be no set standards for labels. Every exhibition calls for the curator to decide whether, and to what extent, labels will be used, how long they will be, and what voice they will adopt. When the decision is to make labels part of an installation, here are some general guidelines. Labels should talk to the viewer and to the art *simultaneously*. They should be written knowing that the art is there in front of the viewers, who are already engaged enough by what they see to want, not only to know more, but also to see more. Imagine the label as part of a three-way switch: from looking at the art, to reading the label, which points back to the art. In this ideal exchange, labels broker a larger understanding of the bigger picture of the exhibition itself. The viewer is not asked to be merely a reader, but an interpreter, who is welcome to bring his or her own unpredictable and unaccountable sense of meaning to what's on view. On a more practical note comes another triangular motif. Curator Laura Hoptman, now of the New Museum in New York, recalls being taught an old museum standard that set the form for wall labels as a triangular in content. Accordingly, text proceeds from the specific to the general, as if in answer to an obvious question posed by the work of art or the show. This question, once answered, might lead to a broader discussion of history or context, a discussion which the reader is free to follow as far as she or he likes. Whether or not, as a curator, one decides to abide by this triangle, its form does serve to underscore a basic premise of our practice: observation is the primary experience to be enhanced, not superseded (or worse, obfuscated) by explanation.

Labels speak for the curator, whose job it is to articulate the reason for an exhibition. When curators don't use labels, or when the labels are badly written, it may indicate that the show was only vaguely conceived from the start. "Many installations are poorly labeled because they are without purpose and therefore cannot be labeled," Coleman warns in his museum manual. (Coleman, incidentally also offers this concrete piece of advice: "If the concluding sentences of a label are written with a view to persuading the visitor to do something about what he has learned [like look at another picture in the show, or think about how it relates to daily life], the label attains to the greatest usefulness.")[21] Thus the reason to label might be reason itself. This is particularly so in the case

21. Coleman, *Small Museums*, 227.

of group exhibitions, where a proposal or premise is clearly being constructed, based on a particular group of works, which have no other reason for being together than a curator's whim. This said, I would reiterate that all exhibitions, including monographic ones, are essentially essays. Ever present, the thread of the curator's vision and thinking is a factor which labels can account for. Indeed, being among the most privileged of viewers, curators should never take their information for granted, particularly in the field of contemporary art. Call it the new connoisseurship—connoisseur means "to know," after all. Today it seems clear that to recognize quality is to know what issues, politics, theories, histories, and images are at stake for artists and culture at large. Exhibitions should make visual those stakes, which can, in turn, be explained by curators through wall text. Even when the premise of a group show is something as apparent as the color blue, consider how reductive this can become. Without a label to say that, for Yves Klein, "International Klein Blue" was physical manifestation of otherwise invisible cosmic energy, his blue pigment is apt to be seen as simply the same color as the rest of the blue stuff in the show.

Having so heartily extolled the virtues of wall text, one might assume that the claim of this essay is that no curator worth his or her salt should produce an exhibition without copious amounts of didactics. Nothing could be further from the point. As outlined from the start, effective wall texts can be quite short (or nonexistent). More importantly, the writing of wall texts should be approached as an enterprise that is absolutely distinct from composing catalog prose or press releases. Never forget that viewers are, more often than not standing—a less than ideal position for reading. (Unless, like Mary Cassatt, you've an umbrella to lean on.) For this reason too, the language of labels should be tuned to viewers' ears. An active voice and short sentences are one way to avoid inducing mental collapse on the gallery floor. Write as you yourself would like to be addressed. In his advice on writing labels, North recounts an anecdote about a label "accompanying a mounted lion in a large English museum: 'Lion, a digitigrade carnivorous mammal belonging to the family Felidae.' A visitor, asking what the label meant was told that the lion is a big cat which walks on the tips of its toes and eats flesh. 'Then,' he replied, 'Why on earth didn't the man who wrote the label say so?'"[22] This story reminds me of one that Richard Torchia, director of the art gallery at Arcadia University, tells of his annoyance at a museum label that compared an Andres Serrano photograph to an abstract expressionist painting, while delicately failing to mention that the photo was a picture of cum.

As much as possible, the label should appeal to someone who knows more, less, and as much as you do. Terms that are buzzwords in the art world (appropriation, Baudelarian, post-conceptual) can only be used when the meaning is shared and elucidated through the work itself. Why not equip viewers with the same heavy artillery

22. North, *Museum Labels*, 34.

165

with which we curators are armed? Language can be rigorous, or colloquial, as long as the overall tone is generous. It's easy to hear when a label sounds pretentious ("I know more than you do"), or worse, patronizing, ("Dear ignoramus"). Unfortunately, it's the art which then tends to suffer the viewer's disdain. Nor should wall labels read like undigested résumés—what does it matter that an artist was up for a Turner Prize and will participate in the next Documenta, when you're really just trying to make sense of this object before you? (And why waste words—good standing time—on listing credentials that many will find meaningless to begin with?) By all means, avoid mystification. The labels for the Guggenheim Museum's Matthew Barney exhibition were laudable in that they dispensed with that completely expendable term "mixed media" and lovingly detailed every petroleum product and feather deployed. However, they were extremely ineffectual as interpretation, doing no more than representing in words the artist's mythology—the complexity of which is self-evident through the work. As a colleague pointed out, this was a missed opportunity for a museum to inform a mass audience about key issues in contemporary art. As it was, a record number of visitors would have left without a clue why it is significant, or possible, for an artist to produce sculpture that visually functions as a film prop.

In researching this essay, I tried to learn from different institutions what policies exist for wall labels. Where I work, at the Institute of Contemporary Art, University of Pennsylvania (which organized the Serrano show with the offensive label), for instance, the curator alone determines what goes on the wall. In speaking to larger, collecting institutions, it seemed that curatorial departments were predominantly in charge of originating the wall text. These were often vetted through education and editorial departments. I never spoke to a museum where educators actually wrote the wall texts, but there were rumors. What seems objectionable to this practice (should it exist) is not some fear that educators cannot write about art, but that curators would relinquish their authority as creators of exhibitions to those whose job it is to instruct. Yes, there is much to be learned by looking at art, but a label should aim to inspire enthusiasm and a sense of acumen about visual experience in its own right. *Why is this exciting or profound?* not *What can this teach me?* should be the label's bead on expression.

When asked who their labels are written for, most museums described their intended reader as "college educated, but not necessarily in art." Again, any rumors that curators must write for second-graders—no three syllable words—went unfounded. All of the major institutions have printed guidelines for label-writing. These guidelines set out the museum's "house style" (clarity is appreciably the main concern); and define various types of labels (there might be appropriate lengths for different types, or levels of information). Guidelines might include rules like no foreign words (*contrapposto*) or technical-seeming terms (triptych); no references to other works of art or artists. Editorially speaking, these rules are not hard and fast, but open

to negotiation. They mostly come into play when there is a question of sense, or meaning. One of my most interesting conversations was with Pamela Barr at the Metropolitan Museum of Art in New York, a museum that does not shy from using words like *chinoiserie*, when appropriate, in its labeling of art. Barr has the encyclopedic task of editing all of the museum's wall texts. She works closely with curators to ensure they write not only for art historians, but for museum visitors as well. Producing an active voice and short sentences are among her editorial objectives. She also works with exhibition designers. There are traffic issues to consider, so that information (and viewers) literally flow through the galleries. A giant didactic pushed into a main artery is to be avoided, as are flotilla of small ones shoved into a corner. When I asked her about working with Richard Martin, Pamela Barr said it had been her great pleasure and honor to work with a curator who would seem to have broken every rule of institutional label writing.

Richard Martin (1945–99) is to be celebrated for the wall texts he composed for the exhibitions he created with collaborator Harold Koda. For many years the editor of *Arts* magazine, then director of the Fashion Institute of Technology, and lastly curator of the Costume Institute of the Metropolitan Museum of Art, Martin was a man of supreme intelligence and vision. Working together with Koda, who carries on the team's brilliant work at the Met, Martin curated exhibitions ranging from "Jocks and Nerds to Fashion and Surrealism" to "Infrastructure," a show about underwear. These shows are known as much for mixing fashion, art and ephemera as they are for their installation design—design in which text played a spectacular role. Printed in scripts stylistically appropriate to the given theme, quotes from sources ranging from symbolist poetry to pop culture to philosophy punctuated the space. (Think of Kosuth's "Unmentionable" exhibition, but cast conceptually in pink not gray.) Labels, long and short, conveyed a sense of passionate interest not only for the particularities of the objects on view, but for their possible meanings in the world. Martin's style of writing was erudite and expansive, full of his own pleasure in knowledge, in words, and in the act of interpretation. Take the words from "Bloom" for instance. The opening didactic for this 1995 exhibition begins: "'Bloom' surveys fashion's treatment of botany and of the brash paintbox of flowers, revealing expressions of regimen and silence, beauty and youth, new life and morality, naturalism and allegory."[23] It goes on to conjure the fragrance of flowers, to speak of their language and fragility, to quote from Edna St. Vincent Millay, to liken a 1950s ball gown to "a bucolic, arcadian ideal," and to see the influence of Burpee seed packages on a 1980s outfit. All in less than 300 words. That can be the power of wall text. When treated as writerly text, and not just a mode of description or information, what is written on the wall can provoke a receptive and associative state of mind. Labels have the potential of art itself, to be sensual, smart, and experiential.

23. Quoted with kind permission of Harold Koda, curator, Costume Institute, Metropolitan Museum of Art, New York.

I would like to thank those friends and colleagues, who took time to share their thoughts, which inform this essay, and in particular, Geoffrey Batchen and Chris Taylor for their helpful readings.

Afterword

This book discusses what makes a visual arts exhibition great. That is an important question for The Pew Charitable Trusts, because we believe that the most successful exhibitions serve the artists, objects, and ideas they set out to illuminate, and at the same time draw audiences into satisfying, even transformative, personal encounters with the work. Moreover, great exhibitions contribute to regional, national, and international art discourses, while conferring visibility and stature on the organizations that present them.

Philadelphia has an extraordinary breadth and depth of collections of art and cultural materials as well as a large and diverse array of collecting and exhibiting institutions. What the region was missing, when the Philadelphia Exhibitions Initiative was established in 1997, were adequate resources to encourage and support those institutions to animate the objects and ideas in their stewardship through challenging, creative, and innovative exhibitions. Many of the shows that were mounted went undocumented; the lack of catalogs for even major exhibitions impoverished the intellectual discourse around art issues and left unfulfilled the potential for educating and enriching the understanding of visual art audiences and the general public.

The Trusts came to understand this predicament through research and interviews with local and national leaders in the visual arts, as part of a process leading to the development of the Philadelphia Exhibitions Initiative. Our objective was to apply to the visual arts an approach that had already worked well in previously established initiatives supporting dance, theater, and music. That is, first we sought to identify priority issues within each arts discipline; in order to properly direct a grant-making program. Then we identified a smart, thoughtful, entrepreneurial leader to direct each initiative (in this case Paula Marincola). And we started working with the program director and our institutional partner (the University of the Arts) to design a strategy that combined project support with planning grants and professional development opportunities for artistic leaders in the community.

Our assumption was and is that to achieve consistent artistic success it takes a combination of time, intellectual as well as financial support, opportunities for peer learning and, often, planning grants as well as those for implementation. The use of grant panels consisting of distinguished national leaders—a combination of

artists, curators, and institution directors—ensures that projects are selected for funding through a rigorous and objective process. At the same time, these panels provide valuable feedback on Philadelphia's place in the larger world of the visual arts (and, through our other initiatives, in the worlds of dance, music, theater, and historical heritage); and guidance in the continual refinement of our program design. In turn, panelists see the growing quality, energy, and innovation of artistic activity in the Philadelphia region and become our ambassadors to the community at large.

The Pew Charitable Trusts cannot make great exhibitions happen. But in the ways I have just described, we strive to create the conditions in Philadelphia that will allow talented artists, curators, and institutional leaders to create them.

We also continually look for ways to respond to new artistic and programmatic ideas and impulses. As the Trusts' artistic initiatives—Dance Advance, the Heritage Philadelphia Program, Pew Fellowships in the Arts, Philadelphia Exhibitions Initiative, Philadelphia Music Project, and Philadelphia Theater Initiative—have matured, we have become interested in expanding beyond the discipline-specific work of each of these programs and are seeking ways to encourage and support more collaborative, interdisciplinary approaches to professional development and grant-making activities. Our intent is to refresh the Trusts' investments in the local arts and culture community by recognizing that some of the most important new work being produced is boundary-crossing and challenges traditional forms and expectations. At the same time, we will sustain the flexibility of our initiatives to identify and support excellence and creativity wherever it is to be found.

As one means to this end, in 2005 the Trusts created the Philadelphia Center for Arts and Heritage to house all six of our artistic initiatives along with the Philadelphia Cultural Management Initiative. Our hope is that the Center will become a place in which a lively and wide-ranging discourse about the arts can be stimulated and nurtured, and where new ideas can guide the Trusts' support of the region's culture to the benefit of artists, institutions, audiences, and the community at large.

This book is one manifestation of that hope. On behalf of The Pew Charitable Trusts, my thanks go to Paula Marincola for her passionate and persistent commitment to this publication and the ideas it embodies, and for her sure leadership of the Philadelphia Exhibitions Initiative, from which it sprang.

Marian A. Godfrey

Director, Culture and Civic Initiatives, The Pew Charitable Trusts

Acknowledgments

This small book has benefited greatly from the work of many over the process of its realization. It didn't exactly take a village, but just about.

At The Pew Charitable Trusts, Marian Godfrey, Director of Culture and Civic Inititatives and the chief architect of Pew's Culture Program, and Greg Rowe, Deputy Director for Culture, encourage those of us who direct the discipline-specific artistic initiatives to consider how we can make larger contributions to our fields as we focus on expanding the capacity of our community and enriching the cultural life of the region. I am deeply grateful to both of them for their leadership and their ongoing, enthusiastic support of PEI's professional development activities, and of this book in particular. Marian's afterword also provides an important context for understanding how the initiatives' work will be going forward now that we are housed together at the Philadelphia Center for Arts and Heritage.

At PEI, my former assistant of seven years, Gordon Wong, worked capably and cheerfully on the many varied, sometimes frustrating tasks involved in assembling this book from its initiation until he left for new professional opportunities in August of 2005. Bennett Simpson, former Associate Curator at the Institute of Contemporary Art, University of Pennsylvania, acted initially as my editorial assistant on this project, and also skillfully conducted one of the interviews for this collection, until he left Philadelphia to become Associate Curator at ICA Boston. I thank both Gordon and Bennett for their valuable contributions to *Questions of Practice: What Makes a Great Exhibition*.

Jeremiah Misfeldt, acting as Publication Co-ordinator, then manfully took up the banner, working on every aspect of the anthology, and helping to shepherd this publication through to completion. His was yeoman's work, requiring patience and diligence, and I very much appreciate his efforts. Tiffany Tavarez, Program Assistant at PEI, has also negotiated image rights and assisted me with research while managing her many other PEI responsibilities with awesome powers of organization. Conny Purtill, designer par excellence of art publications, has created an elegant but edgy graphic treatment for this book.

Joseph N. Newland, riding to the rescue on his editorial white charger, has been the man for whom the book was waiting, and without him, and the assistance of Shariann Michael, *What Makes a Great Exhibition?* might never have seen the light of day. I can not thank

him enough for his expert work as our editor, as well as his positive energy and great good humor. Indeed, it has been my pleasure to work closely on this project with all of the above-mentioned talented and dedicated individuals.

In funding exemplary visual arts exhibitions, PEI is, at a fundamental level, supporting curatorial excellence and creativity. In the last year, the visual arts lost one of its most brilliant, charismatic curators, and we respectfully dedicate this collection to honor the memory of Walter Hopps. I am indebted to Mary Swift for generously allowing us to use her expressive portrait of him on our dedication page.

Most importantly, my deepest thanks are extended to each and all of the contributors, for agreeing to take on the big question and responding to it so variously and with such insight and cogency. Not only the Philadelphia Exhibitions Initiative, but the field at large has been greatly enriched by their generosity and their work.

—Paula Marincola

Director, Philadelphia Exhibitions Initiative

Contributors

Glenn Adamson is head of graduate studies in the research department at the Victoria and Albert Museum in London. He was previously a curator for the Chipstone Foundation in Wisconsin. His publications include *Industrial Strength Design: How Brooks Stevens Shaped Your World.*

Paola Antonelli joined the Museum of Modern Art in February 1994 and is a curator in the department of architecture and design. Her first exhibition for MoMA was "Mutant Materials in Contemporary Design." Her most recent exhibition, "SAFE: Design Takes on Risk," was about design and safety. She is currently working on a book about foods from all over the world as examples of outstanding design.

Carlos Basualdo is curator of contemporary art at the Philadelphia Museum of Art and an adjunct professor at Instituto Universitario di Architettura di Venezia. He was a co-curator of "Documenta11" in Kassel, curator of "The Structure of Survival," at the 2003 Venice Biennale, and most recently guest-curator of "Tropicália: A Revolution in Brazilian Culture" for the MCA Chicago and the Bronx Museum, New York.

Iwona Blazwick is director of the Whitechapel Gallery in London and a critic and broadcaster. Until 2001 she was head of exhibitions and displays at Tate Modern and was previously director of exhibitions at the Institute of Contemporary Arts, London, and commissioning editor at Phaidon Press. Recent exhibitions include solo shows of Raoul de Keyser and Tobias Rehberger; and "Faces in the Crowd: The Modern Figure and Avante-Garde Realism."

Lynne Cooke has been curator at Dia Art Foundation since 1991. She was co-curator of the 1991 Carnegie International, and artistic director of the 1996 Sydney Biennale. She recently curated a retrospective of the work of Lili Dujourie, and current projects include a five-installment Agnes Martin exhibition for Dia:Beacon and a collaboration with the Museum of Modern Art, New York, on a Richard Serra retrospective.

Thelma Golden is the director and chief curator of The Studio Museum in Harlem. Her most recent exhibition was "Frequency," in 2005–6.

Mary Jane Jacob is professor and chair of sculpture at The School of the Art institute of Chicago. She is also an independent curator specializing in public art, including artists' projects for the annual Spoleto Festival USA in Charleston, South Carolina. She recently co-edited *Buddha Mind in Contemporary Art* (University of California Press).

Jeffrey Kipnis is professor of architectural design and theory at the Knowlton School of Architecture at The Ohio State University. As former architecture and design curator for the Wexner Center for the Arts, he curated the exhibitions "Suite Fantastique" (2001) and "Mood River" (2002, Annetta Massie co-curator).

Paula Marincola is the program designer and has been the director of the Philadelphia Exhibitions Initiative since its inception in 1997. She was previously the gallery director at Beaver College Art Gallery (now Arcadia University) and assistant director/curator at the Institute of Contemporary Art, University of Pennsylvania.

Detlef Mertins, professor and chair of the architecture department at the University of Pennsylvania, has written extensively on architectural modernism. He is currently completing a monograph titled *Mies: In and Against the World* and co-editing a translation of the 1920s avant-garde journal *G: Material for Elemental Design.*

Mark Nash, a film theorist and curator, is head of the Department for Curating Contemporary Art at the Royal College of Art and director of the International Centre for Fine Art Research, University of the Arts, London. A co-curator of "Documenta11," he curated "Experiments with Truth" for the Fabric Workshop and Museum in Philadelphia.

Ralph Rugoff is a writer and critic who is director of the Hayward Gallery, London. While director of the CCA Wattis Institute for Contemporary Arts, San Francisco, he was founding chair of the California College of the Arts curatorial practice program and curator of such exhibitions as "A Brief History of Invisible Art."

Ingrid Schaffner is senior curator at the Institute of Contemporary Art, Philadelphia, where she recently curated "Accumulated Vision, Barry Le Va" and "The Big Nothing." Previous exhibitions include co-curation of "Julien Levy: Portrait of an Art Gallery," and "Deep Storage." Her *Salvador Dali's Dream of Venus: The Surrealist Funhouse from the 1939 World's Fair* was published in 2002.

Robert Storr is an artist and critic who serves as dean of the School of Fine Arts at Yale University and consulting curator of modern and contemporary art at the Philadelphia Museum of Art. Formerly senior curator of painting and sculpture at the Museum of Modern Art, he recently curated a Max Beckmann retrospective and SITE Santa Fe's Fifth International Biennial; he is commissioner for the 2007 Venice Biennale.

Philadelphia Exhibitions Initiative

The Philadelphia Exhibitions Initiative (PEI), funded by The Pew Charitable Trusts, administered by The University of the Arts, and located at the Philadelphia Center for Arts and Heritage, was established in 1997 to stimulate artistic development in the regional visual arts community. PEI achieves its goal by supporting public visual arts exhibitions and accompanying publications of high artistic caliber and cultural significance. PEI awards grants of up to $200,000 per project. PEI also provides professional development opportunities through planning grants, curatorial roundtables, and symposia that address innovative exhibitions or pertinent issues for the field and the region, through travel grants, and through its resource library. For further information about the Philadelphia Exhibitions Initiative, visit www.philexin.org.

Philadelphia Center for Arts and Heritage

Opened in November 2005, the Philadelphia Center for Arts and Heritage (PCAH) houses seven existing initiatives of The Pew Charitable Trusts. These programs are dedicated to assisting cultural organizations in the five-county Southeastern Pennsylvania region in developing high-quality public programs and effective management practices. PCAH is the home of Dance Advance, Heritage Philadelphia Program, Pew Fellowships in the Arts, Philadelphia Cultural Management Initiative, Philadelphia Exhibitions Initiative, Philadelphia Music Project, and Philadelphia Theatre Initiative. The Philadelphia Center for Arts and Heritage is supported by The Pew Charitable Trusts and administered by The University of the Arts. For more information, visit www.pcah.us.

The Pew Charitable Trusts

The Pew Charitable Trusts serves the public interest by providing information, advancing policy solutions and supporting civic life. Based in Philadelphia, with an office in Washington, D.C., the Trusts will invest $204 million in fiscal year 2006 to provide organizations and citizens with fact-based research and practical solutions for challenging issues. For more information, visit www.pewtrusts.org.

The University of the Arts

The University of the Arts is the nation's first and only university dedicated to the visual, performing and communication arts. Its history as a leader in educating creative individuals spans more than 125 years. For further information about The University of the Arts call 215.717.6000, or visit www.uarts.edu.

Philadelphia Exhibitions Initiative
Exhibition Grant Recipients 1998–2006

ABINGTON ART CENTER
J. Morgan Puett: The Lost Meeting
 public art project, 2004

ARCADIA UNIVERSITY ART GALLERY
(FORMERLY BEAVER COLLEGE ART GALLERY)
Olafur Eliasson: Your colour memory
 site-specific installation, 2002
The Sea and the Sky
 thematic exhibition, 1999
Period Room: A Project by Amy Hauft
 site-specific installation, 1998

ASIAN ARTS INITIATIVE
Chinatown In/Flux
 community arts project, 2004

BRANDYWINE RIVER MUSEUM
*Milk and Eggs: The Revival of Tempera
Painting in America, 1930–1950*
 thematic exhibition, 1999

CHESTER SPRINGS STUDIO
Reenactment/Rapprochement
 thematic exhibition and
 performances, 1998

THE CLAY STUDIO
River
 site-specific installation, 1999

EASTERN STATE PENITENTIARY
*Janet Cardiff and George Bures Miller:
Pandemonium*
 site-specific installation, 2002

THE FABRIC WORKSHOP AND MUSEUM
Ed Ruscha
 residency and exhibition, 2005
Experiments with Truth
 thematic film/video exhibition, 2003
Doug Aitken: Interiors
 new video installation, 2000
Jorge Pardo: New Work
 site-specific installation, 1998

FAIRMOUNT PARK ART ASSOCIATION
*New Land Marks: public art, community, and
the meaning of place*
 public art project, 1999

INSTITUTE OF CONTEMPORARY ART,
UNIVERSITY OF PENNSYLVANIA
*Architecture + Design Series: Ben van Berkel
and Caroline Bos (UN Studio) and Peter
Eisenman/Laurie Olin*
 site-specific installations, 2005
Accumulated Vision: Barry LeVa
 retrospective exhibition, 2003
*Architecture + Design Series: stratascape:
Hani Rashid + Lise Anne Couture and Karim
Rashid; Intricacy curated by Greg Lynn*
 installation; thematic exhibition, 2001
Wall Power
 thematic exhibition/public art project, 1999

JCCS GERSHMAN Y BOROWSKY GALLERY
A Happening Place
 thematic exhibition, 2002

THE LIBRARY COMPANY OF PHILADELPHIA
FOR PACSCL
Leaves of Gold
 illuminated manuscript exhibition, 2000

MAIN LINE ART CENTER
*Past Presence: Contemporary Reflections on the
Main Line*
 site-specific installations, 2003
Points of Departure: Art on the Line
 public art project, 1998

JAMES A. MICHENER MUSEUM
George Nakashima and the Modernist Moment
 design exhibition, 2000

NEXUS/FOUNDATION FOR TODAY'S ART
Context
site-specific installations, 1998

PALEY DESIGN CENTER, PHILADELPHIA
UNIVERSITY
What is Design Today?
thematic design exhibition, 2001

GOLDIE PALEY GALLERY, MOORE COLLEGE
OF ART & DESIGN
Artur Barrio: Actions after Actions
exhibition and installation, 2005
Jörg Immendorff: I Wanted to Become an Artist
retrospective exhibition, 2003
Raymond Hains: Art Speculator (1947–2002)
retrospective exhibition, 2002
Valie Export: Ob/De+Con(Struction)
retrospective exhibition, 1999
*La Futurista: Benedetta Cappa Marinetti
(1917–1944)*
retrospective exhibition, 1998

PENNSYLVANIA ACADEMY OF THE FINE ARTS
Ellen Harvey: Mirror
site-specific installation, 2004

PHILADELPHIA FOLKLORE PROJECT
Folk Arts of Social Change
thematic exhibition, 1998

PHILADELPHIA MUSEUM OF ART
Thomas Chimes
retrospective exhibition, 2006
*Pontormo, Bronzino, and the Medici: The
Transformation of the Renaissance Portrait*
retrospective exhibition, 2004
*Museum Studies 7: Christian Marclay,
The Bell and the Glass*
installation and performance, 2002
Barnett Newman
retrospective exhibition, 2001
*Out of the Ordinary: The Architecture and
Design of Robert Venturi, Denise Scott Brown,
and Associates*
retrospective exhibition, 2000
*Museum Studies 4: Rirkrit Tiravanija;
Museum Studies 5: Gabriel Orozco*
1998

PHILADELPHIA PRINT COLLABORATIVE
(PHILAGRAFIKA)
(Re)Print
residency and public art project, 2006

PRESERVATION ALLIANCE FOR GREATER
PHILADELPHIA AND PEREGRINE ARTS, INC.
Hidden City
site-specific installations, public art project, 2006

THE PRINT CENTER
*Taken with Time: Ann Hamilton, Vera Lutter,
Abelardo Morell*
site-specific installations, 2005
Imprint
public art project, 2001

ROSENBACH MUSEUM AND LIBRARY
*Flirting With…Artists Projects at the
Rosenbach: Ben Katchor*
book and comic opera, 2002
*Drifting: Nakahama Manjiro's Tale of
Discovery*
illuminated manuscript exhibition, 1999

ROSENWALD-WOLF GALLERY,
THE UNIVERSITY OF THE ARTS
*Yvonne Rainer: Radical Juxtapositions,
1960–2002*
retrospective exhibition, 2000

UNIVERSITY OF PENNSYLVANIA SCHOOL
OF DESIGN, ARCHITECTURAL ARCHIVES
*Crafting a Modern World: The Architecture
and Design of Antonin Raymond and
Noemi Raymond*
retrospective exhibition, 2004

VILLAGE OF ARTS AND HUMANITIES
Bearing Witness
20th anniversary exhibition, 2006

Index

Page numbers in boldface type indicate illustrations

Photograph Credits

All photographs or images courtesy of the artist and the exhibiting venue unless otherwise specified.

Farshid Assassi: p. 137
Photography © The Art Institute of Chicago: p. 155
Pat Binder and Gerard Haupt: pp. 54, 57
Cathy Carver: pp. 41, 42
Courtesy of China Art Objects, Los Angeles: p. 75
The Fabric Workshop and Museum: pp. 150, 151
Reinhard Friedrich: pp. 81, 82
Arno Gisinger: p. 146
Herbert Lotz: p. 154
Ray Llanos: p. 67
Roger Marchant: pp. 45, 47
Attilio Maranzano: p. 138
Milwaukee Art Museum: p. 114
Photograph © Michael Moran: p. 87
The Mies van der Rohe Archive, The Museum of Modern Art, New York, Gift of the Architect, 716.63: p. 79
© 2006 Robert Morris/Artists Rights Society (ARS), New York / Digital Image © The Museum of Modern Art/Licensed by SCALA/Art Resource, NY: p. 115
Neue Nationalgalerie Berlin: pp. 77, 83
OMA: p. 84
Superflex, Copenhagen: p. 136
Mary Swift: p. 6
V&A Images/Victoria & Albert Museum, p. 8
Adam Wallacavage: pp. 161, 162
Whitechapel Art Gallery: 120, 123, 125, 126, 127, 129, 131, 132